D0030247

© 2003 by Marc Serota

About the Author

NORMAN F. CANTOR is professor emeritus of history, sociology, and comparative literature at New York University. Among his many previous books, *Inventing the Middle Ages* was nominated for a National Book Critics Circle Award. He lives in Florida.

Antiquity

SELECTED TITLES BY NORMAN F. CANTOR

Antiquity

FROM THE BIRTH OF SUMERIAN CIVILIZATION
TO THE FALL OF THE ROMAN EMPIRE

Norman F. Cantor

 Perennial

An Imprint of HarperCollins*Publishers*

A hardcover edition of this book was published in 2003 by HarperCollins Publishers.

HarperCollins books may be purchased for educational, business, or sales promotional use. For information please write: Special Markets Department, HarperCollins Publishers Inc., 10 East 53rd Street, New York, NY 10022.

FIRST PERENNIAL EDITION PUBLISHED 2004.

Designed by Barbara D. Knowles, BDK Books, Inc.

Maps by Paul J. Pugliese

Library of Congress Cataloging-in-Publication Data
Cantor, Norman F.
 Antiquity : from the birth of Sumerian civilization to the fall of the Roman Empire / Norman F. Cantor.—1st Perennial ed.
 p. cm.
Originally published: Antiquity : the civilization of the ancient world. New York : HarperCollins, 2003.
 Includes bibliographical references and index.
 ISBN 0-06-093098-5
 1. Civilization, Ancient. I. Title.

CB311.C333 2004
930—dc22

2003042317

08 09 ❖/RRD 16 15 14 13

To My Family

Contents

Author's Note

This book is an attempt to communicate to the educated reader and to students of history some basic knowledge about antiquity from 2.5 million years ago—the dawn of humanity—to the fall of the Roman Empire in the fifth century A.D. I have tried to convey this long history in simple language, keeping names, places, and dates to a minimum, and focusing on the Mediterranean and Western Europe.

Part I, Basic Narrative, lays out the fundamental knowledge about antiquity that every educated person should possess.

Part II, Societies and Cultures, focuses in more detail on the most important aspects of antiquity.

I have used the conventional, European Christian dating of B.C. (Before Christ) and A.D. (Anno Domini, "in the year of the Lord") rather than B.C.E. (Before the Common Era) and C.E.—not for religious reasons, but simply because that is what most readers are familiar with.

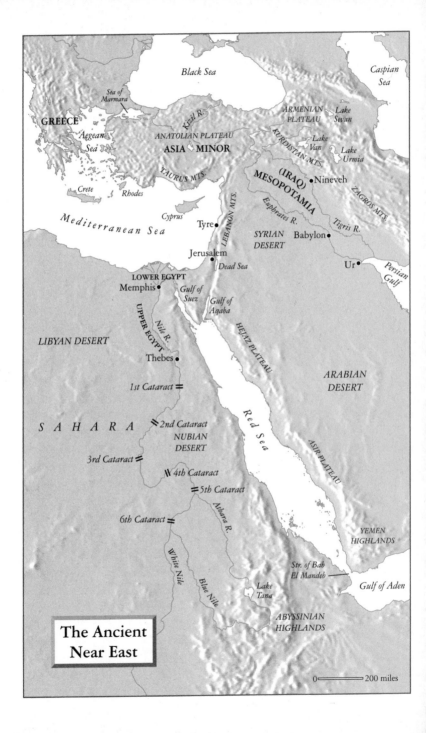

The Ancient Near East

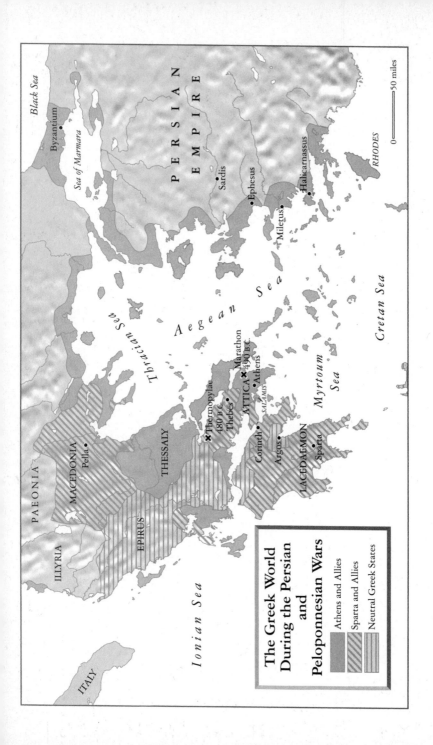

**The Greek World
During the Persian
and
Peloponnesian Wars**

Athens and Allies

Sparta and Allies

Neutral Greek States

Black Sea

Byzantium

Sea of Marmara

PERSIAN EMPIRE

Sardis

Ephesus

Miletus

Halicarnassus

RHODES

0 50 miles

Aegean Sea

Cretan Sea

Thracian Sea

ILLYRIA

PAEONIA

MACEDONIA

Pella

EPIRUS

THESSALY

Thermopylae
480 B.C.

Thebes

Marathon
490 B.C.

ATTICA

Athens

SALAMIS

Myrtoum Sea

Corinth

Argos

LACEDAEMON

Sparta

Ionian Sea

ITALY

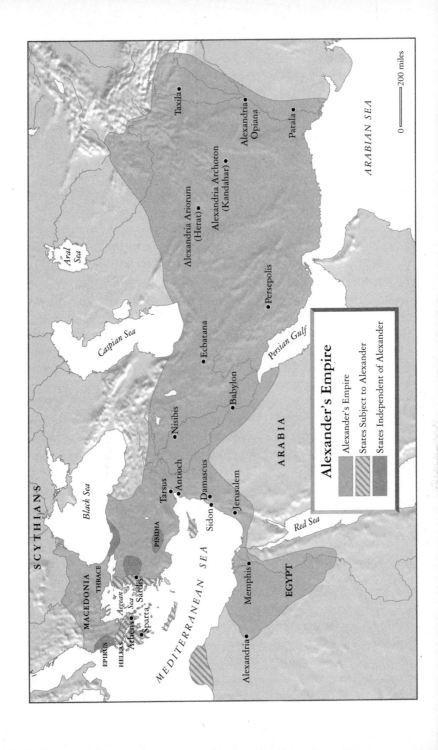

Alexander's Empire

Alexander's Empire

States Subject to Alexander

States Independent of Alexander

0 ———— 200 miles

ARABIAN SEA

Taxila

Alexandria
Opiana

Alexandria Archoton
(Kandahar)

Patala

Alexandria Ariorum
(Herat)

Aral
Sea

Persepolis

Caspian Sea

Echatana

Persian Gulf

Babylon

Nisibis

Tarsus
Antioch

Damascus

Jerusalem

ARABIA

Sidon

PISIDIA

Black Sea

SCYTHIANS

MACEDONIA

THRACE

Sardis

Aegean
Sea

Athens

Sparta

EPIRUS

HELLAS

MEDITERRANEAN SEA

Red Sea

EGYPT

Memphis

Alexandria

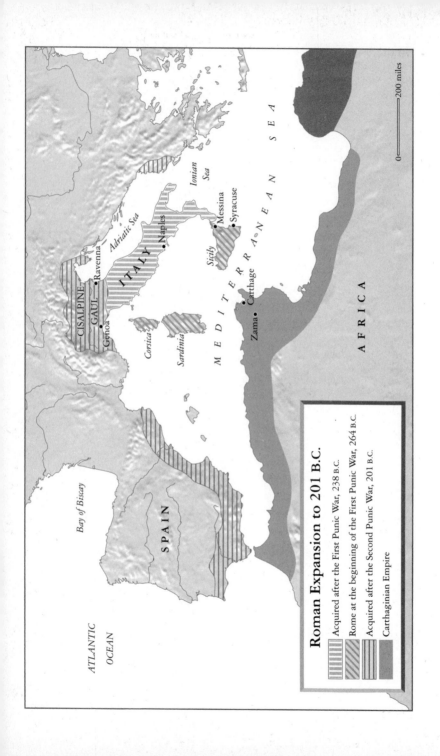

Roman Expansion to 201 B.C.

Acquired after the First Punic War, 238 B.C.

Rome at the beginning of the First Punic War, 264 B.C.

Acquired after the Second Punic War, 201 B.C.

Carthaginian Empire

0 ⊢——— 200 miles

ATLANTIC
OCEAN

Bay of Biscay

SPAIN

CISALPINE
GAUL
Genoa
Ravenna

ITALY
Naples

Corsica

Sardinia

Adriatic Sea

Ionian
Sea

Messina
Syracuse
Sicily

Zama
Carthage

MEDITERRANEAN SEA

AFRICA

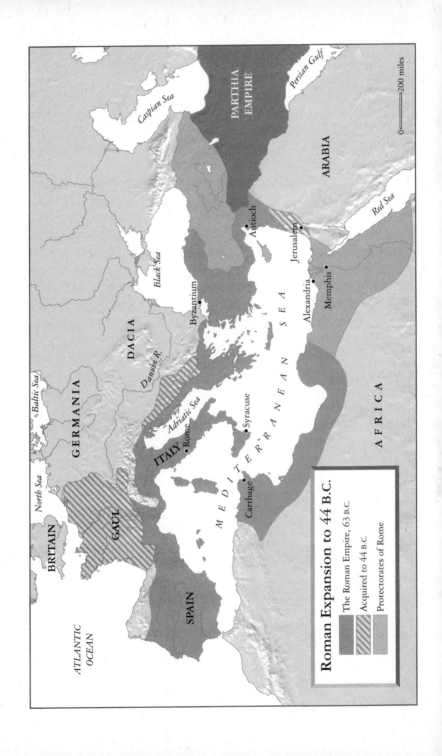

Roman Expansion to 44 B.C.

The Roman Empire, 63 B.C.

Acquired to 44 B.C.

Protectorates of Rome

0 200 miles

PARTHIA EMPIRE

ARABIA

Caspian Sea

Persian Gulf

Red Sea

Antioch

Jerusalem

Black Sea

Byzantium

Alexandria

Memphis

DACIA

Danube R.

AFRICA

Baltic Sea

GERMANIA

North Sea

Adriatic Sea

Syracuse

ITALY

Rome

BRITAIN

GAUL

Carthage

M E D I T E R R A N E A N S E A

ATLANTIC OCEAN

SPAIN

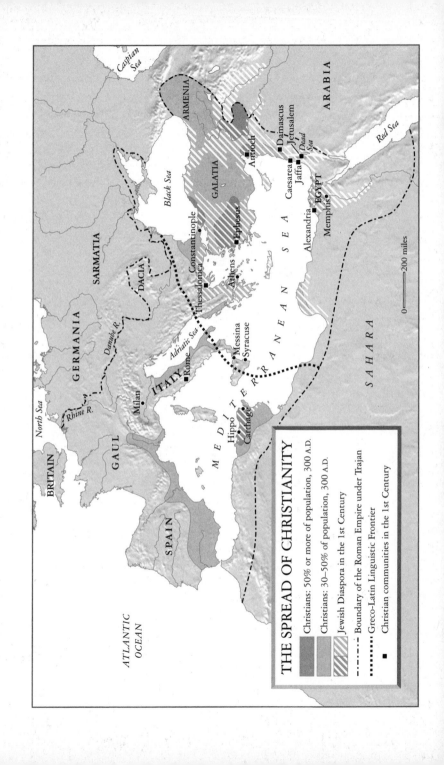

THE SPREAD OF CHRISTIANITY

- Christians: 50% or more of population, 300 A.D.
- Christians: 30–50% of population, 300 A.D.
- Jewish Diaspora in the 1st Century
- —·— Boundary of the Roman Empire under Trajan
- ··· Greco-Latin Linguistic Frontier
- ■ Christian communities in the 1st Century

0 200 miles

One

BASIC NARRATIVE

Hydraulic Despotisms

A very long time ago, some 2.5 million years B.C., the mother of human species as we know it, our ultimate ancestor, appeared in East Africa. She walked erect and was able to close her thumbs and forefingers to make tools for doing what her limbs were unable to do. She was four feet tall and probably black. This is what the science of paleontology told us during the last four decades of the twentieth century.

The earliest humans were related to primates, the apes and monkeys. Humans and gorillas share 92 percent of their DNA. The genetic conformity between humans and chimpanzees is significantly greater. Humans and chimpanzees share 98 percent of their DNA. It is possible that humans and chimpanzees are descended from the same species of animal long ago extinct. Or that humans evolved out of chimpanzees who gave up swinging from trees in order to find food on the ground. Like chimps, humans tend to migrate in colonies. Gorillas are more individualistic, but they, too, are often found to be migrating and living in small groups.

That humans are a species of primate is indisputable. The earliest humans lived and traveled in small groups. They were hunters and gatherers. They gathered fruits and vegetables growing wild in the then-great forests and savannas of East Africa and they hunted animals that they could kill and eat.

Like most humans today, they were carnivorous, but not entirely so. As long as there were vegetables and fruits in abundance, they were satisfied with a vegetarian diet. But fresh meat, eaten both raw and cooked, appealed to them.

Out of stones and bones, they made weapons to kill animals. Their throats and larynxes could utter sounds that allowed for communica-

tion between these humans, and over time, these sounds were shaped into organized languages.

Frequently on the move in search of food, the humans very slowly drifted northward and moved up the great rivers that flowed together to form the Nile valley. Around a hundred thousand years ago, the humans reached the Nile delta and the Mediterranean Sea and began to spread east and north from there. By this time they had learned to be farmers, to plant seeds, to irrigate their croplands, and to build villages and towns, drawing their sustenance from the cultivated earth. But they did not cease to hunt and gather.

The humans reached Europe—at first, the territory adjacent to the Crimea and the northern shores of the Black Sea—about 10,000 B.C.

Based on their excavations, archaeologists tell us that later, around 6000 B.C., two centers of rich and highly developed civilization had emerged in the Near East—in the northern extremity of Egypt and in the Tigris-Euphrates valley, in what is today southern Iraq.

The availability of irrigation systems to water the land and produce grain and other food crops was the material foundation for these two great river-valley societies, Egypt and Iraq. They were hydraulic despotisms, in which a small ruling class, with the aid of soldiers and priests, commanded the material resources that gave sustenance to these civilizations and allowed them to build cities, palaces, and tombs.

The soldiers made sure that the peasants and laborers did what had to be done to maintain irrigation systems, harvest crops, and erect buildings. The priests assured the masses that this forced-labor system was dictated by the gods, who were represented on earth by kings.

The Nile valley was for the most part a natural irrigation system, in which the great river overflowed once a year, covering the land with rich silt brought from East Africa, but pharaohs, as the Nile kings were called, also built some major canals to improve upon natural irrigation. The Tigris-Euphrates valley was a scene of massive and complicated irrigation systems built by human labor to pull the water inland from the rivers.

We know about these two large and prosperous settlements of Iraq and northern Egypt exclusively from the material records offered by archaeology. It was not until around 3500 B.C. that writing

emerged in both societies. Each developed its own distinctive forms of writing.

For another millennium, these written records consisted entirely of state business-accounts and letters, and panegyrics to the mightiness and divinity of kings. (By the dawn of writing, a half million people were settled in each of the Nile and Tigris-Euphrates valleys, where huge temples and palaces were erected for kings, priests, and aristocrats, while the common people lived in small houses made of sun-dried bricks, or in tents.)

The forces for change in the two great societies of Egypt and Iraq were, with one exception, external rather than internal. That one exception was the attempt by Pharaoh Akhenaton (around 1330 B.C.) to create a new monotheistic religion (with similarities to Judaism) and eliminate the power of the traditional priests who served a multitude of deities. This theological revolution was immediately reversed after Akhenaton's death.

Otherwise, what happened in the two river-valley civilizations was determined by wars spurred by invasions from without. In Egypt, dynasties enduring for centuries presided over irrigation and cultivation, huge edifices built by forced labor, and the manufacture of exquisite paintings and jewelry. For a century, around 1100 B.C., Egypt was invaded and ruled by a "sea people," from western Asia, but then effective power returned to a native dynasty.

The history of the ancient Tigris-Euphrates valley was shaped by a series of invasions from the north. As Sumerians, Chaldeans, Assyrians, and Babylonians succeeded one another, the structure of severely class-ridden societies and agriculture-based economies did not change. The series of invasions and conquests ended around 500 B.C. with Iraq absorbed into the expanding Iranian (Persian) empire to the east.

In the first century B.C., Egypt was absorbed into the expanding Roman empire, and remained its wealthiest province until the Muslim Arabs took it over in the seventh century A.D.

* * *

In both instances the hydraulic despotisms were marked by the tremendous capacity for millennia-long continuities in government, religion, urban environment, social structure, and economy. Life expectancy was short, never rising above forty years of age until well

into the twentieth century A.D. Peasants and urban laborers consti-
tuted 95 percent of the population.

Monarchy was considered divine. The priests unequivocally sup-
ported the king. Aristocrats derived their wealth from royal largess.
Whether they were legally slaves or subject to some other variant of
forced labor, the role of peasants and urban workers was to serve the
king, priests, and aristocrats until death.

The physical remains of the Iraqi monarchies have survived only in
small fragments, the most impressive being huge Assyrian statues and
bas-reliefs now found in the Metropolitan Museum of Art in New
York and the British Museum in London. Many of the famous pyramid
tombs of the Egyptian rulers have survived, and some are still unexca-
vated. The higher one was on the social scale while alive, the more
likely one was to enjoy a happy afterlife, accompanied by one's prized
possessions. The contents of the excavated pyramids can be seen in
museums in Cairo, in principal Western European cities, particularly
London and Paris, and in Brooklyn, New York. Egyptian craftsmen
were highly skilled, especially in the making of colorful murals and
gold jewelry. Many Egyptian jewelry designs are still popular today.

No despotism, not even the technocratic monstrosities of the
twentieth century A.D., can entirely shut off the human predilection
for law, art, and charitable ethics. The Iraqis were prone to compiling
law codes, such as that of Hammurabi, which slightly mitigated the
harshness of everyday life for the masses. The Iraqis also developed
myths about the creation of the world, including a story about a Great
Flood, nowadays believed to have actually occurred on the shores of the
Black Sea. These writings may have influenced the authors of the
Hebrew Bible, who lived in Iraq around 500 B.C.

The Egyptians produced attractive murals of domestic life and
idealized depictions of animals, and a host of myths connected to Re,
the Sun god.

The only clear expression of intellectual dissent from hydraulic
despotism occurred in the southern half of the coastal lands of the east-
ern Mediterranean, called variously Canaan, Palestine, Israel, Judah,
and, today, Israel again. Here and in a satellite Jewish colony in Iraq,
between 800 and 500 B.C., visionaries ("the Prophets")—namely
Amos, Ezekiel, Isaiah (at least two different writers writing under this

name), and Jeremiah—wrote elegant poems calling for social justice in the world and a freer, more open and humanitarian society.

This Promised Land of the Hebrews was on the main mercantile-and-army route that ran from Egypt to Iraq. It was the place of egalitarian ideas that contradicted the way of life of the two great empires that lay at either end of the road that traversed Israel.

Proponents of a monotheistic theology that resembled that of Pharaoh Akhenaton, and of a strong national consciousness, the Hebrew prophets called for a just and free society sharply at odds with the hydraulic despotisms, even in the severely edited form their writings were given by the priests before these writings were admitted into the slowly developing Hebrew Bible. Some of the works attributed to Isaiah and Ezekiel were composed in Iraq. Jeremiah spent the last years of his life in Egypt, so that there is more than local significance to the radical, democratic, humanitarian visions of the Hebrew prophets.

The text of the Hebrew Bible read in synagogues today was defined in Spain around 1000 A.D., but this version corresponds very closely to a Biblical text written in or near Jerusalem between 300 and 250 B.C. and discovered in the late 1940s in caves overlooking the Dead Sea, south of Jerusalem.

Historians and archaeologists now believe that the Hebrew Bible crystallized around 600 B.C., in the time of King Josiah, who, together with the Judean priests, undertook a religious reformation. A strict monotheism was ordained, local shrines destroyed, and the important religious services centralized in Jerusalem. A stern moral code and a maze of religious laws were imposed. Shortly after, the main part of the Jewish community was exiled by the Babylonians to Iraq, where some Jewish families continued to live in unbroken peace until 1948. After their conquest of Iraq around 500 B.C., the tolerant Persian rulers encouraged the Jews to return to Judea, and perhaps half did so, carrying with them historical myths and ethical ideas from Iraq.

Their scribes settled down to organize and compose the Bible as it has existed since 250 B.C. and later came to be a part of the Christian Old Testament. God's covenant with the Jews, His chosen people and witnesses to His message of love and law for all mankind, became the prime theme of the Hebrew Bible, which now included the heavily edited texts of the Prophets calling for social justice at a time when a

succession of petty Hebrew kings imitated the hydraulic despotisms in Iraq and Egypt.

A grand national myth was created in which the Hebrews were said to have come originally from Iraq and to have migrated to Canaan and then to Egypt, where they became slaves of the Pharaohs. They were led by Moses into freedom and a return to the Promised Land. Archaeologists after a century of excavation know today that this is only a liberation myth; there was no exodus of the Jews from Egypt, although Passover annually celebrates this event. The rabbis who took over from the Jerusalem priests after the Romans sacked Jerusalem in 70 A.D. placed another conservatizing layer of editing upon the final text of the Bible, making it a persistent reminder of national consciousness but further downplaying the radical call for social justice against hydraulic despotism, which the Prophets had inculcated between 800 and 500 B.C.

The Greeks

*I*t was not until 1948 that Cambridge University stopped requiring a knowledge of classical (ancient) Greek as a prerequisite for admission. This requirement was based not only on the intrinsic merits of ancient Greek literature and philosophy. Knowledge of Greek was a screening device to keep out the less affluent, who attended British state schools, where Greek was less likely to be taught than in private schools.

But the nineteenth-century British genuinely fell in love with the Greeks and thought that mastering Greek ideas was the hallmark of a good education. Benjamin Jowett, the Master of Balliol College, Oxford, was regarded as Britain's leading educator of the 1870s and 1880s. His chief claim to fame was translating most of the dialogues of the Athenian philosopher Plato. It was considered imperative that those young men destined to rule the British Empire should be firmly grounded in the thought of Plato and Aristotle, another ancient Athenian philosopher, as well as in Greek epic poetry and drama.

The amazing thing is that from a small population—not more than two hundred thousand people at any time, including farmers in the nearby countryside—arose the dominance of Athens as the intellectual and literary center it was from about 425 to 350 B.C. Another Greek city, Corinth, shared some commercial success with Athens; and Sparta, an oligarchic society organized around an army, shared political and military power in Greece with Athens and finally prevailed in war with the Athenians. But when the Victorian Brits said "Greece," they meant "Athens." There was very little in the way of a cultural heritage handed on from the other Greek cities.

Those of the middle and upper-middle class (there were no landed aristocracy in Athens or thereabouts) could rely on the labor of 35 per-

cent of the population: slaves. Half of these were engaged in domestic tasks in bourgeois households, or worked as craftsmen, vintners, and teachers. But the other half did hard labor in the small farms within a hundred-mile radius of the city, or were dragooned into the dreaded mines or the oar-propelled galleys that maintained Athens's international trade.

Today, Athens is a small and frugal city surrounded by barren hills, with a second-rate port, Piraeus, ten miles away. Its physical monuments and buildings on a central hill in the city—the Acropolis—are now closed to tourists, so decayed are the structures, above all the great Parthenon. No one today thinks of Athens as an important, or wealthy, or beautiful city.

It was different in 400 B.C.

* * *

Athens was the most successful democratic republic in antiquity. Sixty percent of adult males had the vote. Juries consisted of about six hundred males, drawn by lot.

Athens was the center of an extensive maritime empire. There were Greek colonies stretching from Marseilles on the Mediterranean coast of what is today France, through Sicily and Crete, to the Crimea and shores of the Black Sea, passing by Byzantium on the Hellespont in what is today Turkey.

The Greeks picked up a written alphabet (much superior to the Egyptian and Iraqi form of writing) from another sea people, the Phoenicians (centered in Lebanon and what today is Tunis). By 350 B.C., written and spoken Greek became the international commercial and intellectual language of the Mediterranean. For nine months out of a year, the Mediterranean Sea was actively traversed by Greek ships carrying goods from one end to the other.

The area around Athens was somewhat more lush in ancient times than it is today, but it was commerce rather than agriculture on which Athens's modest wealth was built. It was a thriving, middle-class city, inhabited by many foreigners and lacking a real landed aristocracy. This made for a noisy and sometimes unstable and corrupt democracy, but democracy it was.

The Athenians fought two great wars. With the aid of the Spartans they repulsed a Persian invasion from Asia Minor (Turkey). Then they

waged a long war with Sparta for domination of the Greek peninsula and to keep control over their far-flung colonists in Sicily, which the Athenians lost mainly because of a plague that decimated the city.

This gives Athenian history the appearance of a sharp rise and a likewise sudden fall over a 125-year period. The intellectual vibrancy of Athens is explained not just by middle-class literacy and rationality, but by its contact with the cultures of Egypt and the Iraqi-Persian civilization of Asia Minor. From the Egyptians, the Athenians learned literature, art, and religion. From Asia Minor, they gained knowledge of philosophy, mathematics, and science. Yet what is important is not what Athens borrowed from other societies, but what it did with the ideas it imported.

* * *

Like the Jews with their Exodus, Athenian culture was grounded in an epic historical myth: the Trojan War. The epic poem about this myth is called *The Iliad.* It is thought to have been written around 800 B.C. and purports to describe events that occurred around 1100 B.C. Greece was still ruled by kings then, and the wife of a prominent king (so the epic story goes) was stolen by the son of the king of Troy, a small kingdom on the west coast of Asia Minor. All the Greek chieftains rallied together, invaded Asia Minor, and besieged Troy for ten years, finally taking the city by trickery, and burning it.

In the nineteenth century *The Iliad* was widely read as history, and the wealthy German archaeologist Heinrich Schliemann spent twenty years and a pile of money excavating the modern Turkish village of Troy. He found not one ancient Troy but layers of several Troys. One was indeed burned, but it was not of the era described in the epic poem. He discovered a set of golden vessels and dishes, which he called Priam's Hoard, after the king of Troy in *The Iliad.* Subsequent excavations raised doubts that these gold articles actually dated from the Trojan War. Nevertheless, Schliemann donated the cache to a Berlin Museum; the Russian army removed Priam's Hoard to Leningrad (today St. Petersburg) in 1945.

National historical myths are a way of giving identity and moral authenticity to a people. *Exodus* flattered the Jews half a millennium after it allegedly took place by making them feel like heroic refugees from slavery, and righteous conquerors of a land corrupted by paganism,

wealth, and sex. *The Iliad* made the politicians, merchants, sailors, farmers, and schoolteachers of Athens in the fifth and fourth centuries B.C. into the heirs of austere, remorseless, honorable, courageous warriors, a race of demigods. Contrast this with the real Athenians of ca. 375 B.C.—their bellies full of fishcakes, their throats bloated with cheap resined wine, their far-flung sharp commercial deals a laughable, reverse mirror-image of the noble warriors of the Trojan War era.

Yet this was the book that lay at the base of Athenian consciousness, its text the core curriculum of schools. Supposedly a folk story that grew over time, written down by a blind poet named Homer, it was a work of artful deception created for the bourgeois market, allowing noisy, coarse, but well-educated Athenians to see themselves in pseudo-aristocratic garb. Homer's sequel, *The Odyssey,* reveals clearly that he was a market-driven professional writer, not a spontaneous folk poet. *The Odyssey* is a collection of tall travel tales that borrowed heavily from Egyptian fantasy. It smells of the languid Nile ambience, just as *The Iliad* offers a bracing tonic of the clear, crisp Aegean water that the Greek chieftains had to cross to get to the walls of Troy.

The Greek tragedies, performed in competitions at religious festivals of the fifth and fourth centuries, are similarly placed in a distant heroic past. They deal with one of three themes, or combinations of them: The struggle of individual conscience and sensibility against the needs of the community and the power of the state; arrogance (*hubris*) that blinds the strong and self-righteous individual to possible misfortune and defeat; and endless series of bloody revenges triggered by mad acts rising from anger and sexual drive. In the hands of the dramatists, Aeschylus, Sophocles, and Euripides, they remain works of unsurpassed psychological grandeur.

Human nature in the Greek tragedies is stripped of its protective clothing, and societies of their pious myths. Life is raw and uncompromising, and the future indeterminable. The Victorians' taste for Greek tragedy was limited; the dramas struck too close to home against hypocrisy and ethical pretense.

It was not until the impact of Freudian and Jungian psychoanalysis was felt in the 1920s, and modern theater companies successfully performed unexpurgated versions of the Athenian dramas, that close interest in these masterpieces emerged among educated people. Today

we deeply regret that although Sophocles wrote four or five dozen plays, we only have the texts of seven, including the incomparable *Oedipus Rex*, the best tragedy written before Shakespeare's *Hamlet*.

King Oedipus is another hero from the early, quasi-mythical Greece. He is successful, powerful, happily married, and universally admired. He refuses to listen to warnings that shadows from his early years might darken his present and future. It is revealed piece by piece that he had unknowingly murdered his father and that his wife is his mother. The two unpardonable sins of patricide and incest bring his world crashing down on him. To atone, he gives up his throne and blinds himself. Sophocles does not clearly explicate what exactly is Oedipus's fatal flaw, aside from an understandable arrogance that seemingly offends the gods or Fate.

The dramaturgy is effected with a skill only Shakespeare has attained since. The drama unfolds in eighty minutes, with blinding speed. Its awesomeness increases when one realizes that in Athenian times it was performed with all the actors, including those in the gloomily warning chorus, wearing large masks covering their faces. This compact quality reflects the origin of the tragedies in competitions at religious festivals. But it also heightens the vast fear of the consequences of human fragility, which the playwright was trying to communicate.

The same tragic tone haunts the account of the great war between Sparta and Athens for hegemony of Greece and Sicily, to be found in the unfinished memoir by Thucydides, a failed Athenian general. Athens has everything going for it in terms of culture, politics, and economy. But it falls before the small city-state of Sparta, a society perpetually organized for war. The key moment occurs when the Athenians, in their arrogance, severely punish their discontented colony in Sicily, oblivious to the impact of fear and dismay spreading, as a result, among their other colonies and allies, and are wrathfully punished themselves by the gods or Fate through rebellion and plague.

The structure of Thucydides' work on the Peloponnesian War follows the tragic arc of Sophocles' dramas.

Thucydides' account is the first work of what we would recognize today as historical writing, just as the work of an earlier writer, Herodotus, is the first book on anthropology. An inveterate traveler, especially to Egypt, Herodotus collected behavioral tales, religious

practices, and physical appearances, in Egypt and other parts of the eastern Mediterranean for his sober and respectful stories.

This shows how willing Athenian culture was to learn from other peoples of the Mediterranean.

* * *

It was Plato's philosophical dialogues that, of all the available works of Greek literature, appealed most to the nineteenth-century reader and inspired Benjamin Jowett to translate them into passable English; translations that were still being marketed to American students and readers in the 1950s in Modern Library cheap editions. Jowett's translations omitted the fact that the Athenian ruling class was bisexual and pedophiliac. The body of a ten-year-old boy held the highest aesthetic value for it.

In Plato's dialogues, Athenian civilization reached a philosophical and literary high point. But in the fourth century a threat to Athenian independence rose from the emerging Balkan state of Macedonia. Against this background, Alexander the Great (d. 323 B.C.), a young king from Macedonia, at the northern extremity of Greece, conquered all of Greece after the debilitating Athenian war with Sparta. He then moved south and east, conquering the Egyptians, whom Herodotus and the Athenians much admired, absorbed the Persian Empire, and proceeded across Central Asia as far as northern India, where his army mutinied and refused to move farther.

Some modern historians have regarded Alexander as motivated by a cosmopolitan ideal of uniting east and west and of creating a new international culture. To some extent this was an outcome of his tumultuous reign, but there is really no evidence that he initially set out to develop a new multiethnic, universal citizenship. He was an ambitious young man who had been left a well-trained army of fifty thousand mercenaries, mostly Greek, by his father. Alexander put them to good use in rapid military conquest. Unquestionably he was a great general; he was also very lucky.

After Alexander's death—from malaria and excessive drinking, probably—at the age of thirty-three, three of his Greek generals divided up the eastern Mediterranean and western Asia. These are known as the Hellenistic monarchies. Their most remarkable achievement was the growth or expansion of great trading and cultural cities,

led by Alexandria in Egypt, and the blending of Greek, Jewish, Persian, and Egyptian cultures into an international literary, political, and religious melange voiced through the Greek language in its somewhat simplified Hellenistic form.

This is the language in which the Christian New Testament is written.

Four Worldviews from Antiquity

*W*hen historians and literary scholars talk about the classical heritage, or the legacy to Western civilization from antiquity, they are primarily thinking of four worldviews that were written in Hebrew or Greek among the body of religious, philosophical, and literary texts created before 250 B.C. These are the Hebrew Bible, the philosophies of Plato and Aristotle, and Hellenistic, or Alexandrine, literature.

These four groups of writings comprise the foundations of Western, or European, civilization. They permeated school curricula, religious services, imaginative literature, and in various ways influenced an ever-widening pool of intellectual waters that has nourished the identity, consciousness, and ambitions of the West to the present day.

Take away these four literary and intellectual traditions and what they started and pushed forward into modern times, and we would have no religious services as we know them, no philosophy and science, and no novels and imaginative literature that drives our publishing industry. There would be no United States because the political ideas that our Founding Fathers put into the American Constitution in 1787 also derived from antiquity, and the Fathers were very much aware of the U.S.A.'s debt to this source.

Take away these heritages from antiquity before 250 B.C., and whatever New York City might be today, it would have no universities, colleges, or publishing houses. It would be a place of barbarism, ignorance, and violence (which it may yet become). With all the social, material, and political faults of antiquity, it got Europe and the Mediterranean world moving forward to the culture and education of today, separating Man from the other primates.

The first five books of the Hebrew Bible (put in definitive form by 250 B.C.) present a history from the creation of the world to the appearance of the Israelites at the gates of the Canaanite city of Jericho, through which they allegedly entered the Promised Land. These five books, the Pentateuch (meaning five books) are also known as the Five Books of Moses—even though he didn't write them—or, officially, as the Torah (Law).

The central idea is that of the covenant, or contract, between God and the Hebrews. It is, however, a strange contract, since the *Ivri* (Hebrews) had no freedom of choice in entering this covenant. It was unilaterally imposed on them by God—Yahweh—and reimposed by Him whether they wanted to abide by it or not.

Why God should have entered into this covenant with a small, obscure people (who originated either as invaders from Saudi Arabia or, more likely, as a group of Canaanite back-country religious reformers) the Bible does not tell us.

God intended that the Ivri should be a light unto the nations, witness to His Truth in the world, His messengers. In return, they would have the lush land of Canaan as their homeland forever, and multiply as the stars in the heavens. There are, in fact, only 13.2 million Jews in the world in 2002. In antiquity there were never more than 10 million of them, around 100 A.D.

There are four signs of the covenant. First, circumcision, which was commonly practiced in the Ancient Near East but not in Iraq where half a million deported Jews lived from about 500 B.C. Second, the rigid keeping of the Sabbath—just as God rested on the seventh day while creating the world. Third, special dietary laws of *Kashrut* (purity), prohibiting the eating of pig or shellfish. A taboo against pig was not uncommon in the Near East; the shellfish taboo seems to be unique to the Jews. Many Jews today claim that health reasons lie in the foundation of the *Kashrut* laws; there is no evidence to support this familiar claim.

Finally, Judaism involved an elaborate puritan ethic set down in the Ten Commandments Moses allegedly received from Yahweh on Mount Sinai, whose exact location is unknown. Worship no other gods but Yahweh; do not take God's name in vain; keep the Sabbath; honor thy father and mother; do not kill, or commit adultery, or steal, or bear false witness; do not covet your neighbor's wife or his donkey.

Even for many Jews in the world today, the injunctions of the covenant are extreme and bothersome. The ancient Hebrews also found them burdensome. But a succession of priests, prophets, and rabbis (religious teachers) forced them back on the straight and narrow, provided they did not leave the Jewish community entirely (as many did, beginning in Hellenistic times).

To many of their ancient Gentile neighbors, the idea of the covenant and the rigid code of puritan ethics it demanded were admirable. Protestants of the period between the 1500s and 1800s made this covenant theology and ethic central to their own beliefs and behavior. Roman Catholics at least admired the Hebraic idea of sacred history, in which history moved forward directly, unrepeatable, from the creation to the end of the world, all preordained by divine providence.

While many Greeks (although not Thucydides) thought that history moved in circles, repeating itself infinitely, the Jewish idea that each event was singular and proceeded along a straight line had a great impact on European thinking.

* * *

There were leaders of the Christian Church in the third and fourth centuries A.D. who perceived such similarities between the Hebrew Bible and the philosophy of Plato that they surmised that the Athenian philosopher had visited Judea and imbibed ideas from the disciples of the Hebrew prophets. There is no evidence to support this claim.

But, as a rich young man, Plato did travel extensively. He very likely visited Egypt, and there was a bizarre incident involving his visit to Sicily. There, a petty despot allowed Plato to take over his government and put into practice Plato's own strong, if reactionary, political opinions. Plato did so and made a terrible mess of things.

Plato was part of a fast crowd of rich young men who gathered around Socrates, a hippie stonecutter who expounded on philosophy in the Athenian *agora*, or marketplace, perhaps to avoid going home to face his shrewish wife. Socrates would yell out to a passerby "What is Justice?" or some such leading question. Getting a soft answer like "Giving every man his due," Socrates would use dialectic or logic to probe deeper.

Finally, Socrates so annoyed the democratic governors of Athens that he was put on trial for impiety, blasphemy, and corrupting the

young; convicted; and sentenced to death by drinking hemlock, a poison. Plato and other of Socrates' disciples prepared a boat to enable their master to skip town, but Socrates insisted on going through with his suicidal execution. He logically argued that he had been loyal to the laws of Athens when they were good to him; he was not going to run off when the state turned against him.

In Socrates' memory, Plato founded the Academy, a nonstop seminar and talk show. He published many philosophical dialogues with Socrates, who was the supposed philosophical leader. Plato was a literary genius; he wrote beautiful, clear Greek, and all his writings were copied and have survived. The dialogues are both fun and inspiring to read. How good a philosopher Plato really was aroused great controversy off and on from his day to the present. In general, one either is a Platonist or one hates and condemns him.

Plato and his rich friends in Socrates' circle had a very low opinion of Athenian democracy. In their view, power had been usurped by ignorant and coarse men; certainly they made a mess of things during the devastating Spartan War. And the middle class did not get off the hook in the eyes of the Platonists just because Athens had been hit by a very bad plague.

Plato argued that only philosophers, who understood ideas, should rule the other classes, which besides the philosopher-kings were warriors (guardians) and workers. This hierarchical theory had a lot of followers in both the ancient world and during the Middle Ages. But Plato's political theory was only part of his general philosophy, called the Theory of Forms.

Plato had one Big Idea from which everything else derived. He fundamentally defined reality as that which is permanent and unchanging. Only ideas are permanent and unchanging; anything material deteriorates and decays. Laid up in heaven are Forms, or Ideas, for everything we see and sense. Everything achieves reality insofar as it is conditioned by, or participates in, a pure idea. An idea makes a ship; otherwise, it is a lump of wood and canvas.

Plato went further, ending in a kind of religion that many Christians and some Jews came to admire: When reason has purified ideas to their utmost, a flight of the soul or a mystical experience allows the human mind to know the Idea of the Good, "the source of

all things right and beautiful," or God, who is our Home, Creator, and Redeemer. This is tied to a Platonic view of human nature as bifurcated into soul and matter, which are joined at birth. Rigorous philosophical inquiry and dialectical reasoning allows the soul to recover pure knowledge of ideas.

At death, the soul and body are disconnected and the soul flies back to God. Half a century after the death of Jesus Christ (37 A.D.), Christ's teachings were rewritten in the shape of Platonic philosophy, which dominated all Christian theology until the thirteenth century and still partly prevails.

In one of Plato's seminars a young man with a rural accent stood up one day and said Plato's philosophy was nonsense. You can have ideas that are neither real nor permanent. They can be mere fleeting fantasies. Plato evicted the student, whose name was Aristotle. Unlike Plato, Aristotle was not one of the gilded youth of Athenian society. His social background was solid middle class. But such was the encyclopedic knowledge he came to exhibit, and his skill in logical argument, that in time Aristotle gained rich benefactors, including the king of Macedonia who hired Aristotle to tutor his young son, later known as Alexander the Great.

Aristotle founded his own seminar, the Lyceum. His disciples were called the Peripatetics because like many professors, Aristotle walked up and down while he lectured. His many treatises available to us appear to have actually been put together from lecture notes taken by his students. This accounts for their lack of literary elegance and for an occasional wandering off the subject to answer a student's question.

Because of their sparse literary quality, as well as differences between them and Plato's teachings, Aristotle's works were little read in antiquity. He did not get much recognition before the twelfth century A.D., except for his incomparable textbook on logic.

If Plato leads to ancient Christianity, Aristotle looks forward to modern science. Even if some of his particular teachings on physics came to be repudiated between the 1300s and 1600s, Aristotle clearly grasped how natural and social science works: Engage in exhaustive collection and review of data achieved by observation until a pattern or form emerges in the data. Form and matter are not separate, the one real and the other unreal; they are interactive.

Setting out to write a treatise on politics, Aristotle first collected and examined a hundred constitutions from the Greek city-states. This taught him that neither aristocracy nor democracy, but a mixed form of government was the best political system. Asked about the existence of God, Aristotle replied not with Plato's mysticism but with a sober consideration: Physics showed that ultimately there has to be a first cause, an unmoved mover, which is God.

In ethics, he had two bright ideas. First, that extreme behavior of selfishness and self-sacrifice don't work for most people; look for the golden mean. Second, good behavior is not a result of either sudden inspiration or harsh control. It is a habitual pattern, which means slow and steady conditioning: "One swallow does not make a summer," nor does one good deed make ethical behavior.

* * *

While Aristotle's writings, except for the textbook on logic, received little circulation before 1150 A.D., his work gave impetus to one of the two currents in Hellenistic, or Alexandrine, culture. This was in the area of natural science, particularly in the fields of astronomy and medicine. The majority of Hellenistic astronomers agreed with Ptolemy, the Alexandrian astronomer, that the universe was geocentric rather than heliocentric (earth-centered rather than sun-centered). It was not until the use of telescopes in the late sixteenth century A.D. that data was generated which militated against the geocentric theory, that Ptolemy's view of the earth as the center of the universe was finally abandoned. But Ptolemy had his eye on two Aristotelian principles that founded astronomy as a science: Collect as much observed data as possible, and then plot a paradigm or model that incorporated this data.

In the field of medicine, Galen, the Alexandrian scientist, propounded a view that is still around, nowadays called "alternative medicine." It was taught in many medical schools until the mid-nineteenth century and now is becoming popular again. Human health is the result of the balance of humors, or temperaments. Physical exercise, bathing, and herbal remedies keep the four temperaments in balance, or restore the balance, in case one, such as melancholia (depression), comes to dominate. Today's transactional psychiatry teaches much the same medical doctrine as Galen did.

The great impact of Hellenistic culture was, however, not in natural science, but in the more Plato-inspired imaginative literature. The modern novel has its origins in the ultra-heroic and fantastic literature of the Hellenistic world intellectually centered in Alexandria. The life of Alexander the Great was itself one of the prime genres of Hellenistic romanticized literature, and remained so into the sixteenth century.

The period of the Hellenistic monarchies that succeeded Alexander the Great extended for 150 years beyond 300 B.C. The political system was the same as the hydraulic despotisms that they succeeded, and perpetuated the same kind of centralized imperial control.

But even after the Hellenistic monarchies were subordinated to Rome around 150 B.C., the distinctive worldview of the eastern Mediterranean, which had begun with the era of Alexander the Great, persisted.

First of all, the Hellenistic worldview embraced a mixture of peoples and religions ordinarily coexisting peacefully under a powerful state. Hellenistic culture, therefore, assumed a cosmopolitan tone, a kind of world citizenship. National customs and feelings and specific religions were melded together in large and peaceful political units. There was much influence of one culture and religion upon another. It was a society whose centers were large mercantile cities surrounded by peasant-occupied farms subject to powerful monarchies. In many ways, the worldview of Hellenistic times still prevails in the eastern Mediterranean.

The main intellectual accomplishments of the Hellenistic world were the sciences of astronomy and medicine, perpetuation of Platonic philosophical traditions, highly innovative and imaginative literature, and, ultimately, by 200 A.D., the Christian Church as we know it.

CHAPTER FOUR

The Romans

*I*n 400 B.C., while the Athenians were in the midst of their century of cultural glory, economic enterprise, and all too short-lived political and military power, Rome was still a relatively obscure city on the hills of central Italy. Its population then, including surrounding farms, could not have been more than a hundred thousand.

But four centuries later, Rome was the capital of a vast empire embracing all of the Mediterranean and major parts of what is today Western Europe. When the Roman Empire reached its fullest extent around 100 A.D., it stretched from London to Jerusalem, from Vienna to Tunis. It was another four hundred years before this peerless imperial structure cracked and disintegrated. Yet in the old Greek city of Byzantium, at the eastern extremity of the European part of today's Turkey, on the Hellespont, an entity still calling itself the Roman Empire endured until the Turkish Muslim conquest in 1453.

How did this obscure hill city of 400 B.C. become the Roman Empire of the first century A.D.? This is one of the great dramas in human history, with huge consequences for every aspect of social, political, and cultural life.

The Romans had two myths about the founding of their Eternal City. In the first one, the founders were twin orphans called Romulus and Remus, who were nourished as infants by a she-wolf. In the second one, the founder of Rome, wrote the poet Virgil around 10 A.D., was a Trojan prince named Aeneas, who founded a new imperial city destined to "crush the proud and raise up the humble."

In actuality, Rome in 400 B.C. (three and a half centuries after the alleged founding of the city by whatever myth one chose to believe in) was one of the hill towns of central Italy struggling for hegemony in

Latium, as this rocky part of central Italy was called. The Romans, who had a century earlier divested themselves of their kings, and functioned as an unwieldy constitutional republic, triumphed over their neighbors and then incorporated them into their army. This was the first stage in the emergence of Roman political power.

The next stage involved subjugating all of mainland Italy from the Po Valley in the north to the heel of Italy in the south. This brought the Romans to fight for control of Sicily, with its lush grainfields and beautiful Greek cities, and against the African seafaring power of Carthage, which existed a short distance from the modern location of Tunis. Carthage had originally been founded by Phoenician sailors and merchants from the eastern Mediterranean. For 150 years, during three conflicts (the Punic Wars), Rome and Carthage contended for domination of the central and western Mediterranean and North Africa. In the first war against Carthage, the hitherto landlubbing Romans built a navy from scratch to enable their conquest of Sicily.

In the second Punic War, the Carthaginians under the great general Hannibal, after crossing Spain and the Alps, counterattacked and invaded Italy from the north. In 216 B.C., Hannibal inflicted a massive military defeat on the Romans in central Italy, but he lacked the resources, or perhaps audacity, to assault Rome itself. The Romans built a new army and drove Hannibal and his soldiers and elephants from Italy.

In the third Punic War, the Romans under the leadership of one of their greatest generals, the aristocrat Scipio Africanus, invaded North Africa, defeated the Carthaginians, and razed their great city to the ground.

Rome was now free to conquer Greece, Egypt, and the eastern Mediterranean, taking over from the Hellenistic monarchies that succeeded Alexander the Great, as well as incorporating some independent kingdoms, such as Judea.

The secret of Rome's military success was the organization and composition of its army, its peculiar republican government that endured until the end of the first century B.C., and its liberal treatment of the peoples it conquered.

The first-century historian of early Rome, Livy, gives a highly sentimental picture of the Roman army as the city commenced its Italian

conquests. According to Livy, the original Roman army was a congeries of citizens who temporarily left the plough, the villa, or spacious urban residences—but especially agricultural pursuits—and joined together under nobly born amateur generals to fight for the fatherland.

In fact, by 200 B.C., the ranks of the Roman army were filled with professional mercenaries recruited from all over Italy. They entered service on lengthy contracts at around eighteen years of age. The soldiers were uniformly of peasant stock. They were well-trained, well-fed, and well-rewarded, not only with cash wages but also with a land settlement at the end of their designated years of service.

Normally, the soldiers were unmarried and started families after their contracts ended, but by the first century A.D., as the empire comprised many thousands of frontier miles that had to be garrisoned, some military companies were encouraged to marry and settle down in domestic situations along the borders.

The soldiers were organized in groups of a hundred, and, like all good armies, they bonded together and protected each other. The soldiers wore leather-and-metal helmets and tunics. Their normal weapons were javelins and short swords. They were very skillful and endlessly drilled in using these instruments of war. It was an infantry army; until the fourth century A.D., there was no cavalry to speak of. The paved Roman roads were built more for long and rapid infantry marches than as an aid to commerce.

The two heads of each legion (battalion), comprising five thousand to twenty thousand men, were consuls from the aristocracy. Some were very experienced; many were amateurs, politicians rather than soldiers. These consular generals were supposed to share the supreme power over the legions and to serve normally for only one year. Yet, by the first century B.C., generals of proven skill and good leadership had come to serve, by one legal mechanism or another, as grandiose field marshals exercising continuous power in the field for several years and enjoying the die-hard loyalty of the well-trained and well-rewarded peasants in the ranks.

Contemporary writers did not hesitate to claim that, for three quarters of a millennium, the constant success of the Roman armies was due to their being free men who chose to serve, compared to armies of the Hellenistic kingdoms, which consisted of conscripts and

slaves. Of course, there was something to this contrast, so important to modern sentiment, but the Roman armies won wars—even after defeats in particular battles—mainly because they were hardened, well-rewarded veterans led by experienced commanders.

The Roman republican constitution was a very complicated document, designed to share power among classes and groups, and to avoid dictatorships. Cumbersome and unwieldy as it was, it worked effectively until the middle of the first century B.C. There were two legislatures—a senate drawn from the landed aristocracy, from whose ranks came the military consuls and provincial governors (proconsuls), and an assembly of middle-class people called *equites* (knights), who chose two tribunes each year to speak on their behalf to the senate. Important legislation required the approval of both representative houses, but initiative in legislation normally came from the senate. The tribunes and the assembly functioned more as a restraining force on the senatorial aristocracy than as an independent legislative house.

During the last two-thirds of the first century B.C., this political system underwent severe strains that finally resulted in the setting up of a thinly disguised military dictatorship under an emperor, the holder of imperium, or power. First, the friendly Italian cities that contributed importantly to the army and to agricultural and commercial wealth rebelled against being treated as second-class citizens. They got the equality they wanted.

Then the Gracchi brothers—tribunes of the people, although from a noble family—fomented various kinds of political unrest to get a land redistribution from the holdings of the senatorial aristocracy for peasants dispossessed by the expanding great estates of the nobility and for army veterans unsatisfied with their rewards. This Gracchi maneuver led to fierce debates, turmoil, street fighting, and the eventual assassination of both brothers.

At this point, in the middle of the first century B.C., naked civil war broke out over which noble families and social groups would control the legions, dominate Rome, and allot very lucrative provincial governorships to their friends, relatives, and followers. The Roman Empire inspired insatiable greed among a handful of aristocratic families and their supporters in the middle class. Greed led to conflict and civil war.

The civil war's tide turned in favor of the great general (and a good writer) Julius Caesar whose imperial ambitions led to his assassination by a senatorial cabal in 44 B.C. When the smoke finally cleared, Caesar's adopted son, Octavian, systematically eliminated his rivals and stood on top of the Roman world as Augustus Caesar, the emperor. The senate still functioned, but mainly as a social club and a pretentious façade behind which Augustus wielded full political power and controlled the army.

Bloody happenings occurred in Rome then and later, but by the first century A.D. the Roman Empire was at peace, the fabled *Pax Romana*. The city of Rome numbered a million people—a third of them slaves or unemployed, living on handouts from the government. Given the primitive communication system—it took four to six weeks to get a letter from Rome to London—vast authority had to be vested in the provincial governors drawn from the senatorial aristocracy. They engaged in corruption and plunder, for which they were rarely held to account. But the multiethnic societies they ruled tolerated their hegemony, because peace and security was provided and taxation was low.

* * *

The Roman Empire, comprising fifty million, came to resemble the old Hellenistic empires, in which the nodules of commerce and culture resided in cities and the emperor took on a divine aura.

The central government was a despotism tempered by military rebellion and assassination and replacement of one scurvy lot of ruling dynasts by another. But the high politics of the city of Rome little affected the lives of the masses or even of the provincial nobility. It was the wonderful army that provided the continuity and peace that this vast population enjoyed. After about 180 A.D., the security was breached; the later Roman Empire suffered intermittent instability and invasion.

The brilliant historian Tacitus, who came from the politically displaced aristocracy and wrote around 100 A.D., hated the Caesarian system with a passion. Of Augustus and his successors he said: "They made a desert and called it peace." But it was not as bad as all that. There were many good things about the Roman Empire at its height, 30 B.C. to 180 A.D.

First, it was a peaceful, multiethnic, multilingual society, with Greek as the common language in the east and Latin in the west, but

with many national dialects surviving. It was tolerant about religion. The state temples demanded very little of the population, and a variety of faith-healing and savior-centered cults flourished and blended into each other. There was unprecedented commercial and agricultural prosperity. Freedom to travel, to seek new habitats, and enter crafts and professions made the Roman Empire a relatively open society. Very few provincials would have cause to note the death of the emperor or even the emergence of a new ruling dynasty.

But there was a dark cloud overhanging the Roman world: the cloud of slavery. As much as forty percent of the population was in legal servitude. The slaves were mostly drawn from peoples subjugated by the Romans during the imperial expansion of the last two centuries B.C. The huge agricultural estates in Italy, Sicily, and North Africa were worked by gangs of slaves, providing food for the cities. Slaves also worked the mines and propelled the oar-driven commercial galleys. They were pressed into labor for the construction of huge buildings and memorials in the cities. They built roads and aqueducts and amphitheaters.

An economy built on slave labor is vulnerable in two ways. One, availability of forced labor discourages technical innovation. The very wealthy empire experienced no industrial revolution. Two—even more crucial—slaves do not reproduce their own numbers. As Rome's wars of conquest ended, the slave population began to shrink, leading to a shortage of agricultural laborers by 200 A.D. Although the army consisted of freemen mercenaries, here too a manpower shortage was prevalent in the third century. Partly because of disease, the population of the empire began to decline. The frontiers of the empire, attacked by Germans on the Rhine-Danube border and by Persians to the east along the Syrian border, were too extensive and too fragile, requiring constant replenishment of military manpower while the total population was diminishing. In the long run, as more and more free citizens had to be recruited and pressed into military service, there developed a shortage of soldiers needed to defend the immensely long frontiers. By 250 A.D., the empire needed two million soldiers to defend its frontiers at the same time as the economy suffered from a shrinkage of the slave population.

Yet the Roman Empire of 150 A.D. was a glorious thing, to be long remembered as a golden age. Deriving ideas from the Greeks, lit-

erature and philosophy flourished. Among the upper- and middle-class males, there was a high degree of literacy. A legal system was in place by 100 A.D., which became the basis of the legal systems of all but England's, and even England's evolved under Roman influence. The cleanliness and beauty of Roman cities, their architecture derived from the Athenian Acropolis, still commands great respect and frequent imitation.

The society became steadily more cosmopolitan. By 212 A.D., all inhabitants of the empire, except for slaves, were deemed to be citizens. The old Roman aristocracy was not fixated upon race and color. Wealth and literacy were what opened the doors of their urban mansions and country villas.

Finally, the Roman Empire was very far from imposing sexual repression. Divorce was easy. Prostitution flourished without controls. Homosexuality was commonplace. Even bestiality was practiced and received little censure. And, in spite of this sexual freedom, until the end of the second century the empire was as yet little harmed by venereal disease. The Roman Empire was a religious cauldron and a sexual paradise.

Along with high rates of consumption, and a high degree of intellectual and political freedom, the empire was distinguished by sexual promiscuity perhaps unmatched until the late-twentieth-century United States. The Fathers of the American Constitution, well-versed in the classical heritage, consciously constructed an awkward governmental system like republican Rome's: much better at blocking change than facilitating it. By the early twenty-first century, the ambience of American urban life resembled that of the Roman Empire's cities, with lavish displays of wealth standing alongside cruel poverty, although average life expectancy in the Roman Empire never rose above forty years, while in 2003 United States it's in the mid-seventies.

CHAPTER FIVE

The Classical Heritage

*T*he nineteenth-century English literary critic Matthew Arnold believed that Western civilization was the result of the confluence of two cultural streams, the Hebraic (Biblical) and the Classical. But it was to the Greeks that he gave credit for making the most important formative contributions to Classical Antiquity. In his view, the Romans were merely students and imitators of the Greeks in all matters intellectual.

Today, however, we give near-parity to the Romans in the shaping of the classical heritage. The Romans made distinctive contributions of their own, and several aspects of the classical heritage handed down from antiquity bear a diacritical Roman stamp.

First, Roman culture was a logocentric one; that is, it was focused on the *written* word. The aristocracy and middle classes of the Roman world were profoundly committed to communication and dissemination of information and ideas through written texts. The transmission occurred in two forms of written material—inscriptions on stone and writings on paper. Vast numbers of stone inscriptions from Roman times have survived. They were first edited, collated, and published by the late-nineteenth-century German historian of Rome, Theodor Mommsen, and are still being discovered, edited, and published today.

The vast amount of writings on paper, used for government documents, legal records, private correspondence, and literature, have for the most part disappeared in the cold and wet climate of Western Europe, but many such paper texts have survived in the dry and warm climate of the eastern Mediterranean.

Fortunately, in the period between the 500s and 900s A.D., Christian monks and other churchmen in Western Europe copied the

contents of most literary and theological texts, written in Latin, from Roman paper onto parchment, made from stretched and bleached skins of sheep. These copies, made in the early Middle Ages, allow us to understand the complex dimensions and rich diversity of antique Roman written culture.

The second important contribution of Roman culture to the heritage of classical antiquity was the educational system that created the high rate of literacy among the upper and middle classes of the Roman world, possibly 50 percent of the adult male population. Schools for young boys led on to high schools for adolescents trained in the rhetorical style and complex grammar of ancient Latin writings.

A third and highest educational level were elite schools of rhetoric, which trained their students to be government officials, lawyers, and imaginative writers of nonfiction. These advanced institutes were mainly supported by the city governments of the Roman Empire, with occasional assistance from the emperor and other rich patrons.

This educational system had already been foreshadowed in the Hellenistic societies of the eastern Mediterranean during the second century B.C., but it was the Romans who improved, systematized, funded, and extended this crucial educational opportunity to all of the Roman Empire's population. Only a strong, entrenched educational system with relatively open access could have generated a culture focused on the written word.

A distinctive aspect of the Roman educational system was that the content of the curriculum was entirely that of literary humanities. Students were engrossed in texts of imaginative literature and Platonic philosophy. They learned no mathematics, history, natural science, or civics beyond these literary and philosophical texts, many translated from Greek into Latin, but many also Latin originals. Even medicine was learned from texts.

The medieval Western Church inherited this curriculum for its schools, and this singular written content was passed into the schools of contemporary European states. The students graduating from the private ("public") schools of nineteenth-century Britain, who, like the Roman graduates, went on to rule a vast empire, still received the old Roman humanistic education. Compared to our schools and colleges

today, the spectrum of information it disseminated was narrow. But this Roman-shaped literary curriculum produced graduates who were highly skilled in writing and well-versed in the content of the texts of Greek and Roman antiquity.

The contemporary French lycée and the German gymnasium fostered the same kind of narrow literary curriculum. Changes and broadening of the curriculum came to France and Germany around 1890, but in England there was no significant departure from the classical curriculum until the 1920s. Today, when students at Oxford University say they are studying "Greats," they mean they are majoring exclusively in the Greek and Latin classics, and this is still a popular, although disappearing, option.

Poetry was the literary field in which the Romans excelled, and they proliferated texts of epic and lyric poetry. After Homer's work, nearly all of the best Greek poetry is to be found in the theatrical tragedies. The Romans seem to have avoided tragedies, but their writers devoted themselves to free-standing poems, both long and short, that serve as models of verse to the present day.

The subject matter was mainly erotic love (Catullus and Ovid), patriotism and heroism (Virgil, Horace), social commentary (Juvenal), and even natural science (Lucretius). Augustus Caesar played an important role in the development of Roman poetry. Virgil, Horace, and, until his exile to the Black Sea for sexual indiscretions, Ovid all wrote under the emperor's patronage.

To be a poet was a reasonable ambition for scions of the Roman upper class, who enjoyed family wealth or imperial support. The Romans understood poetry as embalmed and concentrated emotion, which is still, for the most part, its character today.

Virgil showed later Europeans how to construct artificial heroic epics. Horace provided models of odes and sonnets. Catullus's love poetry was of exceptional emotional depth within controlled and intricate versification. Ovid absorbed the prolific imaginative literature of the Hellenistic world and imparted it in readable and condensed form, providing genre and themes for poets down to the present day.

The Romans liked philosophy that offered guidance for behavior. They tended toward applied moral philosophy. Their quintessential philosophic works embraced the theory of Stoicism, to which the second-century A.D. emperor Marcus Aurelius made important contributions.

The Stoics taught a life of restraint and control, the personal culti-
vation of learning, beauty, and reason. The Stoics asked the Romans to
realize that much that is encountered in life is beyond the individual's
control. Make the best of what can be humanly cultivated. It is a kind
of Platonism shrunk to a pursuit of private feelings and thoughts: Do
the best with what you can control and refine, and let the rest go.

The world is rational, but it is only amenable to active intervention
within the limits of the individual's capacity. Do not try to be an over-
achiever. Do not dream of social transformation. Private cultivation
rather than social action makes for the good life. Although the slave
Epictetus was one of the principal Stoic writers, the emperor Marcus
Aurelius's upper-class background is more typical of its devotees.

Stoicism is a narrow ethic, one suitable to the emotional and intel-
lectual needs of aristocrat and slave alike, but less useful for the ambi-
tious middle class.

* * *

The embodiment of the Stoic ideal and its prime disseminator—
through his prolific writings in the form of juristic orations, huge
numbers of letters, and moral and political treatises—was the first-
century B.C. writer Cicero. His elaborate political compositions came
to be regarded as prose models in the Latin schools of antiquity and
later—in fact, to the present time.

Cicero positioned himself as the prime example of the Stoic-
minded old Roman aristocracy, and he certainly moved in these
exalted circles. His writings extrapolate the Stoic philosophy, but he
was a self-manufactured aristocrat. In reality, Cicero—about whom we
know more, in thought and deed, than about anyone else in the
ancient world—was largely a self-made man who rose from the edu-
cated middle class. He made a fortune practicing law and bought a
sumptuous villa to imitate the lifestyle of the old aristocracy. Far from
being self-controlled and reserved, he plunged passionately and loudly
into politics. After he was elected consul by the old aristocracy, and
celebrated it with a very un-Stoic poem—"O, how great for the
Roman state was the date of my consulate"—his political career went
into steep decline, leading to his death during the turmoil of the late
first century B.C. But no one could handle normally clumsy Latin prose
with as much skill and force as Cicero.

The law that Cicero practiced was that of the Republic, which fea-

tured his great orations before a jury of eighty people. By the end of the first century A.D., the jurisconsuls (legal experts) had, at the emperor's urging, fashioned a legal system amenable to imperial centralization and smooth operation. The law was now in the hands of panels of prosecuting and deciding judges appointed by the imperial government. Legal proceedings featured not Cicero-type eloquent and passionate argument in court (what is called oral pleading and is still a feature of our Anglo-American common law), but written pleading or arguments submitted to the judges in the form of "briefs" (the word meant letters or documents). The jury was superseded by decision of the judges, who, in criminal cases, used torture to get self-incrimination from the defendant.

This is still the procedure in continental European and Latin American law, although torture was abandoned in the eighteenth century. Under Roman law, defendants could—in antiquity and today—be kept in jail indefinitely until they confessed.

In civil (non-criminal) law, the Romans developed the theory of the written contract, which is still the basis of our business law. For the contract to be valid, the two parties must be reliably informed of the facts of the matter and voluntarily affix their signatures to a written document of agreement.

Roman law stands beside Greek philosophy as one of the two intellectual achievements of classical antiquity that are still central to our culture. The law (called the Civil Code, the law of civilized society) is much more applicable and practical than Platonic and Aristotelian theory, but it still involves highly sophisticated and intricate reasoning. Cicero remained the model and inspiration for the successful lawyer but, in fact, the Roman legal system that has made such a widespread impact to the present day went beyond the loose-and-liberal judicial practices of Cicero's day. He would have found the imperial legal system constraining, and the imperial judges would have told Cicero to stop talking and submit written briefs.

To those who relish abstract theory, Roman law seems mundane. But it brought learning, applied philosophy, and recognition of the state's role in society to create a system that functioned well beyond its immediate articulation in the Civil Code.

Roman law both reflected and stimulated a cast of mind that was statist and conservative and applicable to the literate thinking and

lifestyle of the Roman upper classes. As did Greek philosophy, which it partially imbibed and perpetuated, Roman law lay at the center of the classical heritage. It was a social system artificially constructed by a small group of highly literate lawyers and government officials, who saw themselves imposing a grid of uniformity, stability, and rationality upon a multicultural and ethnically and religiously diversified society. This mindset is still perpetuated in the European Union and among the bureaucrats and judges who rule it.

An attractive feature of Roman law, in antiquity and today, is that since it is all written down, it is easily mastered by systematic study within two or three years. The Civil Code thereby instigated professional law schools in the form we know them today.

The classical heritage as shaped by and filtered through Roman culture had two great flaws. First, it prevented the very rich oral cultures of the ancient Mediterranean from surviving from antiquity into later times. All that was left as creative forces were Greek philosophy and Roman law. These were very substantial cultures but they represented a great narrowing of what could be passed on from antiquity to later centuries.

The Romans also transmitted a body of poetry that has never been surpassed, as the Greeks did with their theatrical tragedies. But there was not much else. The thoughts and feelings and aspirations of millions that had been transmitted orally from one generation to the next were suppressed or simply forgotten. Those who today celebrate the classical heritage are cultivating only a small part of ancient culture as it really flourished under the protective cover of the Hellenistic and Roman empires.

Second, another deficiency of classical culture was its lack of social conscience, its obliviousness to the slavery, poverty, disease, and everyday cruelty endured by more than half of the fifty million people who inhabited the empire. The classical heritage represented a narrow and insensitive social and political theory reinforcing a miserably class-ridden and technologically stagnant society.

A possible rebellion against this conservative, narrow, and insensitive classical heritage threatened for a while to come from the Christian Church. But by 400 A.D., Christianity had also been put through the wringer of Roman logocentric culture and its class-ridden and cruel manifestations.

The Christians

*T*here are no contemporary witnesses to the life and death of Joshua of Nazareth, who came to be known in the Greek-speaking world as Jesus Christ (the king). He was born, it seems, in 4 A.D. and died at the age of thirty-three on the cross, a cruel fate the Romans reserved for their more hated convicts.

The earliest accounts of the life of Jesus were three gospels (good news reports) written twenty or more years after his death. His ultimate successor as leader of the Christian sect, Saint Paul, never saw Jesus in the flesh but only in an epiphanic vision on the road to Damascus.

For 175 years, New Testament scholars have mulled over the scraps of information and threnodies of sentimentality in the three "synoptic" (connected) gospels that may have taken their stories primarily from one common source written by a writer known to us by the code name "Q," who was a contemporary of Jesus and witnessed his crucifixion, or maybe not.

The Nazarene was one of many preachers roaming Judea early in the first century A.D., during a time of incipient political rebellion and spiritual ferment. He had a relative named John the Baptist, who was one of these purifying and faith-healing preachers until he somehow ran afoul of the puppet king Herod, whom the Romans had temporarily installed to keep order, and was decapitated by royal command.

John had predicted the coming of one greater than he was, and Jesus fulfilled his relative's prophecy. He achieved local fame in the Galilee area of northern Judea both as a faith healer and as the preacher of an ethic of peace and love and sensitivity to the miseries of the poor. Urged by a group of Galilean fishermen, who were among his most

devoted disciples, he carried his ministry to big-time in Jerusalem, where he drew the attention and ire of both the Hebrew priests and the Roman authorities. An incompetent Roman governor named Pontius Pilate (who never got another job in the Roman imperial administration) had been installed after King Herod's death. Pilate decided that Jesus, as "King of the Jews," was a political subversive and crucified him as a common criminal. Stories spread that three days after Jesus' body was taken down from the cross, it disappeared, suggesting possible resurrection and elevation to heaven, like the old prophet Elijah.

Under Simon Peter ("Rocky"), the small sect of Christians remained loyal to the laws of the Torah, but memorialized Jesus as someone special. People wondered why this impoverished sect went around with smiles on their faces. They gained converts. Everything changed when Saul of Tarsus, an eccentric Jewish rabbi (teacher of the law, not a priest), joined the group and, much to Peter's chagrin, set about transforming the beliefs and practices of the Christians.

Saint Paul, as we know him, was much impressed by the later chapters of the Book of Isaiah (probably written around 500 B.C. in Baghdad). Here the writer had spoken of the Lamb of God, a Messianic figure, as God's suffering servant through whose shedding of blood the Gentiles were vicariously forgiven their ugly sins. Saint Paul saw Jesus as such a suffering servant.

Well versed in Greek philosophy and religion, Paul transformed Jesus into a dying and reborn savior, a common religious belief in Asia Minor where Paul came from, as well as in Egypt. Paul also opened— after a terrible row with Peter and James, "the brother of the Lord"— the Christian sect to Gentiles, who were not required to be circumcised or follow the *Kashrut* laws. Paul made Christianity a universal religion open to Jew and Gentile, to freeman and slave, to man or woman, to any ethnic group in the Roman Empire. Reported to the Roman authorities as a subversive, probably by rabbis, Paul insisted that, as a Roman citizen, he be tried in Rome. There he died in or about 66 A.D., four years before the great Jewish rebellion against Rome led to the destruction of the Temple and exiling of Jews from Jerusalem.

Christian legend later claimed that Peter also went to Rome and there became head of the Christian community, that is, a bishop. Both Peter and Paul, according to the Catholic version, died as martyrs in

the Eternal City. Paul definitely went to Rome, and may have been martyred there. But that Peter, a very devout, timid Jewish fisherman, uneducated, and knowing little or no Greek, and no Latin, would have ended in Rome is most unlikely. Thus the whole claim of later bishops of Rome (the popes) that their authority in the Church was derived from its alleged first bishop, Saint Peter, was likely wishful thinking, if not an absolute hoax, that developed in the late second century A.D.

* * *

By 100 A.D., Jesus had become the Divine Word to whom the Christians were individually attached by two sacramental (magical) rites. The first was baptism, which John the Baptist (among many other Jewish preachers) had practiced. The other was the sacrament of the Mass, or Eucharist, the eating of a wafer (the body of Christ) and drinking of wine (the blood of Christ).

Sacramental attachments to a dying and resurrected savior was a common idea in the Roman Empire. The religion of Mithraism, very popular in the army and open only to males, bathed the initiate in the blood of a bull.

Christians found a basis for the Mass in one of the gospels. Reportedly, just before his arrest by Roman authorities, asked by his disciples at a Passover seder to tell them how to memorialize him, Jesus took a piece of matzo and a cup of wine and suggested that consuming this seder fare would remind his disciples of Jesus after his death. And so it was and continues to this day.

The most important fact to know about the Christian Church in the two hundred years after Jesus' death is that only at the end of this period did the Church comprise as many people as the far-flung Jewish community numbered (five million) in the Roman Empire. Christianity developed an intense rivalry with Judaism, and for many decades was compared to the Jews as a minority. This accounts for the intense anti-Semitism that became enshrined in Christianity by 200 A.D.

Judaism was a legal religion in the Roman Empire; Christianity was not until the first Christian emperor ascended the throne in the fourth century A.D. There were periodic persecutions of the Christians by the imperial state and local officials. The resulting martyrs, often upper-class women of unusual devotion, only served to draw more

attention and converts to the Church. When the first Christian emperor, Constantine I, ascended the throne in Rome in 312 A.D., 25 percent of the population of the empire was already Christian. Some historians believe that Constantine was just betting that the Christians were the winning side. Otherwise, his surprising conversion was due to seeing Christian symbols in the sky and to the inevitable dreams that claimed to give him power to conquer.

Constantine enriched the bishops, endowed new churches, and favored Christians for appointment to imperial offices. When emperor Theodosius I banned paganism in 393 A.D., the great majority of the population of the empire was already Christian. The practice of Judaism was still allowed but under severe restrictions until Jesus, in his Second Coming, would decide what to do with the adherents of this gutter religion.

The ultimate triumph of Christianity was aided by the internal drive within Roman paganism toward some kind of monotheism. By 150 A.D., whatever vitality had once existed in ancient polytheism had mostly declined, and the gods played little or no role in individual lives. The state temples to the old gods became civic centers rather than religious entities.

But paganism went about reforming itself. It drew upon the Alexandrian mystical form of Platonism, taught by Plotinus—what we call Neoplatonism—to conjure an image of the deity as a single spiritual fountain of life that fructifies the world.

This Neoplatonic monotheism became popular in aristocratic circles in fourth-century Rome and gave such renewed vitality to paganism that the triumph of Christianity had to be bolstered by state proscription of this latter-day monotheistic paganism. By 390, Roman paganism was almost as close to monotheism as was Christianity.

The sociology of religion gives another reason for the triumph of Christianity. The Church provided a sense of community and institutions of friendship and caring within the largely joyless, anomic world of the Roman Empire. Sociologists suggest that its social utility, more than its doctrine, account for the rise of the Church.

In spite of the tension between Roman political authorities and the Church before Constantine, the triumph of Christianity was facilitated by the nature of the empire itself. It provided law and order and

a peaceful ambience in which the Church's missionary work could be pursued through freedom to travel and, in large part, freedom to preach and communicate. Saint Paul was proud of his Roman citizenship, and his letters to various Christian communities in the empire presupposed an effective communications system that only Roman government, law, and military might allowed.

The Church's administration evolved as the imperial government's structure was modified over time. An archbishop ruled a large territory that the Romans called a province. A bishop ruled a diocese, a smaller Roman administrative unit dominated by a large city.

The capitals of the eastern and western parts of the empire—Constantinople and Rome—came in time to signify unusual and superior power for the bishops resident there. When the Roman state was dissolved in the Latin-speaking world around 458 A.D., the pope replaced the emperor as the political leader of the Eternal City.

* * *

At the end of the fourth century, the three Church Fathers—Saint Augustine of Hippo in North Africa; Saint Ambrose, Archbishop of Milan; and Saint Jerome, who spent his later years in Jerusalem being attended to by adoring matrons—shaped Christian doctrine, literature, and ritual.

Ambrose insisted that only males should govern in the Church, and he also inaugurated the troubling doctrine that priests should be celibate (a doctrine not enforced until the twelfth century). Jerome translated the Bible into Latin from Hebrew, Aramaic, and Greek. Jerome's Vulgate ("Popular Version") is the foundation of all later translations before the twentieth century.

Saint Augustine proliferated central theological and political doctrines of the Church, following Saint Paul closely. History is the scene of the struggle between the Heavenly and Earthly Cities, but only God before the Last Judgment knows the membership rolls. Human nature is so sinful (rebellious and corrupt) that only those who have received grace, i.e., have been chosen by God to love Him, can be saved for eternal life. This theory caused a lot of trouble for the medieval church, which by and large abandoned it. It was revived much later by Martin Luther.

By the early fifth century, at a series of church councils, the Christians had hammered out a compromise theory of the Trinity—

God the Father, the Son, and the Holy Spirit (Church)—more or less of one substance but with three personalities. Those who would not accept this compromise were branded as heretics and sooner or later persecuted by the imperial state.

The Gnostics (also called Manichees) postulated that there were two gods—the Christian God of goodness and light, and an evil anti-God of darkness. This theory provided an easy explanation of why there was evil in the world. It was rejected by Catholic Christianity in favor of the monotheistic view that there was one God who created only goodness. Evil was sin, a rebellious falling-away from God, a perversion of His goodness. This was the foundation of the evolving Christian concept of Satan.

The Arians said Christ's nature was divine, but of a lower degree of divinity than God the Father's. The orthodox enemies of the Arians complained that the Arian view was a reversion to Roman polytheism. The Monophysites said Christ's nature was divine, not human. All three minorities were persecuted, but, meanwhile, a lot of sharp theological discourse resulted from these intellectual conflicts. At least fifty volumes of Christian theology survived to later centuries and are scarcely read today.

By the early fifth century, the Church that had begun as a tiny group of fishermen and other poor people meeting in modest abodes had joined the Roman trend in classical culture in becoming logocentric, relying heavily on written texts—the Bible, the sacramental services, and the theology of the Church Fathers.

Beginning as a movement in Egypt around 200 A.D. and reaching France by 500 A.D., a special place of holiness was attributed to monks and nuns in a monastic setting because of their celibacy. Monks often became bishops; nuns were told to stay in their convents and shut up.

Jesus' preaching had emphasized care and love for the poor and downtrodden. Along with some of the Hebrew prophets, he uttered the most democratic cries to be found in antiquity. By 400 A.D., the bishops and theologians had pretty well drained this egalitarian strain out of the Church.

It was still there in the Vulgate of Jerome, but by then there had been a severe decline in literacy in the Roman world. The bishops did not encourage reading of the Bible. In fact, Augustine thought that Jerome was wasting his time and literary genius putting the gospels

into good Latin. It would take many centuries before Christian preachers started to teach that when Christ said, "Blessed are the poor for theirs is the Kingdom of Heaven," he meant not just the poor in spirit (the pious), but the actual impoverished masses of people.

The conservative and narrow spirit of the evolving classical heritage during late antiquity filtered out the radical side of Jesus' teachings. It is very difficult for even religious leaders to go against the structure of the dominant culture. And the bishops, many of whom came from the old aristocracy, did not even try.

The Decline of the Ancient World

*I*n 376 A.D. a motley mixture of Germanic (originally Scandinavian) people called Visigoths were living in the Danube Basin, across the great river from the Roman Empire. The Visigoths were being assaulted from the rear by Mongolian Huns, who innovatively and terrifyingly fought on horseback, whereas the Visigothic army, like the Romans, was all infantry, so the Visigoths asked for and received permission from the imperial government to cross the Danube to escape the Huns. But they were soon dissatisfied with their land settlement, and, in 378, the Visigoths rebelled against the Empire.

At the Battle of Adrianople in Macedonia, the Visigoths killed the emperor and decimated his army. This sent a shock through the Roman world. A second shock occurred in 410 A.D., when the Visigoths, still campaigning for a lucrative land settlement, took Rome itself and carried out a desultory sacking of the Eternal City for the first time in nine centuries.

This was the initial phase of what became known as the Barbarian Invasions. Barbarians were not civilized people who spoke Latin. They said "ba, ba, ba" and sported beards.

By the mid–fifth century, the western—Latin-speaking—empire had disintegrated and successor Germanic and Mongolian kingdoms were established in its place, accompanied by a massive decline in trade, urban population, literacy, and law and order. The most heavily populated, eastern—Greek-speaking—part of the empire, centered around Constantinople, survived in shrunken form until 1453.

Since Edward Gibbon wrote his multivolume *Decline and Fall of the Roman Empire* in the last quarter of the eighteenth century

("Scribble, scribble, eh, Mr. Gibbon?" said a subliterate duke to whom Gibbon had proudly presented a volume of his work), historians have puzzled over the causes of the decline of Roman antiquity.

And it was an internal decline, as well as an assault from the outside, since the barbarian invaders, including women and children, did not number more than 5 percent of the empire's population. The Visigoths never put more than ten thousand soldiers into the field at one time. Something went terribly wrong with the Roman world in late antiquity.

Gibbon himself had two explanations. The first was that the empire suffered from "immoderate greatness," or, as we would say today, its communication and transportation system could not sustain a political structure of such size. The trouble with this argument is that the empire functioned effectively in the first two centuries A.D. Only then did something go wrong.

Gibbon, a skeptic, had a second explanation. What occurred was "the triumph of barbarism and religion." The Church was to blame. It imposed an otherworldly ethic on society and it took superior personnel away from the imperial government to use as church officials. There is some plausibility here, but if Roman society was functioning normally, the Church's culture could not have had such a major negative impact.

Another thesis was propounded by the French medievalist Ferdinand Lot in 1920: The end of the ancient world was due to corruption and decline of public spirit. Lot seems to have had his eye on the French Third Republic. The later researches on fourth- and fifth-century imperial government simply proved Lot wrong. There was nothing corrupt or lacking in public spirit among Roman officials in late antiquity. On the contrary, they made heroic and skillful efforts to operate in the face of shrinking resources. This is the corrective picture we get from the work of A. H. M. Jones (1966), *The Later Roman Empire.*

In the 1950s, the English classicist and Christian theorist Arnold J. Toynbee offered a teleological and mystical thesis. Roman civilization, like all previous civilizations, was accorded the destiny of preparing the way for a new universal religion. This is faith, not history.

Michael Rostovtzeff, the great social and economic historian of the Roman Empire, thought he saw a parallel between the decline of

Rome and the Russian Revolution. He postulated that class polarization accelerated in late antiquity, so that the aristocracy was facing an ever-expanding and ever-more-miserable proletariat. Eventually, the elite culture succumbed to a confrontation with the proletarian masses.

There is merit in this thesis. Its weakness is that there is no evidence of increased proletarian class consciousness in late antiquity, nor signs of revolutionary organization. There was only one serious slave revolt in Roman history. It was led by Spartacus and occurred in the first century B.C. There was no Lenin in late antiquity.

Rostovtzeff was on the right track in looking for a social trauma that caused the decline of the ancient world. He did not realize that the trauma was in biomedical disease.

* * *

What we have come to realize since around 1970 is that the Roman Empire suffered from a shrinking of its population by 25 percent between 250 and 450 A.D. This demographic debacle, in turn, meant a diminishing production and tax base, as well as a shortage of soldiers to protect the far-flung imperial frontiers.

The cause of the population decline was the spread of epidemics since the middle of the third century: smallpox, bubonic plague, and some variety of venereal disease. The Roman Empire was lucky in avoiding pandemics in its first 250 years. It was generally healthy without any effective medicine. But when the disease germs came up the Nile valley from East Africa, following the route of human migration a hundred thousand years earlier, the population was extremely vulnerable, and its numbers were severely eroded by disease.

There is a subsidiary cause for Roman decline: its operation as a slave society. Slaves do not reproduce their own numbers, and once big boosts of new slave population ceased with the ending of imperial conquests in the first century A.D., the size of the working population slowly but steadily declined.

The German economic historian Franz Oertel in the 1950s points to another drastic consequence of a slave economy. A slave economy initially allowed an increase of productivity through augmenting the slave-labor supply, but eventually inhibited an industrial revolution, which would have increased productivity through the invention and use of new machinery. Roman products remained at a simple level and could be reproduced by handicraft. By the fourth century, for example,

the robust pottery industry of Greece was in sharp decline because other parts of the empire also learned to make pottery.

The decline in international trade in the Mediterranean in the fourth century was partly due to increasing piracy, but it was also due to lack of industrial innovation and of need for exchange of manufactured goods.

There was some kind of cultural cause for the decline of the ancient world. It was neither corruption of public spirit nor Christianity. It was due to the rise of the logocentric culture rooted in written text. This engendered, in general, a conservative, backward-looking frame of mind, hostile to critical military and technological innovation. It widened the gap between the highly literate elite and the still-illiterate masses. It aroused social strains that the imperial government would not, or perhaps could not, confront. Once the Visigoths had won a lucky battle or two, a general pessimism, docility, and privatism settled in.

The ancients had a phrase for this. They said the world was "growing old." It was a mature culture. The Romans in late antiquity needed social and intellectual restoration, not more intensive cultivation of the classical heritage.

Cities

*T*he social and cultural dynamics of antiquity lay in cities, which we may define as urban enclaves comprising at least ten thousand people. By 100 A.D. there were hundreds of such urban enclaves throughout the Mediterranean world, and a few more inland in Western Europe. Technically, the ancients called an urban enclave a "city" if it was a governmental center. Otherwise, it was simply a town. But nearly all urbanized areas were government centers, the locus of "civilized" life. To the ancients, the cities and civilization were synonymous. Cities were where you had schools and libraries.

Cities were commonly located on or near the seacoast, or on a large, trade-bearing river. All cities from Hellenistic and Roman imperial times were laid out like early Athens and Rome. In the center of the city there were a number of governmental and religious buildings, preferably made of marble. Here also was located a large space where citizens could congregate (the Romans called it Forum, the Greeks Agora) to debate policy and receive oral proclamations from the mighty.

By 100 A.D. a city would also have in or near its center an amphitheater where games were held, such as gladiatorial contests and chariot races. Wild animals were displayed, and criminals and subversives, like obstreperous (and suicidal) Christians, executed. There is no doubt that to the ancients of circa 100 A.D., games implied bloodshed; but gladiators' hand-to-hand combats to the death featured in Hollywood movies are overdone, since gladiators were splendid physical specimens who took a long time to be selected and trained and were not easily dispensable.

The most amazing fact about ancient cities is that they accommodated so many people. First-century A.D. Rome had a million people;

Alexandria 750,000; Athens and Marseilles 300,000 each. By 400 A.D., Constantinople had possibly half a million.

After the fall of the Roman Empire, cities experienced a very severe shrinking. Rome in 700 A.D. had no more than 100,000 people. In 1500 A.D., Paris had only 200,000; London half that. No post-antiquity European city reached a population of a million people before 1820.

How do we account for the large size of dozens of ancient cities? Security was provided by the state, and expensive walls were unnecessary. The state assured a continuing food supply, most of it locally produced, and grain could be imported over long distances. These constants slowly evaporated in late antiquity. By 350 A.D. Constantinople was the prototype of a medieval city. High walls protected its landward side; the sea protected its other quarters. By then, transfer of food over long distances was steadily diminishing.

Yet the third need that a large ancient city required besides security and food was potable water, and Hellenistic and Roman aqueducts provided this. The ancients were not as effective in plumbing systems to remove human waste, and, therefore, they were prey to infectious diseases that emerged around 250 A.D. Prior to that, the urbanized ancients were just plain lucky in matters of public health.

The lifestyle of the upper class of ancient cities is well known to us thanks to archaeological excavations and preservations since 1800— the public buildings and urban townhouses (surrounded by walls and gardens) of the rich.

Less is known about the housing and lifestyle of the poor and lower middle class, since the great antique cities are nearly all still occupied, and extensive digs there are impossible. The urbanized masses in ancient cities lived miserable lives, comparable to Latin American and African urban enclaves today. But, until 350 A.D., governments were liberal in providing food and entertainment.

Wood was too valuable to be used as housing for the masses. Houses of mud and sun-dried brick were the norm; these, too, have very low survival rates.

If we judge the ambience of ancient cities from the Acropolis and Agora in Athens, or the Forum in Rome, or the lavish homes in Pompeii—a small city south of Naples, frozen in time (79 A.D.) because of the eruption of a nearby volcano—there is no doubt of the

beauty and grandeur of the center of ancient cities. If we could reconstruct the areas where the masses lived, we would feel pity and contempt. Huge fires were a constant threat in ancient cities (as in medieval and modern ones before 1900). Garbage and excrement filled the streets, animals wandered around freely, thievery was rampant. There was no public transportation.

What the Acropolis in Athens looked like, including the Parthenon of the gods, is best told today at the British Museum in London, which houses the marble statuary removed by Lord Elgin, the British ambassador to Constantinople in 1801–05, and sold at a knockdown price (only 3 million dollars in our money) to the British Museum a couple of decades later. Although Elgin had or bought the permission of the Turkish sultan then ruling Greece, some contemporaries, including the poet and pro-Greek activist Lord Byron, already denounced the Elgin Marbles as "pillage." So the Greek government has claimed since the 1970s, but the British won't return them.

The surviving monuments on the Athenian Acropolis have suffered severely from pollution. The Roman Forum is in even worse shape; only the surviving Coliseum (amphitheater) gives a visceral impression of the glory that was Rome.

After the Elgin Marbles and Heinrich Schliemann's ill-fated excavations at Troy (he found small cities on the site but never the Troy of *The Iliad*) in the 1870s, the most impressive archaeological remains of antiquity are at Knossos on Crete. Here, in the first decade of the twentieth century, the British digger Arthur Evans uncovered a monstrous palace that dated as early as 1400 B.C., before the alleged Trojan War, and inhabited by a people who wrote a crude form of Greek.

Archaeological digs are incredibly expensive and very slow to execute, according to modern scientific principles introduced in the 1920s. Every beaker and amulet must be catalogued, described in minute detail, and its location marked on a map. Publication of the results of a dig can occur decades after the actual dig.

It was much simpler for Evans and Schliemann. They were rich men, who simply bought the property they were uncovering. They communicated directly with the press and circumvented local government.

There are other special problems connected with the discovery of ancient cities. Alexandria was ravaged by fires and street fighting, and its ancient waterfront is underwater. Some discoveries at Pompeii were

not revealed for many decades, because the wall paintings are so pornographic.

Modern governments in Iraq showed little interest in antiquities. The Tigris-Euphrates valley was the locus of successive destructive invasions and wars in ancient times. The best-preserved Iraqi artwork is that of the Assyrians, simply because a British consul in Baghdad early in the twentieth century bought up these oversized monuments, which were eventually given to the Metropolitan Museum in New York by an American philanthropist. If you want to see the grandeur of ancient Iraq, make your way to Manhattan, not Baghdad.

A negative consequence of the digging up of ancient cities is that they debunked the glories of Jerusalem of the Hebrew kings David and Solomon. Jerusalem under David was a small hillside town. Solomon's city was more impressive but still modest. When the Bible was put together around 250 B.C., its authors knew about the qualities of great Hellenistic cities and falsely attributed them to the Jewish kings of the tenth and ninth centuries B.C. Every visitor to Jerusalem passes through King David's Gate, but the attribution is mythical; the gate probably dates from Roman times or possibly later.

The only sure remains of King David's reign is a small cistern that could not have supplied drinking water to more than a couple of hundred people. We do not know what King Solomon's Temple looked like. The second Temple has also vanished, being destroyed by the Romans in 70 A.D. Only part of the surrounding wall (the Wailing Wall) alone survives. But it is likely that Solomon had a huge harem, which, for a time, included an Ethiopian queen. The ancient Jewish king was better at sex than at urban architecture.

* * *

The Roman Empire was a collection of cities within the façade and structure of imperial defense and government. This system worked well during the first two centuries A.D., leading to Edward Gibbon's famous judgment that those times were happiest for humanity. But, from the beginning, there was a flaw in urban financing and management that got exacerbated in late antiquity.

The taxes needed to support the building of urban public facilities and the operation of local government were light. They were substantial enough for middle-class people, but for the rich, whether aristo-

crats in their walled townhouses or wealthy merchants, the tax burden in the first 250 years A.D. was of small consequence considering their high level of income. These same very wealthy people were expected to, and customarily did, undertake additional voluntary burdens— using their disposable capital to build urban public facilities and monuments, and support games for the masses. Sometimes they would also serve as patrons of the better schools and academies.

By the middle of the third century, during times of imperial civil war, the government in Rome began to seek heavier tax payments by the urban wealthy class to support the imperial armies and governmental operations on an empire-wide scope. The days of light taxation quickly passed.

By 300 A.D., as the disintegration of public health through infectious disease reduced the population on the tax rolls, the imperial government made much heavier demands on the urban rich. The need for imperial defense against migrating and marauding barbarians further increased the imperial government's need for money.

Desperate measures were tried: debasing of the coinage and then price controls around 300 A.D., to hold the lid on the inflation that inevitably followed. In the second half of the fourth century, the urban populace was supposed to remain in their fathers' occupations to ensure continuity and stability of the tax base.

Under these circumstances, the lightness of the tax burden of the early empire on the middle and wealthy classes was completely superseded by draconian levels of imperial taxation and stern measures to collect taxes. The rich no longer had the fiscal means or psychological mindset to be generous patrons of urban facilities.

At this point, a social flaw that always existed with regard to the aristocrats in their townhouses became more evident. No longer finding urban life as secure and amenable as in the early empire, the landed rich gave primacy not to their urban mansions but to their country estates, making the latter their principal residences. The dominant forces in urban life increasingly became the bishops and cathedral clergy.

The vitality of the aristocratic class was now committed to country lordships of one kind or another. The Latin-speaking world in particular slipped over the line from urbanism to rural feudalism. Even in

Byzantium, in the Greek-speaking east, rural lordship sustained by contingents of heavily armed retainers became more evident, weakening the primary position of cities in political life.

* * *

There was much wealth and usable capital available in the cities of antiquity. There were strict class gradations in the urban population, from slaves through the proletariat up to the middle class, the great merchants, and the aristocracy. Yet what was lacking in antiquity were thinkers who provided close analysis and abstract theory about economy and society.

The mindset of antiquity lacked economic science and sociological theory. The ancients did rather well with political narrative, although, except for Thucydides, no first-rate political annalist or analyst emerged from the literary populace. But the ancients never showed a capacity, or even an inclination, to examine closely the urban world they themselves inhabited.

Neither, however, was the medieval world in the 500s through the 1500s, which succeeded antiquity, much better at economics and sociology. It was only in the eighteenth and early nineteenth centuries that this kind of thinking emerged with Adam Smith and Alexis de Tocqueville in response to industrial and political revolutions.

What interested the urban dwellers of antiquity were the gods. During the Hellenistic and Roman eras the theoretical capacity of the literate urban population was given over to thinking about the nature of divinity. The chief theological formats were polytheism (many gods); monotheism (one god); dualism (two gods, one good, the other evil); and dying and reborn savior gods that could also be fitted into the other three categories of divinity.

There were four reasons for the god-intoxication of antique urban populations. First, the hydraulic despotisms created theories about the godhead to make the masses obey and work hard. Second, the shortness of life and the weak defense against physical and biomedical disasters frightened even highly literate people into imagining and speculating about gods who could protect and save humanity. Third, the nature of antique education was a literary one, equipping learned people to write much about gods but little about nature and economy.

Fourth, the dominant philosophy of the ancient world was

Platonism, which had theological speculation built into the center of its intellectual program. If Aristotle had been popular in ancient cities, other, more secular, intellectual directions might have been effectively pursued. As it is, at least 20 percent of the surviving writings from heavily urbanized antiquity is focused in one way or another on the gods. Nearly all of this literature is unreadable today, except to highly specialized scholars. The great exception is the Bible.

Two

SOCIETIES AND CULTURES

Egypt

*T*he center of Egyptian life, geographically and in a broader cultural sense, was the Nile River, which, in prehistoric times, formed a valley running north from the mountains of Ethiopia across the Egyptian desert to the Mediterranean Sea. Near its mouth, it dropped the silt that, in the course of centuries, formed its broad, fertile delta. As it crosses the delta, the Nile becomes a myriad of smaller rivers before it flows finally into the eastern Mediterranean.

Toward the end of the fourth millennium B.C., the Egyptians, already a homogeneous cultural group, came down from the hills bordering the Nile to farm the fertile land along the river. Their dikes transformed the marshes along the river into fertile fields, and their small villages took form on higher ground near these fields. Then as now, every summer the Nile overflowed its banks, submerging the fields. When the river receded in the fall, it left a deposit of fertile silt carried down from the mountains, and crops were sown in the rich brown fields. It almost never rains in Egypt, so the success of the harvest has always depended mainly on the timing and magnitude of the Nile flood. If the flood is too small, there is no crop; if it rises too high, it drowns the fields and destroys the crops.

Egyptian society and government were molded by the river and the desert. The fertile strips of land along the river were bordered by the desert, and while the fields watered by the Nile normally yielded a very rich harvest capable of sustaining a large population, the desert boundaries placed an absolute limit on the amount of land available. From its beginning, Egypt was a densely settled agricultural community. Its soil was rich, and because farming necessarily ceased during the months of the annual inundation, its people were not forced to toil

endlessly in order to survive. The peasant farmers could support a wealthy aristocracy without suffering extreme privation, and an important segment of the population was able to devote a substantial amount of time to nonagricultural pursuits. In short, for most of its long history, Egyptian civilization was wealthy and comfortable.

Egypt's fundamental unity was founded on its natural desert barriers, which eliminated fear of invasion while they limited expansion. Only in the extreme south and in the area of the delta was Egypt open to the outside world. The Nile was a natural highway for the maintenance of communications within the country. Every settlement constructed its own wharf and boats. Land travel was restricted to the dikes bordering the fields—it was considered a crime to travel across the waters that blanketed the fertile land.

* * *

In prehistoric times, the local communities in Egypt were united into two kingdoms: upper Egypt, which extended down the Nile valley, and lower Egypt, centered in the delta region. About 3100 B.C., the first pharaoh united upper and lower Egypt into one kingdom, and their unification marks the beginning of the truly creative period of Egyptian civilization. Except for a few brief interludes, the pharaohs and the unity of the two kingdoms shaped the basic form of the Egyptian state for the next three thousand years. Historians have designated the history of the united Egyptian Kingdom (down to about 2200 B.C.) the period of the "Old Kingdom."

The identity of the first pharaoh is not known—there is no real evidence of the existence of the legendary Menes—but whatever his name, he established his palace on the Nile at Memphis, just south of the point where the river flows into the delta. This first pharaoh was regarded by his countrymen not merely as a great political figure or a great warrior but rather as a god whose rule over Egypt was part of the divine ordering of the universe. An explanation of the pharaoh's position is found in the legend called the Memphite Theology, which describes the accession of the pharaoh as part of the creation of the world. The earliest extant document that contains this legend dates from about 800 B.C., but we know that by then it had been handed down for countless centuries. According to the myth set forth in this account, the earth was created as the land arose from the primeval

waters, a scene that was re-created each year for the Egyptians as their land rose from the waters of the Nile inundation. The earth god, Ptah, created the world and the gods that were an inseparable part of it—Re, the sun god, and Hapi, the god of the Nile, among others. Horus and Seth, respectively the good son and the evil brother of Osiris, the god-king of the dead, competed for dominion over Egypt, and Horus was the victor. Thus, whoever was pharaoh was identified with Horus, as the living king of Egypt. When the pharaoh died, he became Osiris, king of the underworld, and his son, in turn, became Horus, the son of Osiris and, consequently, the legitimate ruler of the living.

Every aspect of life in Egypt was under the control of the pharaoh. His word was not merely a command; the Memphite Theology calls it an "authoritative utterance"—the very word of the pharaoh transformed whatever he spoke into authority. The ordering of society was thus a part of the eternal and divine order. The person of the pharaoh was the embodiment of the world order, and his dominion existed not only in life but in the afterlife, the divine life that was a continuation of earthly existence.

The pyramids of Egypt are the clearest expression of the beliefs held in the Old Kingdom of Egypt. Since Memphis was the permanent capital of Egypt, the royal cemeteries were built as close as possible to that city. However, as the best sites were used up, the pharaohs were forced to move farther south. This meant that the palace of the king was often far from the city so that he could supervise the work on his tomb, which continued throughout his lifetime. When a pharaoh died, his successor might choose to build his pyramid in the same area or, if the most favorable sites were taken, he might move the court to a new spot. Memphis remained the seat of government, but the king might be as far away as the location of his tomb demanded.

The pyramid was the eternal abode of the king in the afterlife. Its exterior was formed of precisely fitted stones, while the inside was a labyrinth of passages with a central resting place for the pharaoh, whose body was preserved. Surrounding the pyramid were the tombs of the nobility, who hoped to continue their earthly relationship with the pharaoh after death. The tombs were decorated with scenes illustrating all phases of life, which, in this way, could be carried over into the afterlife. Temples were built in the cities and in the pyramid com-

plex; they were intended to supply the pharaoh after death with the goods he would need in the next world. The spirits of the dead, usually in the form of birds, were believed to flit through the air in the vicinity of the tomb.

The earliest pharaohs ruled the kingdom through an administrative system that was both complex and efficient. All decisions, at least in theory, came from the pharaoh. In the Old Kingdom, the pharaoh usually filled administrative posts with members of the royal family, but this became increasingly difficult and was no longer the rule after the Fourth Dynasty. All land was owned by the pharaoh, who each year distributed seed and equipment to the farmers and then took a fixed proportion of the crop. He was responsible for all public works, including the building of dikes and temples, and for external trade and warfare. It is assumed that the pharaoh led the army to the eastern coastal regions of the Mediterranean, bringing back timber, metal, and other goods, which were then distributed down the hierarchy of Egyptian society, but we do not have positive evidence of these expeditions until after 1500 B.C. There was no money economy in Egypt, and all exchange of goods was carried out by barter. Each citizen paid a tax in kind of everything he produced, and the wealth of the pharaoh thus consisted of the grain, livestock, and other goods that he took as taxes. He also received metals and other goods as tribute or in trade from abroad.

The word of the pharaoh was the source of right and justice in the land, so the judicial system consisted not of a code of law but of the decision in each case handed down by the pharaoh through his courts. The ideal of the exercise of authority was expressed in the word *Maat*, which meant truth, justice, and order in the world. This ideal formed the basis of the moral authority of the state. The word of the pharaoh was *Maat*.

Egyptian society was, above all, an agricultural order. True cities never developed, and thus—in contrast to Mesopotamia—the city had no central place in Egyptian society. The exchange of goods was an aspect of the administration of the kingdom rather than the activity of a distinct social and economic class. The social order was seen as merely one part of the unchanging order of the world, and in it, each person had his place. Egyptian society rested on a peasant base, whose

members acted at times as artisans, soldiers, and laborers on public works. The great mass of the peasant population provided the wealth that supported the royalty and nobility, who occupied themselves engineering the great pyramids and furnishing them in a manner fit for a god. Exploitation of the peasant was limited by his essential role. In spite of the heavy fixed tax on land, and his subjugation and exploitation, the peasant, for most of Egyptian history, cooperated with rather than resisted the exercise of hierarchical power.

The actual government of the kingdom was carried on by the bureaucracy, which rapidly grew to extend beyond the ranks of the royal family. At first, it consisted of servants appointed at the pharaoh's pleasure and constantly transferred by him from job to job, but soon it was transformed into a hereditary class. Often its members were rewarded with gifts of land from the pharaoh; these gifts allowed the nobility to establish power in local areas. A peasant might work the land of a great man, of the pharaoh, or of a temple.

The multiplicity of temples gave rise to a priestly class, which also eventually became hereditary. Offerings to the gods, which comprised the revenue of the priests, enabled the temples to become a major political force in the state. During the Old Kingdom, the priestly class formed a harmonious part of the pharaoh's order, but, later in Egyptian history, it successfully challenged and put a rein on his unlimited authority.

During the Old Kingdom, Egyptian society rapidly evolved a culture whose basic tenets endured throughout Egyptian history. The central concern of Egyptian art, literature, and architecture was the divine world order—the pharaoh and the gods, who were essentially one and the same. To the Egyptians, that divine order was eternal and unchanging, but it did not rest on a coherent and defined system of belief. The same god might be seen one time as the sky, another time as a bird; he might have a mythical mother, yet it might be said that he gave birth to himself; the sky could be both a cow and a goddess. The Egyptians did not think in chronological or logical terms but pictured the same phenomenon in a number of different ways.

For the Egyptian, the divine and natural orders were one. The dead pharaoh in his tomb was fed by offerings of food brought to him from his temple and by the pictures and images of food that decorated

his tomb. Often the deceased had a statue of a man in his tomb so that if there was work to be done in the afterworld, the figure represented by the statue would do it for him. The reality of symbols also played an important part in ritual. A ritual act was not a symbol of the event it re-created; it *was* the event.

Because the Egyptians had no feeling that events of the moment were transitory, they viewed the present as eternal. The world was static; what seemed like change was only recurrence of the eternal order. Thus, Egyptian literature does not contain careful records of the deeds, or distinctive characteristics of the pharaohs. Rather they are portrayed as the divine ideal, always just, wise, bold, strong, and victorious. Neither did artists depict events to be remembered for their uniqueness; instead they tried to show the typical and ideal. The aim of the artist was to portray the eternal nature of his subject, independent of time and space, and this aim eventually crystallized into a set of stylistic formulas. Each figure was painted partly in profile, partly in frontal view; an event was portrayed not pictorially but symbolically, in several different ways in the same work. The pharaoh was always larger than the other characters, because he was more important. One part of a scene, whether in a painting, a relief, or a carved palette, could be upright, with other parts perpendicular to it. The static quality of Egyptian art was heightened by the absence of perspective.

Morality was viewed by the Egyptians not as the assertion of self against the world but rather as the individual search for harmony with the eternal order. The ideal man of the Old Kingdom was the aggressive man who was effective within the system, without flamboyance and without fear. The Egyptians had no concept of altruism or self-sacrifice. The ideal of *Maat* meant truth, justice, and order, but it also meant "what is advantageous." Public officials were urged to be honest because honesty was efficient. The young scribe was urged to work hard because the life of a scribe was the best life in society. The Egyptian was free to seek out a place in a benevolent world order, but he was not to disrupt it by either nonconformity or self-abnegation.

The Egyptian language was written with a hieroglyphic script; it was pictorial rather than syllabic. In its earliest form, it allowed the expression of the concrete more naturally than of the abstract. The genius of the Egyptians was expressed in the solution of practical prob-

lems rather than in sophisticated theoretical advances. Mathematics was used to predict the time of the annual Nile inundation as well as to figure the dimensions of stones for the pyramids, and although the Egyptians did not use the zero or complex fractions, they were able to make these calculations with almost incredible precision. In the field of medicine, the Egyptians recognized the importance of the heart, and they treated ailments like broken bones as natural phenomena rather than the irremedial work of the gods. Their advances in medicine, however, as well as in other areas of science, were limited to their attempts to solve the problems confronting them. They did not attempt to probe into the realm of theory.

History for the Egyptians was the cyclic recurrence of the elements of the divine eternal order. Just as the land was reborn each year, so the pharaoh who died and became Osiris was reborn in Horus, his son and successor. The passage of time was marked by the succession of pharaohs, who were grouped into dynasties and numbered.

* * *

Although the Egyptians viewed their history as fundamentally unchanging, in fact, the position of the pharaoh had declined by the end of the Sixth Dynasty, about 2200 B.C. The following two centuries constituted a hiatus in the traditional power of the pharaoh. As the local power of the nobles grew, they were able to ignore the pharaoh's authority, and Egypt was broken up into local domains under control of the nobility. The nobility usurped not only the power of the pharaoh but his image as well. As early as the Sixth Dynasty, nobles began to build their tombs in their local districts instead of clinging to sites at the foot of the pharaoh's pyramid, even arrogating to themselves the power to become gods after death.

This period of political chaos was also marked by social change. The class structure became much more fluid; one writer lamented that the man who once had nothing now had wealth and power, while the man who once was great now was reduced to destitution. The concept of the afterlife was finally enlarged to such a degree that anyone who could afford the proper mortuary care could be assured of a blissful afterlife as a god. The word *Maat* came more and more to stand for a kind of social justice and to represent the demand that society give every man his due.

By about 2000 B.C. the pharaoh was again able to unite the kingdom. To some extent this unity was a façade behind which the old quarrels and internal struggles continued, but gradually the pharaoh once more became the effective center of the state. His recovered supremacy, however, was that of the first among equals; his unique position had been weakened. Nevertheless, he was able to reassert his predominance in the afterlife, a renewed authority attested to by the decrease in the relative size of the tombs of local magnates.

The Egyptian state itself increased in size and power. Regular mining and quarrying expeditions were sent over long distances by land and sea. Egypt expanded territorially to the south, where political conditions were unstable. The state of the Middle Kingdom, from about 2000 B.C. to about 1800 B.C., was powerful, unified, and aggressive.

About 1800 B.C., the ambitious expansion of the state gave way to disaster when Egypt succumbed to the rule of the Hyksos, a group of Semitic warriors from western Asia. The Hyksos were not a unified nation but a loose gathering of various tribal and ethnic groups who established themselves in heavily fortified settlements in the delta region. From these strongholds they held sway over Egypt, collecting taxes while allowing the pharaoh to remain the nominal ruler of Egypt. The Egyptians suffered a deep humiliation; for the first time they succumbed to foreign conquest and were forced to pay tribute.

When the Hyksos were driven out in the sixteenth century B.C., the power of the pharaoh was enhanced again. Defeat changed to expansion as the armies of the pharaoh pushed farther southward, and northward into western Asia. At first the expansion took the form of spasmodic raids into Asia, but by the time of Thutmose III (1504–1450 B.C.), the Egyptian Empire spread far into western Asia. The Egyptian sense of timeless security had lapsed forever with the Hyksos invasion. Henceforth, to defend itself, the state had to be concerned with the lands beyond its frontiers.

The new power of the pharaoh was accompanied by his alliance with two great forces in the Egyptian state: the priesthood (especially the priests of the god Amon) and the bureaucracy. The pharaoh began to consult the gods before undertaking important actions, and victories were followed by lavish gifts to the temples. The high priest of Amon became one of the most powerful officials in the state; and

Thebes, with its great state temple of Amon, became the capital of Egypt and its most important city. At the same time, the pharaoh came to rely on his administrators to operate the system of regulation and taxation, which permeated every phase of Egyptian economic life. Colonial government in the south was carried on by a viceroy, while, within Egypt, the direct overseer of the royal administration was a vizier who reported to the pharaoh daily. Scribes, judges, and governors came to be the essential pillars of royal administration. At the same time, the strength of the priests grew in the temples, and as the power of the army expanded, it assumed a new role as the guardian of Egyptian interests on the border, in Nubia to the south, and in western Asia. The increasing demands of the state were accompanied by administrative complexity, the enforcement of discipline, and the assertion of authority.

The end of Egypt's isolation turned what had been only occasional and incidental contact with the rest of the Near East into a constant and significant exchange of goods and ideas. The new cosmopolitanism introduced new forms and motifs and a growing naturalism to art. Egypt had always been receptive to immigrants, who had easily been assimilated into its culture; now even the pharaohs could marry foreigners. In addition, the increase of commerce and the emergence of a cosmopolitan urban population—at Thebes and other cities—marked the first real urbanization in Egyptian society.

The changes in Egyptian life brought about a radical and violent reaction on the part of the young pharaoh Amenhotep IV (1375–1358 B.C.) and his supporters. Early in his reign, he changed his name to Akhenaton and moved his capital away from Thebes. Akhenaton pronounced himself to be the son of Aton, and elevated that god to a supreme position. During Akhenaton's reign, the pharaoh served and worshipped Aton; all others served and worshipped the pharaoh himself. Hitherto, Egyptians had tolerated a number of gods and had not required any clear-cut theological explanation of their relationship to one another. Now the lesser gods were ignored, and some of them—especially Amon, who had previously been one of the most exalted gods and for whom the great temple at Karnak had been built—were consistently attacked. Even their temples were destroyed, and thus a great blow was struck at the basis of priestly power. The ideology of

the new religion was based on the traditional *Maat,* and now *Maat* was taken to mean the truth of Aton, and it was comprehensive and exclusionary.

The same emphasis on truth was found in art; even the pharaoh himself was portrayed in naturalistic terms. Some representations of Akhenaton, with his thin face and potbelly, are so naturalistic that they verge on caricature. The static view of the Old Kingdom was no longer expressed; the art of Akhenaton's time clearly placed objects in time and space. Akhenaton's revolution was not based on a desire to return to the past; rather, his innovations sought specifically to remove the exercise of power from the hands of the priests and to restore the unquestioned spiritual and political authority of the pharaoh.

There was, however, no stopping the changes that had taken place in the Egyptian society. When Akhenaton died, his son-in-law Tutankhamen was forced to restore the older order. Within just a few years, the memory of Aton was wiped out and the priests of Amon regained leadership. Henceforth, the pharaoh relied upon the cooperation and advice of the high priest of Amon in matters of state. As before, he went to battle under the standard of Amon and rewarded the god lavishly upon his victorious return.

After an interval of recovery and consolidation, Egypt again launched a program of expansion, which reached its height under Ramses II in the thirteenth century B.C. After years of warfare, Ramses II made an agreement with the Hittites to the north of Palestine and was able to spend most of the rest of his long and comfortable reign (1292–1225 B.C.) within Egypt. Ramses devoted himself to a life of unparalleled luxury, and built numerous temples and other public buildings. He also made extensive additions and repairs to the huge temple at Karnak, the enormous complex that is the work of kings from the beginning of the Eighteenth Dynasty until the Romans.

In the years after the reign of Ramses II, it became ever more obvious that Egypt was sinking into decadence. Gradually, Egyptian influence in Asia declined, and vulgarity and satire in art and literature gave way, by the Twentieth Dynasty, to a technique that was nothing more than careful copying of ancient works of art.

The government suffered from external pressure from the Sea Peoples—groups of wandering Mediterranean warriors—and from the

laxity and dishonesty of its officials. Increasingly, the temples became the predominant power in the state, absorbing an ever larger share of its income. Egypt was rich in copper ore, which, as the base of bronze, had been valuable through the entire Mediterranean world. By 1150 B.C., however, the Iron Age had succeeded the Bronze Age. Egypt had no iron and so lost power in the Asiatic countries where the ore existed; the adjustment of its economy to the new metal caused years of inflation and contributed to the financial distress of the central government. The pharaoh could not meet the expenses of his government; he had no money to pay the workers on public buildings, and his servants robbed him at every opportunity. Still a god in theory, he was satirized in literature and became a tool of the oligarchy. During the centuries after the twelfth B.C., the Egyptian state disintegrated into local units loosely connected by trade. Occasional spurts of energy interrupted the decline, but these were short-lived and served only to illuminate the general passivity.

Ancient Judaism

*W*hether the Israelites of the early first millennium B.C. were a nomadic people who came out of the southern desert to overrun the urbanized Canaanites along the eastern littoral of the Mediterranean, or whether they were originally a religious or social subgroup among the Canaanites themselves, they became bound together in a loose political confederation. More important, they had a religious identity—their devotion to their god Yahweh (YHWH, Jehovah) and the belief they were bound to Him by a covenant (B'rit).

Whatever had been the origin of these people called Israel, they were now a people collectively and identifiably called by God. Yahweh would protect the tribes of Israel, and in return they must obey certain religious commands set down by Him. The Jews also developed a memory (however invented) of the captivity of some of their tribes in Egypt and their rescue from Egypt by Yahweh through the leadership of Moses. Despite a tendency to confuse Yahweh with local gods and to worship according to the forms practiced by the Canaanites, these traditions were assiduously cultivated.

The covenant was not a negotiated contract—the Jews had not entered voluntarily into a compact with Yahweh, nor could they withdraw from their obligations to God. Of His own inscrutable will, Yahweh had chosen this obscure people as His own.

Parallels drawn by W. F. Albright and others between the Jewish covenant with God and ancient Near Eastern business contracts and diplomatic pacts are not convincing. The B'rit is not the outcome of a deal between two free parties. It is an act of providence unilaterally imposed by divine majesty upon the Jews.

The covenant idea was that God had given to the fathers of the tribe—Abraham, Isaac, and Jacob—the land of Canaan as their own

land and, when the Jews were slaves of pharaoh in Egypt, He had sent Moses to lead them out of captivity and back to the Promised Land. Yahweh had also imposed on His people His ethical norms and religious commandments, beginning with the tablets given to Moses on Mount Sinai. The Jews had no choice but to maintain God's covenant—this was their burden and their glory.

The power and meaning of the covenant is adumbrated early in the Bible in the story of Abraham's willingness to sacrifice his son Isaac at God's command. Of course, divine intervention precluded this killing of the child, but that Abraham was willing to perform this heinous ritual at God's command is held to be meritorious and worthy of immense reward. The covenant has been upheld, even to the point of death, and Yahweh is immensely pleased:

> *By Myself I swear, the Lord declares: Because you have done this and have withheld your son, your favored one, I will bestow My blessings upon you and make your descendants as numerous as the stars of heaven and the sand on the seashore. And your descendants shall seize the gates of their foes. All the nations shall bless themselves by your descendants, because you have obeyed My command.*[1]

The story of the sacrifice of Isaac had a profound message for the Hebrew mind down through the centuries.

In biblical history, the people complained often enough and aroused God's wrath frequently enough by violating the covenant, even to the point of worshipping idols and false gods. But the people had been called, and they could not repudiate the covenant. The prescribed circumcision of all Jewish males memorialized the eternity of the covenant. The benign Sabbath symbolized the covenant's continuing humane value in Jewish life.

In this land of Canaan that God gave to Abraham, Abraham's seed would prosper and multiply. Abraham would be "the father of a multitude of nations." Canaan would be "an everlasting holding" of the people of the covenant:

> *I am God Almighty. Live always in My presence and be perfect, so that I may put My covenant between Me and you . . . I am setting up My covenant between Me*

[1] Jewish Publication Society translation.

> *and you and your descendants after you as an eternal covenant, to be your God and*
> *the God of your descendants. And I am giving you and your descendants after you*
> *the land where you are now aliens, the whole of the land of Canaan as an eternal*
> *possession, and I will be God to them . . . You shall circumcise the flesh of your*
> *foreskin, and this shall be the sign of the covenant between Me and you.*

These words of Yahweh to Abraham in the Book of Genesis are the foundation myth of Jewish history, the idea out of which the sacred chain of self-imposed collective Jewish destiny was forged.

This theme is reinforced in the Book of Exodus by God's message to the people of Israel assembled at the foot of Mount Sinai:

> *And now, if you hear My voice and observe My covenant, you shall be My*
> *possession before all the peoples; for the whole earth is Mine. You shall become*
> *to Me a kingdom of priests and a holy people.*

The covenant idea is the polar opposite of democracy, multiculturalism, and ethnic equality. It is intensely elitist. It singles out the people of Israel and raises them uniquely above all other people as a holy community of priests designated to witness God's word in the world, as summarized in the Decalogue, the Ten Commandments that Moses received from Yahweh on Mount Sinai:

> *I am the Lord your God.*
> *You shall have no other gods besides Me.*
> *You shall not make for yourselves an image of God.*
> *You shall not take the name of the Lord your God in vain.*
> *Remember the Sabbath day to keep it holy.*
> *Honor your father and mother.*
> *You shall not kill.*
> *You shall not commit adultery.*
> *You shall not steal.*
> *You shall not bear false witness against your neighbor.*
> *You shall not covet your neighbor's house.*
> *You shall not covet your neighbor's wife . . . or anything that is your*
> *neighbor's.*

Bound together by these beliefs and moral law, the Jewish tribes overcame the power of hostile Canaanites, we are told. In the tenth century B.C., the tribes of Israel, faced with a great threat from the Philistines, united into one kingdom. David, later remembered as their greatest king, was able to defeat the enemies of Israel and to establish a hegemony in the land. He captured the hill city of Jerusalem and made it the capital of his empire. In the reign following David's, his son, rich and mighty Solomon, built the Temple, which was to become the center of religious observance in Israel. The rise of David's monarchy (tenth century B.C.) can be perceived from circumstantial biblical accounts reinforced by meager archaeological data.

The emergence of kingship among the Israelites in the ninth century B.C. was the consequence of the invasion of Canaan from the Mediterranean side by a sea people, the Philistines, who possessed superior iron weapons. The Philistine center was along the southern coast in places like Ashdod and Ashqelon. In response to this threat, the Hebrews could no longer rely on the leadership of "judges," *ad hoc* military leaders (some of them, peculiarly, women; perhaps reflecting, as feminists claim, an earlier matriarchal society). The Hebrews needed the continuity and strength of a united monarchy.

The first such king, Saul, was given divine sanction for his rule over the people by the ceremony of anointment, wherein the high priest Samuel poured holy oil on Saul's head. Even though Saul came from the smallest of the Hebrew tribes, his anointment to the kingship and some early success against the Philistines won him popularity and loyalty. Despite increasing tension between two power brokers, the ambitious leader of a powerful mercenary band, David, from the largest of the tribes, Judah, would not raise his hand against anointed Saul and try to overthrow him.

When Saul and his sons fell fighting against the Philistines, David took the kingship, defeated the Philistines (from whom the Jews learned iron-making and to whom they gave their alphabet), and set up his capital in the newly conquered citadel of Jerusalem, on the high, arid inland plateau. A convenient court seer proclaimed the durability of David's line despite the king's boisterous sexual behavior. An elaborate system of cisterns and wells, now again visible after recent archaeological discovery, provided water to the new Jewish citadel.

Solomon, the son born of the most scandalous of David's numerous unions, temporarily ruled an imperial territory larger than Israel itself. Solomon generated high-glitz court glamour, and he, too, enjoyed a multitude of wives and concubines. He imposed heavy taxation on the people to build the Temple in Jerusalem. The sacrifice of animals to Yahweh was centralized here. And the Temple priesthood came to play a dominant role in religious life.

Nothing in the story of David and Solomon, told with elaborate detail in the Bible, distinguishes them from any other minor dynasty of the ancient Near East—except the commitment to Yahweh and the covenant, even though Solomon had a relish for Gentile women.

The period of a united empire was brief. After Solomon's death in 931 B.C., the empire disintegrated into two kingdoms—Israel in the north and Judah in the south, reflecting long-standing separatist tendencies. Neither kingdom was able to retain its independence for long. The two kingdoms were so placed between Egypt and the Mesopotamian empires that they were frequently the scene of battles between the contending great powers. Finally, Assyria extended its predominance from Mesopotamia and reduced the two Jewish kingdoms to a state of vassalage.

During the period that Israel and Judah were menaced by the great powers, Jewish religious practices and beliefs changed—partly in response to the foreign threat and partly in reaction to conditions within Israel itself. Along with the worship of Yahweh, there had also been, from the tenth until the eighth century B.C., worship at other shrines. Intermarriage with foreigners was frequent, and because Yahweh was worshipped at local shrines, there was a tendency to fuse Him with the gods of the locality. There was another significant social change: In contrast to the conditions of relative social and economic equality that had prevailed in primitive tribal times, the community was becoming increasingly separated into rich and poor. The characteristic Near Eastern social conflict of landlord against peasant, town against country, royalty and priesthood against commonality, prevailed.

The prophetic movement of the eighth to the sixth century B.C. attributed the impending misfortunes of Israel to its forsaking of the covenant with Yahweh. The prophets were visionaries and rigorous

moralists who made public pronouncements communicating Yahweh's current message to the people of the covenant. The prophets did not advocate simply a return to the practices and way of life of earlier times. They were progressives who demanded fulfillment of morality and social justice and the pure worship of Yahweh. To save the nation, it would be necessary to purify national life and reform society.

Some of the prophets were associated with the Temple. Some represented political factions within the nation. Yet they were always individuals whose personal experiences led them to believe that they were chosen by Yahweh to speak to the nation on His behalf. Often they experienced communication with Yahweh through ecstatic visions, and they felt compelled to convey His message to the nation regardless of its reception or the consequences. Unfortunately, the writings of the major prophets in the Hebrew Bible were much edited in later centuries, and texts do not well disclose the individual personalities of most of the prophets.

In the mid-eighth century B.C., the prophets spoke out to the Jews with a common message. In the northern kingdom of Israel, two prophets, Amos and Hosea, foretold the destruction of Israel. Amos asserted that the demands of Yahweh were moral and spiritual; he spoke against the oppression of the poor by the rich and attacked the ritualistic practices of Israel. His contemporary, Hosea, explicitly named the Assyrians as the instrument by which Yahweh would destroy Israel if it did not repent. In the kingdom of Judah to the south, the warnings and demands of Amos and Hosea were echoed by the prophet Isaiah, who identified the sin of Israel as its rebellion against Yahweh, and by Micah, who, like Amos, called for an end to chronic social grievances.

The prophets did more than attack the syncretism of the Hebrew faith with other cults and the excessive attention to ritualistic externals. They insisted that Yahweh was the one and only God and that obedience to Him and fulfillment of His ethical demands was the only possible course for the salvation of the Jewish nation. Eventually their calls for reform profoundly influenced the official—priestly and royal—position that they sometimes criticized. The oppositional character of prophecy was steadily moderated into one of cooperation with the ruling group.

The destruction of the northern kingdom of Israel at the hands of the Assyrians under Sargon II in 721 B.C. made more insistent the prophets' religious demands in the surviving Judean kingdom in the south.

* * *

The Hebrew word for prophet is *nabi*, one who calls or is called. A prophet in ancient Judaism is not someone who predicts the future, although the Hebrew prophets did plenty of that. It is rather someone called by God to proclaim or communicate His word. Therefore the prophets are God's chosen successors to Abraham and Moses as truth-speakers of divine intelligence. It was, and still is, the tendency of Christian interpreters of the Hebrew Bible, in the Middle Ages and in modern times as well, to view the prophets as oppositional to priestly Judaism. Thereby, the Christian interpreters can claim that the prophets were envisioning a more liberalized and ethically based Judaism and downplaying the importance of the legal code derived from the covenant, and so were, allegedly, preparing the way for Jesus and the New Testament, the new dispensation that abandoned much of the old code of religious law. In the nineteenth and early twentieth centuries, there was a tendency in Reform Judaism to go somewhat along this interpretive road, viewing the prophets as advocating a more ethically centered Judaism, less focused on the legal demands of the covenant.

Some Reform rabbis and secular commentators still take this position, but, in recent years, there has been an overwhelming tendency among Jewish interpreters of the Bible to view the prophets as within the mainstream of priestly and legalistic Judaism, and to downplay the oppositional character of the prophetic movement.

The most interesting text in this regard is in the Book of Isaiah, where God seems to look askance upon fasting, while promoting activist social justice:

> *Is such a fast I desire a day for men to starve their bodies? Is it bowing the head like a bulrush and lying in sackcloth and ashes? . . .*
>
> *No, unlock fetters of wickedness, and untie the cords of the yoke, to let the oppressed go free . . .*

Today, the almost universal view among Jewish scholars is that Isaiah is not placing justice over a code of prescribed religious praxis, but

instead is saying that the latter must be fulfilled by the spirit and sensibility of the former. A behavioral code without intense moral consciousness is not the Jewish way. Law fulfilled by justice is the Jewish way.

Already in ancient times this section of Isaiah was read aloud to the congregation on the Day of Atonement to remind the community that the Law must be fulfilled inwardly as well as outwardly. This is the prophetic message, so that even if the prophets may have started out as critics of the priesthood, the two religious ways rapidly coalesced. Today, among Jewish biblical scholars, this is the consensus view of the prophets.

The essence of biblical Judaism is the blending of a legalistic with a prophetic tradition—a religion of command with a religion of moral commitment. In the Book of Deuteronomy, drawn up in its present version in the seventh century B.C., after the era of the great prophets, this blending of law and prophecy, command and commitment, takes the definitive form of God saying: "I have put before you life and death, blessing and curse. Choose life . . . by loving the Lord your God, heeding His commands and holding fast to Him."

The prophet Isaiah blends the covenant ideas with Israel's designated role in spreading God's message of justice and love to the whole world:

> *This is My servant, whom I uphold, My chosen one, in whom I delight. He shall teach the true way to the nations . . .*
>
> *He shall not grow dim or be bruised till he has established the true way on earth . . .*
>
> *I the Lord, in My grace, have summoned you, and I have grasped you by the hand. I created you and appointed you a covenant people, a light of nations.*

This synthesis of legal tradition and prophetic enthusiasm provided emotional sustenance during the difficult days of the later eighth century B.C., when the political life of Judea was marked by conquest, revolt, and internal conflict. The Assyrian siege of the city of Jerusalem was broken in 701 B.C., when the forces surrounding the city were struck by plague and forced to withdraw, leaving Jerusalem the only unconquered city in the Jewish realms. The status of Jerusalem and the Temple were thereby greatly increased, and the

national god Yahweh was regarded as the defender of His city against the invaders. But the brief respite that followed the siege was only the prelude to a period of demoralizing vassalage to Assyria, whose military strength was much too great for the Jews to resist.

Some members of Hebrew society went beyond cooperation with the conquerors. Some even worshipped Assyrian divinities, assigning to Yahweh the highest place in the Assyrian pantheon. New prophets arose to condemn such abuses. In the late seventh century B.C., Jeremiah prophesied that Solomon's Temple would be destroyed because the singular worship of Yahweh, as set down in the covenant, had been forsaken.

In response, under the leadership of the ruler Josiah (639–609 B.C.), a reforming movement in Israel achieved concrete and immediate results. Josiah was bent on reforming worship, and his major undertaking was the plan to centralize all worship in the Temple at Jerusalem. The shrines that dotted the mountains of Judah were destroyed, and the priests who had attended them were brought to Jerusalem and made subordinate to the priests of the Temple. The Temple itself was purified, and an austere ritual was mandated. Once all worship was restricted to the Temple in Jerusalem, the practice of accompanying almost every significant action with ritual magic had to stop. Josiah's reforms served to infuse some of the prophetic ideals into official religious observances.

King Josiah gave royal legitimacy to the newly completed Jewish behavioral code, the book of religious law that we now know as the Book of Deuteronomy in the Bible. During Josiah's reign, priests and scribes, drawing on some ancient sources but adding much of their own, presented the Deuteronomic book as having been newly discovered in the Temple, and received from the king legitimation and authority for this priestly ordained code.

The official story was the discovery, in the course of purifying and repairing the Temple, of a law book that outlined how the blending of prophetic and traditional practices could be accomplished. This was the book that Josiah attempted to follow in his reforms. It represented the first written segment of Torah (Law, literally instruction), the final and sufficient word of God. From this time forward (although it would undergo important changes after the death of Josiah) the religion of

Israel depended more and more on the strict observance of God's law as described in the Torah.

Josiah's reforms had only begun to be implemented when he died. The time was too short for extensive implementation. Jeremiah's incessant prophesying that the Temple would be overthrown soon came to pass. This time, the Babylonians, who had replaced the Assyrians as rulers of the Near East, besieged Jerusalem. The city fell to Nebuchadnezzar in 586 B.C., and Solomon's Temple was destroyed. Most elite members of the Judaic population were sent into exile in Babylonia, where they established a colony. Jeremiah took refuge in Egypt. Passive elements were left in Judea, and new colonies were brought in by the Babylonians, who thus removed the possibility of effective opposition.

"Lonely sits the city, once great with people. Judah has gone into exile . . . ," lamented old Jeremiah in his Egyptian exile. Yet those who had gone to Mesopotamia, we are told in the Bible, swore that they would never forget Zion. By the waters of Babylon they sat down and wept and swore a mighty oath that the covenant between Yahweh and the Jews would not be abrogated.

Despair was mitigated by hope of redemption and restoration in the future. Destruction and exile would in time be succeeded by return to Jerusalem and by restoration of David's royal line. In Jeremiah's lyrical pronouncement:

> *He who scattered Israel will gather them, and will guard them as a shepherd his flock. For the Lord will ransom Jacob, redeem him from one too strong for him.*

The recurring cycle of defeat and triumph, of exile and restoration, of destruction and redemption, here articulated by Jeremiah, became a central motif of resurgent theology in biblical and all subsequent Jewish thought.

The destruction of Judah and the Babylonian willingness to allow Judeans to settle throughout their empire provided impetus to dispersion of the Jewish population. The most vital group was the Jewish colony established in Babylonia. Living in a foreign land, they were deprived of worship in the Temple, but instead of losing their identity

and becoming assimilated into the native population, they developed a highly self-conscious religious community. Many Jews, of course, were assimilated into Mesopotamian culture, but for the rest, obedience to the Law was held as the source of the distinctiveness of the Jews. Circumcision and observance of the Sabbath became more crucial than ever, as did observance of dietary restrictions, to strengthen Jewish identity while Jews lived in multicultural exile (circumcision was common in the ancient Near East, but the Babylonians did not practice it, so for the Jews it became even more important than before).

The foundations of the synagogue, which would become critically important in later Judaism, can be traced to the meetings of this Jewish community in exile from Jerusalem. In the absence of the Temple, religious meetings had to forsake ritual and rely on prayer and reading of religious texts.

In Babylonia the Jews spoke Aramaic, the common language of the country. Aramaic is a Semitic language that closely resembles but is still distinct from Hebrew. After some of the Babylonian community returned to Judea, they brought Aramaic back with them, and it became the language of the Jewish populace for several centuries. The Jewish prayer for the dead is still recited in Aramaic, reflecting its sometime popular use.

Some modern scholars, like John Allegro of Manchester University in the UK and Columbia University's Morton Smith, have speculated that what the Jews learned in Babylonia was more than Aramaic and synagogue worship. Rather it was there, in the valleys of what is today Iraq, that the Jews in the middle of the first millennium B.C. are said to have learned much of their monotheism and to have written drafts of most of the Pentateuch's narrative text, which they later brought back to Jerusalem. The Bible symbolically hints at this derivation by placing the homeland of the patriarch Abraham in Iraq.

By this view, well-speculated but unproven, Judaism was a derivation from Mesopotamian religious culture. Allegro and Smith also contend that Jews brought back with them from Mesopotamia a volatile brand of esoteric religion to go with the more sedate biblical religion we recognize.

Even in Babylonia the prophets continued to speak out, but after the destruction of Jerusalem their preaching took a new tone. Instead

of prophesying the destruction of Jerusalem, they explained that the misfortunes of the Jews were punishments for their sins, and anticipated the eventual restoration of Halakah (religious law) in Jerusalem. Ezekiel had foretold the destruction of Jerusalem, but, writing as an exile, he also denied the idea of collective guilt and claimed that each individual received retribution for his own sins. At the same time, for Ezekiel, the Israelites were the chosen people of a universal God, and he looked forward to the redemption of the nation.

Not surprisingly, the later prophets who wrote in exile tended to give universal significance to the Jewish faith, a trend illustrated by the writings of Second Isaiah. Deutero-Isaiah enunciated the idea that Yahweh, the universal creator of the universe, had chosen Israel to be His witness among the Gentiles. Just as the Hebrew people's suffering had been a lesson to mankind, so would its restoration be brought about as a sign of a new age of universal peace and justice. In order that war might end and nations beat their swords into agricultural implements, the word of God must again go forth from Zion and the Law be proclaimed from Jerusalem.

The prophets who wrote in exile recognized a common brotherhood of all peoples, and Yahweh as the father of all mankind. Yet this kind of universalism did not detract from or erode faith in the Jews' covenanted destiny as God's chosen witnesses to mankind. On the contrary, it enhanced the strength of this belief. The Jews must return to Jerusalem and restore the Temple so that mankind might enjoy peace and justice.

The hopes of the exiles were answered in 539 B.C., when the Persians took the city of Babylon and established their control over the Babylonian empire. Since the Persians' policy encouraged local religious organizations within their empire, the Jews were allowed to return to Jerusalem and were even permitted to rebuild their Temple. But after two generations of exile, the return to Jerusalem was slow, and the population dwelling on the land was not especially eager to restore the Temple. Neither the returned exiles nor the indigenous Jews had the kind of funds required for the restoration of Jerusalem. Reconstruction was begun by Zerubbabel, under the Persian king Darius I, and the new Temple was consecrated in 515 B.C. But only under the administration of the Persian governor Nehemiah, in the

mid-fifth century, was real reconstruction carried out and the enforcement of religious law achieved. Nehemiah was empowered by the Persian king to institute important reforms. He prohibited marriages with non-Jews, provided for the payment of tithes and the observance of the Sabbath, and allowed for the remission of debts to lift the heavy burdens that oppressed the poor. Finally, Nehemiah saw to the rebuilding of the walls of Jerusalem.

Those who had remained in Judah as well as those who had, under Babylonian rule, been assimilated into the population from abroad were not eager to see the power of the Temple restored, for this would mean the predominance of the returned exiles. Therefore, they opposed Nehemiah's reforms and continued to live much as they had during the exile.

To counteract their obstructionism, Ezra, a member of the group of exiles in Babylonia, early in the fourth century, undertook a commission from the Persian king to restore the systematic observance of Jewish law in Judea. As a result of his work, the books of the Law, the Pentateuch (the so-called Five Books of Moses), incorporated the results of the exile experience with the reforms of Josiah and the prophetic tradition. The Law now began to take on its final form. In the future, mainstream Judaism would be a religion of the Law that religious leaders insisted was binding on all of the Jewish nation.

As far as practice was concerned, the most important change in this amended version of the Law was the observance of the Day of Atonement. In doctrine, the most important addition was the development of an eschatological view of history—the view that a Messiah would come forth to lead the Jewish nation in the Day of the Lord. Yahweh was no longer the national champion of Israel but rather the judge of the entire world, a universal God whose will was absolute justice. The judgment of God was worked out in history, and His commands were expressed in the Law of the Jewish nation, whose misfortunes were a lesson to all mankind and whose eventual triumph was assured because they were the chosen people of the Lord.

In the meantime, the Jews remained a conquered nation—the vassal state of the Persians, and then of Alexander the Great and his successors, the rulers of the Hellenistic kingdoms of the Near East that emerged in the fourth century B.C.

In a couple of decades before his death in 323 B.C., Alexander of Macedonia created the largest empire the ancient world had known, stretching from Greece to northern India. Early on, Judea was incorporated into the realm of the world conqueror, who treated the Jews generously. After his death, his empire broke up into three political entities. Judea was initially under Egyptian rule, but this was soon superseded by incorporation into the Syrian empire of the Seleucid Dynasty.

The differences were political, but the culture of the post-Alexander Hellenistic world was largely the same everywhere in the Near East. Hellenistic civilization was an urban-centered blending of the religions and lifestyles of the eastern Mediterranean, bound together by the Greek language (in post-classical, vulgarized form) and, among the educated class, by Platonic philosophy.

In the Hellenistic era, numerous divisions and conflicts centered around the priesthood within Judaism itself. With the reorganization of the Temple, the high priest became the most important official in the state, but the power struggle within the priesthood meant that there was no peace within the Jewish nation. Most conflicts were fought around one crucial issue: Would the integrity of Jewish religious culture be preserved despite a growing tendency toward absorption into the Hellenistic world?

Jews were given a privileged position in the Hellenistic kingdoms. They were allowed to settle freely in the cities of the Near East and were granted social and economic privileges second only to those of the Macedonian and Greek conquerors. The attraction of the Hellenistic cities was very powerful, and large colonies of Jews dotted the Near Eastern world. But even this dispersion did not cause the Jewish colonies to lose their identity. Instead, synagogues were established, the Law was respected, and proselytes were added to the ranks of the faithful. Converts who attended the synagogue and observed some of the Law—omitting the more stringent requirements, such as circumcision—also swelled the ranks of the Jewish community.

Within Jerusalem itself, hellenizing influence took a political form expressed in cooperation with the foreign monarchies, and a cultural form expressed in the adoption of the Greek language and lifestyle. The Pentateuch was translated into Greek by Alexandrian

Jewish scholars in the Septuagint version. There was even a Greek gymnasium in Jerusalem, where the young men of Israel took part in athletic contests in the Greek manner. Some Greek preference for nudity was particularly appalling to the faithful, though all the Hellenistic innovations were widely opposed by the more conservative elements of the Jewish population.

* * *

Political and cultural discontent flared into open rebellion in 168 B.C., when Antiochus IV Epiphanis, the Seleucid ruler of Syria, came to Jerusalem and flagrantly polluted the Temple. The old shrines began to be converted to the worship of new Hellenistic gods, and the population was threatened with adoption of new Greek observances. Possibly Antiochus's motives were political rather than ideological—he was trying to extort money from the Jews to pay for his military campaigns—but a bitter conflict erupted.

At first, widespread compliance was broken only by martyrs who refused to take part in the new rites, but, in 166 B.C., open and organized revolt began. At the outset of the struggle, the rebels merely retreated to the hills and engaged in occasional guerrilla warfare against the foreign officials, but under the leadership of Judas Maccabeus the rebels won several battles. The military skill of the Maccabean family gained them the open support of Jews who were deeply opposed to the religious oppression of their Syrian overlords but who had initially been cautious about the possibility of rebellion.

The Book of Daniel, which was written at the time of the Maccabean revolt, indicates the highly emotional, apocalyptic speculation that accompanied the conflict with the Syrian empire. The latter was seen as the fourth and final empire in history; it would be replaced by the kingdom of God.

The revolt spread rapidly, and, because of troubles within the Syrian Empire, the Maccabeans were able to gain recognition of Judea's virtual independence, and the state that they established lasted for almost a century, until the Roman conquest in 63 B.C.

The symbol of Maccabean rule was the menorah, the seven-branched candelabra on a three-legged base. Later, under Roman rule in Judea, a solid base for the menorah became fashionable, and in this modified, post-Maccabean form, the menorah became the symbol of the modern state of Israel.

A special expanded menorah, allowing a light for each day of Hanukkah, the eight-day festival of lights, is used to commemorate the Maccabean reconquest of the Temple from the Syrians and the Temple's cleansing and renewal. Traditional legend told of the discovery of a flask of holy oil in the Temple, enough to burn for eight days.

Joyous celebration of the Maccabean military triumph and spiritual rededication ignores the sad later history of the Maccabean (also called Hasmonean) Dynasty, whose kings turned out to be just another family of greedy, manipulative, and often inept rulers.

Much of the support for the rebels and the new ruling dynasty had come from those elements in the population that were particularly concerned with establishing pure religious beliefs and practices, but once independence was won, the Maccabean kings were mainly interested in preserving their own independence and political power. The new monarchy was torn by factional struggles and forced to play politics with the Syrian Empire to maintain its independence.

The situation did not change when the Romans under Pompey established their hegemony in Judea in 63 B.C. Although the Jews were allowed to continue their religious life, the policies of the Roman governors and the puppet kings they set up frequently came into conflict with the beliefs and practices that made the Jews unique within the Roman Empire. Revolt always simmered just below the surface of Jewish political life in the late first century B.C. Even among the aristocrats and wealthy groups, many never completely accommodated themselves to Roman rule. Roman pacification of Judea was incomplete.

Such a political situation offered no solution to the controversies that tended more and more to split Judaism into religious factions and sects. The reliance on written law gave rise to the predominance of scribes, men of learning who studied and interpreted the Law. It also fostered religious controversy, which focused on two groups of interpreters: the Sadducees and the Pharisees. The Sadducees were the more aristocratic of the two groups. They dominated the Sanhedrin, the Jewish high court in Jerusalem. The Sadducees refused to recognize anything not explicitly stated in the written Law. They appear to be descended from the Zaddokites, family members and their allies who had controlled the priesthood from the time of a certain Zaddok, high priest in the time of King Solomon. Possibly the term "Sadducees" is a derivation from "Zaddokites."

When the Maccabees defeated the Syrians and took back Jerusalem, they evicted the Zaddokites from the priesthood and put their own men in charge. This Maccabean move greatly disturbed the Zaddokites, and a militant wing of the Sadducees, the Essenes, plotted a revolution in response.

The Pharisees were eager to supplement the text of the Law with oral tradition and rabbinical interpretation. In that sense, they were liberal and progressive. The Pharisees insisted that in addition to the written Law (Torah), which Moses and the Israelites had received from Yahweh on Mount Sinai, the Jews had received an oral law of equivalent importance, and it was the obligation and privilege of the learned scribes, the rabbis, to interpret the oral law and make it fully compatible with the written Law. Through interpretation, the Pharisaic rabbis would bring this double-faceted legal heritage up to date and apply it to current needs and issues.

Therefore, while the Sadducees held to a rigid and literal reading of the written Law, the Pharisees were malleable and progressive updaters of the Law, a large part of which, they claimed, was orally received. This Pharisaic view has remained the basic assumption of rabbinical, or Orthodox, Judaism. While, in general, the Pharisees were also more strongly opposed to Hellenistic influences than the Sadducees, the Pharisees borrowed from Mesopotamian religion the popular doctrine of personal immortality and resurrection of the dead, which is absent from the Torah.

The Pharisees were a middle-class phenomenon. Unlike Sadducees, they were laymen, not priests or members of aristocratic priestly families. The Pharisees were scribes and teachers, the secular community leaders whom the Jews called by various names but most commonly and persistently referred to as rabbis.

The Pharisees banded together in fraternities and clubs to discuss the implementation of the Law. They divided into two schools, led by Shammai and Hillel, the teachers of the Law. The school of Shammai was more rigorous and legalistic, that of Hillel more pragmatic and humanistic. It was Hillel who responded to the scoffing request of a heathen to teach him the whole Torah while the heathen was standing on one foot: "What is hateful to you, do not do to your neighbor: that is the whole Torah, the rest is commentary."

Both the Sadducees and the Pharisees accepted the rule of a foreign power as a necessary evil, though the more socially upscale Sadducees were more willing than the Pharisees to collaborate with the Roman conquerors. But other Jewish groups were unwilling to compromise. The Zealots continued the tradition of revolution against foreign domination that had characterized the early phase of the Maccabean resistance. They demanded political independence for Israel and refused to pay taxes to the Roman emperor, claiming that they owed allegiance only to the one true God. Some members of this minority movement used terror and guerrilla activity to stir up resistance to the oppressors. They became Sicarii (assassins). They sought a war of national liberation from Roman rule.

While the Zealots represented a breakaway from the majority of the Pharisees toward a more radical spiritualism, the desire to lead a pure life of obedience to God's will led the Essenes to withdraw from the Jewish community altogether. As an elect community of the pure, they established themselves at Qumran in the desert along the Dead Sea, where they tried to fulfill the Law in spirit as well as form. The Qumran community's library, the so-called Dead Sea Scrolls, was discovered in caves along the Dead Sea in the late 1940s.

A New York University expert on the Dead Sea Scrolls, Lawrence Schiffman, believes that the Qumran community was founded around 150 B.C. by a group of pious Sadducean priests who rejected Pharisaic canonization of the oral law. Believing themselves to be living in the last age, the Essenes, under the charismatic leadership of a "Teacher of Righteousness," practiced a highly disciplined form of asceticism. They held property in common. Some of the Essenes did not marry, and refrained from sex—a monastic disavowal unique in ancient Judaism.

The Qumran community represented a strenuous attempt to fulfill the prophetic demands for righteousness through obedience to the will of God. Yet, even in their own day, some saw Essenic activism as non-Jewish, influenced by ideas from Hellenistic philosophy and religion.

The proliferation of factions and sects among the Jews in the era of Roman domination reflects the extreme threat to the integrity of the Hebrew faith presented by the power and attraction of Roman and Hellenistic civilization. How far the Jews could collaborate with Roman power, how much they could compromise with Hellenistic

culture and still remain true to Yahweh and His Law, was the agonizing question they encountered daily. Giving additional force to this dilemma was the belief, widespread in Judea at the end of the first century B.C., that the final, crucial stage of history had been reached, that God was about to judge all the nations and particularly to call the Jews, His chosen witnesses, to account. Some kind of Messiah (Redeemer) would be God's chosen instrument to achieve these things.

Among the Jewish aristocrats, particularly those descended from the Maccabeans, there were collaborators with Roman power, and some Jews were powerfully attracted by the wonders of Hellenistic art, literature, and philosophy. The majority, however, under Pharisaic leadership, held out against both acquiescence to Roman rule and absorption into Hellenism. They marched to a different drummer and did not go the way of all the other peoples of the Mediterranean world. They continued to believe that, as God's chosen people, they had the duty to fulfill His will at all costs; their reward would come when the Day of the Lord occurred. This Jewish intransigence and separation, so irritating to the Romans, so repulsive to the Greeks, made the people of the covenant unique in the Mediterranean world.

Gentile commentators admired the Jews for their holy scriptures and their steadfast devotion to the Law of the covenant. Yet, the Jews were also regarded in the Mediterranean world as arrogant, subversive, and untrustworthy. The leaders of the Jewish community did not calculate the consequences of their removal from paganism. In their view, there was no other way to live than by the Halakah, God's Law, by which the covenant was fulfilled. In practice, this meant that many hundreds of thousands of Jews, especially those living in the Diaspora outside Judea, who found Mediterranean culture more meaningful and accessible than strict biblical teaching and Pharisaic law, drifted away and were completely assimilated into the surrounding population. The adherents of the covenant became the Orthodox voice of Judaism.

For the past 125 years, a legion of scholars, both Jewish and Christian, have tried to establish clearly the development of the Hebrew faith between King David and Jesus Christ, spanning the last millennium before the Common Era. The details remain uncertain in many aspects, and, in general, it is not a happy story.

But the prime ingredients of ancient Jewish history in the first millennium B.C. are evident enough: the priestly code of behavior pro-

mulgated by the kings and clerics who commanded the Temple in Jerusalem; prophetic pronouncements on ethics, universal history, and expectations of the future, which over time coalesced with the priestly code; the demotic experience of the Diaspora, beginning with the Babylonian exile, when divinity had to become less physically rooted and a communal synagogue became the prime place of worship of an immaterial God; and a belief in personal immortality and resurrection of the dead, which only filtered into Judaism in the two or three centuries before the Common Era.

Alongside these fundamental attitudes were messianic expectations. The Redeemer was either the Jewish people as a whole, "the man of sorrows," who vicariously suffered for and cleansed transgressions of the rest of mankind; or a charismatic individual, descended from the "Tree of Jesse" (House of David), who would restore the glorious, old, ramshackle monarchy; or some conflation of these two ideas.

By the later years of the first century B.C., these had become the key doctrines propounded by the Pharisees, whose successors were the teaching and judicial rabbis left standing after the destruction of the Second Temple in 70 A.D. and another massive forced exile of the Jews. Today we call this Pharisaic and rabbinical Judaism the Orthodox, or canonical (Halakic), faith. Even though in 100 A.D. (as today) the majority of Jews, probably a great majority, in the world were not full adherents or strict practitioners of Pharisaic-rabbinical-Orthodox Judaism, it is correct to call this "mainstream" Judaism.

At least two alternative forms of Hebrew faith existed alongside rabbinic orthodoxy: Essenic, apocalyptic, and mystical Judaism (as in the religion of Qumran, of the Dead Sea Scrolls), advocated vehemently by very small but intense minorities and a culture that in the Middle Ages and early modern times occasionally sought to unite with and embrace the Orthodox tradition; and the philosophic, Hellenistic, assimilated Judaism of the Alexandrian and other great eastern Mediterranean communities. Hellenistic Judaism resembles the liberal and Reform Judaism of today.

The threefold split in Jewish religious culture, which was to prevail into modern times, was already evident in the first century B.C. We call rabbinical Judaism mainstream because it is a direct outgrowth of the previous millennium of Jewish history. It has a closely held, deeply textured, continuous history down through the centuries,

and it flourishes today again in Jerusalem as well as in New York. In the first six centuries of the Common Era, it generated the Talmud, and it became the dominant religious faith and practice of the great Eastern European communities from the seventeenth century into the twentieth century.

Pharisaic-rabbinical Judaism was the faith and culture against which the other communities of believers measured and defined themselves. This was the core culture. Efforts are constantly made, both in learned treatises and in the sermons of Orthodox rabbis, as well as in suburban guidebooks on "Jewish literacy," to define the nature of mainstream Judaism. Yet the most insightful effort was made by the German Protestant sociologist Max Weber in 1906, in his book *Ancient Judaism.* It has never been superseded.

* * *

The most important characteristic of mainstream Judaism is that, unlike all the other religions of the ancient Mediterranean world, including Christianity, it does not involve magic. The word "magic" in anthropology means that some physical act, like a sacrament or faith healing or astrological calculation or touching of some object, is being used to bring divine assistance to mankind. Mainstream Judaism recognized only prayer and righteous conduct as a form of communication with the divine. It is true that for centuries animal sacrifices had been offered at the Jerusalem Temple altar, which is a low-grade form of magic. But the developing Pharisaic-rabbinical Judaism jettisoned the intercession of all magic to summon divine favor and help. Probably this nonmagical mode had begun in the two centuries between the First and Second Temples, when burnt offerings could not be made in Jerusalem. And, after 70 A.D., there was again no Temple. So, rabbinical mainstream Judaism had to rely on a purely spiritual relationship between God and the people of the covenant.

Yet the development of Judaism as a nonmagical religion was not only a reaction to the absence of the Temple and its altars. Ingrained in the prophetic tradition was God's disavowal of His pleasure in sacrifices and other magical rituals and insistence on the human supplication of God in purely spiritual and moral terms.

In 1960, Yehezkel Kaufman of the Hebrew University confirmed Max Weber's interpretation of ancient Judaism, when he wrote:

The religious idea of the Bible . . . is that of a supreme God who stands over every cosmic law, every destiny and every compulsion: unborn, uncreated . . . a God who does not fight against other deities or power of impurity, who does not sacrifice, predict, prophesy and practice witchcraft; who does not sin and needs no atonement; a God who does not celebrate the festivals of his life. A free divine will that transcends all that is—that is characteristic of biblical religion, and that makes it different from all other religions on this earth.

God is Who He Is—absolutely transcendent, and beyond effects of human magic to summon or influence, the eternally self-subsisting One. "Hear O Israel, the Lord our God, the Lord is One." This became the essential declaration of Jewish faith. This is probably not where Judaism started in the late second millennium B.C., but it was where it arrived in the Pharisaic, mainstream form by 200 B.C.

This antimagicality is the distinctive quality of the Hebrew covenant religion as it took its definitive form toward the beginning of the Common Era. This, too, is the ultimate reason for the rise of ideological anti-Semitism at the same time. By choosing, in their mainstream faith, a radical course different from the religion of all other Mediterranean communities, including the Christian one, the Jews challenged the legitimacy of these other cultures.

At some point in the Christian era, all Orthodox Jews became accustomed to beginning the day with a prayer of thanks that God had made them different from the Gentiles, even when—or especially when—the Gentiles had wealth and power and were persecuting or even exterminating the people of the covenant. Living under the covenant, in accordance with the Pharisaic-rabbinical-Orthodox faith, indeed made the Jews different from the Gentiles, "the peoples of the earth." The difference is obvious in circumcision, the dietary laws, and the observance of the Sabbath and the Day of Atonement.

The crucial difference lies also in a mentality, a consciousness that mainstream Judaism engendered. First, the Orthodox Jew had no physical or ritualistic crutch. He could not rely on a dying-and-reborn divine savior incarnated in human form, in a material sacrament to unite him with this savior God, in astrological calculation, in touching of sacred objects and other familiar facets of magic. He could rely only on the goodness and majesty of God. If bad things happened to good

people, the Jew had to accept these disasters and go on with living as best he could.

He had to rationalize a disaster in one of several ways. He, the Jew, was really at fault, after all. He had acted badly, if only by being too self-confident and self-righteous in his goodness, and Yahweh was rightly chastising him. Or, suffering was a learning process and an act of purification, and he, the Jew, would come out of it a better person and better able to fulfill God's commandments. Or, the suffering of the Jew was somehow for the benefit of mankind, a vehicle for communicating God's word to the Gentiles and a strategy for implementing God's mercy.

In the last two centuries B.C., these rationalizations for why the Jews suffer collectively and why bad things happen to ostensibly good individuals prevailed in the Jewish dialogue and were embedded in their consciousness. This "theodicy" (justification of the ways of God to man) was to have a very long and intense workout in Jewish history. There is no more continuous intellectual theme in the exercise of the Jewish imagination. All of Jewish history is a theodicy.

The second most critical ingredient of the mentality that mainstream Judaism engendered was historicity. For the pagan cultures of the ancient Mediterranean, the time was always now, always the eternal present. The Jew saw himself as part of a very long and tempestuous continuity reaching from the patriarchs to the present. Everything the Jew did he did in the context of his extended temporal dimension, replicating and perpetuating it, and interacting with it.

We have seen that Jewish historicity is a peculiar one, a backward-bending historical curve, in the sense that the details of historical information terminate with the early Maccabees. After that, the Jews still function very much within a temporal dimension, but the details of the post-Maccabean era in Jewish history are left mostly blank, because these details would arouse too many questions and too much controversy, some of it uncomfortable for the rabbis.

Jewish historicity has a plenitude, indeed a plethora of historical information about the earlier history of the Jews (much of it fictional or heavily romanticized), and a sparse deficiency for the post–early Maccabean era. This was the model of Jewish historicity that existed until the beginning of modern historiography in the early nineteenth

century, and this backward-leaning historical curve still conditions the sermons of rabbis of all persuasions.

The Jewish mindset also stressed community. No man was an island. The individual's acts were made significant in a group context. This attitude per se was far from unique; the Greeks insisted that we are all social or communal beings. The difference in Jewish thinking was that their community was temporal as well as spatial in dimension. Their community was on a move through time, on an unbroken pilgrimage route somewhere, sometime, to the end of days. Thereby, the community in which the Jew was immersed was not only the current large group but the whole retinue of the Jewish people through two millennia, from Abraham through Moses, David, and Jeremiah, to the present. Every act of every individual had to be imagined and judged in the perspective of whether it advanced or impeded the pilgrimage of the community through time.

The psychic burdens of theodicy and historicity were severe and unyielding. Anyone who had to rethink continuously and fundamentally the divine and historical significations and their relationship to personal feelings and present personal conduct would become stressed to the point of madness. The practical solution for everyday living that mainstream Pharisaic-rabbinical-Orthodox Judaism offered was minutely listed mitzvoth, or good point of conduct (ultimately, 613 of them), that codified the behavior of the devout Jew from the moment of waking in the early morning to falling asleep (and beyond) at night.

The tremendous psychic pressures of Jewish theodicy and historicity meant that this was a religion that rejected all the magical props of other cultures and faiths yet offered an extremely detailed, obsessive code of human behavior to make daily life endurable. Thus the great paradox of the covenant religion as both an extraordinarily liberating and a compulsively confining culture.

The tensions and distresses of living with God's covenant are recognized in the Bible. The Book of Exodus described how, while Moses was up on the mountain receiving tablets of the Law from God, "the people were out of control" and made an idol, a golden calf to worship, and Aaron, Moses' brother and the high priest, "had to let them get out of control." When Moses returned, in his fury, he not only destroyed the idol but also turned loose the Levites, the priestly tribe,

on the people, and the Levites proceeded to slaughter three thousand of them. There is obviously a downside to the eternally binding pact between God and His people. Break it and be slaughtered by Yahweh's priestly shock troops.

That Ezra and the final editors of the Bible let this violent story stand indicates their attitude to those in the Jewish community who visibly violated the covenant. There will be covenant breakers, the redactors were saying—the people will get out of control. Punishment must be used to restore discipline when necessary and where possible. This is a realistic assessment of the difficulty of maintaining the covenant.

Ezra and the redactors of the Bible also let stand in Genesis the chilling story of the sacrifice of Isaac, to communicate the demand enforced on every Jew to accept Yahweh's dictates, even if they are inhuman.

The scribes and rabbis also included in the biblical canon the late work Ecclesiastes (Ko Hi-Lot) with its deep pessimism:

> *A season is set for everything, a time for every experience under heaven . . . A time for being born and a time for dying . . . A time for crying and a time for laughing . . . A time for loving and a time for hating . . . I realized that the only worthwhile thing there is for men is for them to enjoy themselves and do what is good in their lifetime.*

Some modern commentators have seen Ecclesiastes as an anomalous work in the Hebrew Bible. It is held to reflect the fatalistic sentiments of Stoic philosophy and so was a product of Hellenistic influence on Jewish thought. But it conforms to the fatalistic sensibility behind the story of Isaac's sacrifice. It does not seem to be outside the parameters of Pharisaic mentality.

Similarly, the whole of the Book of Job, written probably around 300 B.C., is devoted to the problem that covenant theology raises. Why do bad things happen to good people? It never really answers this question. In the end, a voice comes out of the whirlwind and tells the distraught Job to shut up, have faith in God, and stop whining. At the end of the book, an epilogue (probably by a later author) restores Job to his wealth and health. The immensely learned historian of Hellenistic Judaism, Elias J. Bickerman, calls Job, along with Ecclesiastes, one of "the four strange books of the Bible": What is it doing there in the

canon, raising contrary anxieties? The rabbis must have had enough of such concerns themselves to put Job in the Masoretic canon.

The fifty-third chapter of the Book of Isaiah (written by Deutero-Isaiah in Babylonian exile around 523 B.C.), which later so excited the disciples of Jesus of Nazareth, tries to explain the suffering of the Jews as the means of mankind's redemption:

> *He was wounded because of our sins, crushed because of our iniquities, he bore the chastisement that made us whole, and by his bruises we were healed.*
>
> *And the Lord visited upon him the guilt of all of us . . . He bore the guilt of the many and made intercession for the sinners.*

So in imposing the covenant unilaterally on the Jews, God was going to use this people as "a sheep led to the slaughter," says Deutero-Isaiah, a sacrifice for mankind "that through him the Lord's purpose might prosper." By the covenant, the Jews not only are given a hardship post in that they are meant to bear the agonies of life without the therapeutic relief provided by magic but also are sent on a sacrifice mission for the benefit of the human race.

This is a hard message, but, again, a realistic assessment of reality. The Jews are not powerful. They will be beaten down by the great forces, by the megaton empires. The covenant means sacrificial suffering. Be prepared to endure it in God's Holy Name.

The idea of covenant is as far as you can get from romanticism, although today, in American suburban synagogues, it is normally interpreted in an upbeat, sentimental manner. The old rabbis knew better. They knew what the Jews were in for in the long pilgrimage through Gentile territory. Their realism prepared the Jews to face their difficult and, at times, cruel destiny. Only this kind of tough-minded, realistic temperament could have preserved the people of the covenant down through the centuries of defeat and Diaspora.

The 74th Psalm frankly recognizes the hatred that the Jews incur on all sides from the Gentiles:

> *Your foes roar inside Your meeting-place . . .*
>
> *They made your sanctuary go up in flames: They brought low in dishonor the dwelling-place of Your presence . . .*
>
> *burned all God's tabernacles in the land.*

Shoah, destruction, holocaust, is an ever-present prospect for the Jews. Nor can God's people find solace anymore in the preaching of the new prophets. The age of the prophecy is over:

No signs appear for us; there is no longer any prophet; no one among us knows for how long.

A deep social pessimism, an awareness of ever-impending disaster is central to the ethos of Pharisaic Judaism. In response, mainstream Judaism fashioned a defensive code of behavior, a wall of religious law, against the consequence of the Jew's sacrificial and redeeming role in history. The Torah separated the Jews from the goyim, the other peoples of the earth, by insisting on circumcision of all males, by mandating complete rest from labor every seventh day, by implementing an elaborate system of dietary taboos, by calling for fasting on the Day of Atonement.

In addition, after the return from Babylonian exile and the building of the Second Temple, requirements were imposed that all males engage in communal prayer each morning and evening, that all male children be sufficiently educated to read the Word of God in the holy scriptures, that the primal creed ("Hear, O Israel, the Lord our God, the Lord is One") be placed in a mezuzah (ornamental box) fixed on the doorposts, and that word similarly be placed in a phylactery (leather-covered box) that hung between the eyes during morning prayer.

Writing in 1979, Jacob Neusner, one of the most learned and prolific of the new wave of Jewish studies scholars on American campuses, stressed the centrality of prayer as the way of the Torah:

Life under the law means praying — morning, evening, at night, and at mealtimes, both routinely and when something extraordinary happens . . . The way of the Torah is the way of constant devotion to God.

In the mainstream, Orthodox tradition, a good Jew is a penitent *Ba'al T'Shuva*, a master of penitential prayer.

A religion based on a diurnal discipline of frequent prayer, unmodified by magic ritual, forms a temperament characterized by determination and reticence. What is to be done is known by the prescriptions of the written and oral law. God is beseeched to fulfill the covenant by rewarding good behavior and refined sentiments.

But God is too transcendent to be predictable. There is faith but no assurance that individual fulfillment of the Law will produce personal blessing. There is no known practical alternative to beseeching Yahweh the Good, One, and Omnipotent, to succor and reward.

Constant prayer has embraced the individual in a behavior pattern and a sensibility that is the core of personal being, and such a program of prayer persists and sustains even in the face of personal defeat and disappointment and seeming injustice. Prayer for the observant Jew also has the effect of encouraging communal action. The more elaborate and full schedule of prayer only occurs in a minyan, a group of ten adult Jewish males, fostering group dialogue and comity.

* * *

Looking outward, from the individual to group solidarity, was also stressed by the Pharisees' confirmation of the prevailing prophetic injunctions toward social justice. Mainstream Judaism did not condemn competitive business enterprise, the holding of slaves, the accumulation of wealth, or a hierarchic class structure. Since the absence of magic left the individual to make rational, purely human choices for himself, Judaism produced a mindset that was highly conducive to market enterprise based on calculation of rational choices. Judaism and capitalism were fully compatible.

But there were heavy communal demands that the strong, affluent, and fortunate exercise charity (tzedakah) toward the weak, poor, and downtrodden. The widow, the child, the physically afflicted were not only to receive substantial aid but also to be treated with dignity. Poverty and affliction were never to be shamed.

Mainstream Judaism allowed for capital accumulation but imposed strictures on the rich, not only in terms of charitable giving but also by demanding postponed gratification and condemning conspicuous consumption and personal indulgence.

The prophets and, later, the rabbis were deeply concerned with the social and moral consequences of the flaunting of wealth and of the humiliation that accompanies poverty. Their psychological insight into the culture of poverty was a keen one, and they sought to excise such a downside cultural aspect from the Jewish community, whatever its modest economic circumstances.

The leaders of the Jewish community, the masters of prayer, the redactors of the Bible, the rabbinical interpreters of the Law, were all

males, whereas in many pagan religions, including the Roman, priestesses played an important role. Circumcision, the mark of the covenant, was a Jewish male rite. Pharisaic Judaism honored women as mothers and daughters, but, essentially, it placed women in a secondary and marginalized position within the family and community. To the present day, Orthodox Jews in their daily morning prayer thank God not only for not making them Gentiles, but also for not making them women. The Halakah is very adamant about preventing sexual intercourse with a menstruating woman. A woman in the full exercise of her sexuality is taboo.

At the beginning of the first millennium B.C., as was common in the ancient Near East, there likely were priestesses in Israel, presiding over local altars. In the age of the judges, there were women military and political leaders. The Book of J, the core narrative of the Pentateuch, may have been written by a royal princess, and it accords with a feminine mentality. By 150 B.C., when Pharisaic Judaism had fully crystallized, there was no social or intellectual leadership of women within the religious community, and assertive and prominent women in royal families in the later decades of the era of the Second Temple were not fondly viewed by scribes and rabbis.

To the present day, the architecture of Orthodox synagogues preserves the ancient rabbinical propensity toward the marginalization of women in the Jewish community. Women sit in a segregated balcony, separate from their husbands and sons. In mainstream, Orthodox Judaism, women may not be at the back of the bus, but they are segregated in the synagogue. Orthodox Judaism is tolerant of divorce, but it is granted only to males. Wives on their own cannot obtain divorces.

Pharisaic Judaism insists that descent in the Jewish community comes through the mother—to be a Jew, the Orthodox still insist, you must have a Jewish mother. This is sometimes cited as evidence of the high esteem in which women are held in the Jewish community. But it actually reflects toleration of the double standard of sexual behavior, so alien to women's equality. Because men in ancient Israel produced children by relations with Gentile slaves and concubines, the only way in which purity of Jewish blood could be scrutinized was by the rabbinical ruling that Jewish descent had to go through the legitimate Jewish wife. Unless a Gentile wife of a Jewish male converted, her children were not regarded as Jews.

The husband was relatively free to have sexual contact with part-

ners other than his wife, and this frequently involved Gentile women. These *mamzerim* (bastards) whose mothers were Gentiles were excluded from the Jewish community. It was a nice question for later rabbinical courts whether bastards engendered by adulterous relations between Jewish men and Jewish women were full and equal members of the Jewish community. Most courts said no.

In return for the burdens and strictures of living according to the covenant and Halakah, in return for being God's witness in the world, a light to the nations, and a sacrificial lamb to cleanse mankind, what did mainstream Judaism have to offer in the way of reward to the prayerful, observant Jewish male? The following: that God would give the Jews the land of Israel; that the seed of Abraham would be fruitful and multiply; that the observant Jew would feel satisfied he was a righteous person walking in the way of the Lord; that he belonged to a community, a people who were something special, who were separate from the Gentiles, and divinely designated.

That this reward system in ancient Judaism was not entirely adequate to compensate for the burdens of the covenant is indicated by the quiet acceptance into the rabbinical mainstream, after 200 B.C., of the widespread Near Eastern belief in personal immortality and resurrection of the dead. This was not a doctrine vehemently preached among the Jews. It was more like a concession, marginally allowed to the anxious masses by their religious leaders. Personal immortality has rarely been vigorously propounded in the Orthodox tradition; it is more of an add-on reward, a bonus, than a prime inducement to observance of the covenant.

The only clear statement about the resurrection of the dead in the Bible occurs in the Book of Daniel, the last work in the Masoretic text to be written, about 160 B.C., during the Maccabean revolt: "Many of those who sleep in the dust of the earth will awake, some to everlasting life and some to the reproach of eternal abhorrence." This tepid statement indicates how awkward, tardy, and undeveloped was the intrusion of personal immortality into ancient Judaism.

The burdens and sacrifices of being a fully observant male Jew cannot receive adequate reward within mainstream Judaism. You are a Jew because God chose you for this role in history and society, not because of the compensation system.

The belated introduction into Pharisaic Judaism of the doctrine

of personal immortality as compensation for the suffering of the just person in this life did not fit easily into mainstream Jewish belief. Contrary to Hellenistic and Persian beliefs, the Bible does not separate the soul and the body but rather conceives of *nefesh*, the integrated human being. Personal immortality raised the issue of dividing soul from body, which generations of rabbis and philosophers now had to contemplate, without clear consensus.

The essential idea of Pharisaic Judaism is not expectation of reward through immortality but complete faith in the majesty and goodness of God, as affirmed in the tragic heroism of the Twenty-third Psalm:

> *The Lord is my shepherd; I shall not want . . .*
> *Yea, though I walk through the valley of the shadow of death, I will fear no evil . . .*
> *Surely goodness and mercy shall follow me all the days of my life; and I will dwell in the house of the Lord forever.*

Mainstream Judaism that developed after 600 B.C. had such strong and positive qualities that, short of physical elimination of the Jews, it was almost bound to continue and to evolve after the destruction of the Second Temple by the Romans in 70 A.D. Indeed, in the midst of the ill-fated Jewish wars against the Romans in the first and early second centuries A.D., the austere Orthodox rabbis, led by Yochanan Ben Zakkai, secured from the accommodating Romans permission to set up religious schools elsewhere in Judea even as the Romans assaulted Jerusalem, destroyed the Temple, and dispersed the population.

This withdrawal of the rabbis from the political fate of the home-land was the end result of what was already clear in the first century B.C. Pharisaic Judaism was a self-sufficient culture and a kind of mobile religious and moral tabernacle that could function autonomously and perpetually almost anyplace where Jews had a modicum of physical security and economic opportunity. This was to be the single most con-tinuous and important theme in Jewish history until modern times, the sacred chain that binds the generations together.

But the downside of mainstream Judaism was also evident in the last two centuries B.C.—the very severe demands it made on its adher-ents and the psychological stress and social difficulties under which it

put them. This meant that alternative forms of Judaism would be sought within the homeland, and in the already large Jewish Diaspora in the eastern Mediterranean there would almost inevitably arise a more liberal and softer kind of Jewish faith that would make life easier for its followers and allow them a greater measure of participation in Gentile culture and society.

The outcome of the first era of Jewish history, down to the beginnings of the Common Era, is, therefore, a deeply ambivalent one. That is not the way it is taught today in synagogue schools or articulated from Jewish pulpits. In these forums, the Bible's second millennium B.C., from Abraham to King Saul, is treated as straight history; King David and King Solomon are extolled as splendid rulers and fascinating people, and even the succeeding long period of disunity, defeat, exile, and return only to experience further alien conquest is presented in a highly upbeat fashion, culminating in the Maccabean triumph, which, since 1967, has been viewed through the triumphalist prism of the Six-day War and other Israeli gains.

The best and most dispassionate historical scholarship, however, greatly deflates the authenticity of this traditional perception of early Jewish history. The first millennium of Jewish history, as presented in the Bible, has no empirical foundation whatsoever. It was made up later, as a work of imagination, and shaped by doctrinal and political needs. King David lived, but the colorful figure in the Bible can only be validated to the extent that he was just another small-time, modestly successful, Near Eastern ruler. The glorious imperialist Solomon, builder of the Temple, also existed, but, at the very least, the Bible inflated a second-rate Near Eastern monarch to one who operated at a very high level of grandeur, power, and wealth. This cannot be confirmed, and it is highly unlikely.

Circumstantial Jewish history, which has many gaps but also strong, empirically sustainable segments, begins with Solomon's death in 931 B.C. and the split into the two kingdoms, north and south. Thus, authentic ancient Jewish history begins with an event of negative value, the start of political decline, and with two exceptions—first, the return from exile under Persian auspices, the building of the Second Temple, and the completion of the text of the Bible under Ezra; and second, the early triumphal years of the Maccabean dynasty

before it crumbled into corruption and decay—this long history is neither happy nor glorious.

Yet, out of this millennium of frequent political defeat and only occasional social progress emerged a thick culture of mainstream Judaism, around which subsequent Jewish history turns and develops.

Pharisaic-rabbinical Judaism also slowly fomented an ethnically identifiable people—a nation grounded in blood, Martin Buber called it in the early 1920s, before the rise of Nazism made such racial discourse politically incorrect—out of the motley array of Canaanites and other Near Eastern peoples who lived in ancient times between the Golan Heights and the Negev Desert.

Within Judea, the consistency of Jewish ethnic stock after 100 B.C. was not mitigated by a significant number of conversions from the Gentile population. Pharisaic Judaism welcomed converts, but within Judea, among the urban population of Greek-speaking Gentiles that the Romans established along the Mediterranean coast, its efforts at proselytizing were only mild and haphazard.

Full conversion of Gentile males to Judaism was rare because of the painful and hazardous requirement of adult circumcision. Occasionally, an observant Jewish male married a Gentile woman convert, and, as the rabbis today never stop telling us when they find themselves on multicultural panels, one of the lesser books of the Masoretic Bible is devoted to the story of such a convert, Ruth the Moabite, whom biblical legend embroidered into an ancestor of King David. But the strictures of life according to the Law and total rejection of part-Gentile children of Jewish males from the community of the faithful (unless they converted), meant that, over time, observant Jews became an extremely endogamous group, marrying within a very limited circle.

Consequently, by the beginning of the Common Era, Jews who observed the written and oral Law were not only a compactly organized social and religious group, but also had become an ethnically homogeneous people, separated by blood, as well as culture, from other peoples.

In origin, the Jews may very well have been merely a sectarian or subversive subgroup among the Canaanites. But, in time, they had become a distinct race, an ethnic group.

Around the year 1000 B.C., there was nothing distinctive about the Jews ethnically, linguistically, politically, or economically. They were one among several small groups in the eastern Mediterranean, and their behavior and structure in these social categories was typical of that part of the ancient world. What distinguished the Jews by 800 B.C. were the essentials of their religious experience and expressions that were beginning to emerge.

By 500 B.C., this religion had become elaborately articulated into biblical Judaism and continued to develop in Babylonian exile. Half a millennium later, at the beginning of the Common, or Christian, Era, the now-established text of the Bible, combined with the traditions of oral law as interpreted by the scribes and teachers who comprised the Pharisaic rabbis, spoke for a nation distinctive ethnically and genetically as well as spiritually—a people bound together in both blood relationship and cultural forms.

All Ashkenazi males (European Jews outside the Iberian Peninsula) carry the same genetic makeup.

Athens

*N*ineteenth-century writers, and neoconservatives today, see Western civilization as the confluence of two great intellectual streams, Hellenism and Judaism, the way of life of the Greek polis (city-state) led by Athens, and teachings of the Hebrew Bible. There is enough plausibility in this traditional view to give it authority. Each fall, on thousands of American campuses, students are given this paradigm. Ancient Judaism and Athenian culture join together as the mainstream of Western civilization. But, looking at Athens more closely, one is impressed by how different the Athenian experience was from that of the Jews, how distinctive Athenian history and teachings were from the peoples of the Ancient Near East.

Although war with its neighbors was a fact of life for every Greek polis, in the first three decades of the fifth century B.C. these conflicts were dwarfed in importance by a major threat to the independence of all Greek cities. The empires of the Near East had for centuries been so busy fighting one another that they were little concerned with Greek affairs. The cities of Ionia had succumbed to the rule of the Lydian Empire, but the only burden they bore was an annual tribute. Control over their affairs was loose as long as they were friendly to Lydia, and there was no interference with their vital trade routes to the Black Sea. However, the situation in the Near East changed drastically in the last half of the sixth century. One power, Persia, under the leadership of Cyrus the Great and his successor, Cambyses, virtually conquered the entire area. With the defeat of Croesus, the king of the Lydians, the cities of Asia Minor came under the Persian yoke, and the cities of mainland Greece were practically contiguous with this colossal power.

A crisis was not long in coming. In 499 B.C., Miletus, one of the Ionian cities, revolted and asked for aid from the Greek poleis. Sparta

refused to become involved, but Athens and Eretria sent a force of twenty ships. The revolt was not easily crushed, and the Milesians, with the help of the Athenian fleet, managed at one point to sack Sardis, the provincial imperial capital of Persia. The Persian king, Darius the Great, was outraged, and when the revolt was finally put down in 493 B.C., he resolved to punish the troublemakers on mainland Greece. Fortunately for the outmatched Greeks, the first punitive expedition was destroyed in a storm off Mount Athos in 492 B.C.

However, Darius did not forget the Athenians, and, two years later, a formidable Persian force moved out across the Aegean Sea toward Greece. Athens desperately asked Sparta for aid, but, because of religious proscriptions surrounding the festival of Apollo, the Spartans would not fight until the new moon. The Athenians, with the aid of almost a thousand men from Plataea, were left to face the invading Persian force alone. Luck and strategy were on the side of the Athenians, and their superior discipline, heavier armor, and skill at infighting proved decisive. After their fleet landed at Marathon, the Persian army had to face the sudden charge of the Athenians. In order to meet the larger Persian force, the Athenian commander, Miltiades, stretched the center of his line thin and placed heavily concentrated forces at its ends. The Persians soon broke through the weak center, only to be trapped between the two Athenian flanks. In panic, the Persians ran for their ships. The rout was complete, costing the Persians more than 6,000 dead against only 192 Greeks lost. The Persian fleet returned to Asia, and the Athenians had miraculously saved Greece.

Fortunately for Athens, the Persian Empire had trouble elsewhere in its vast domains and Greece had a breathing space of ten years before the next Persian onslaught. It was clear that neither Darius nor his successor, Xerxes, had forgotten the Greek problem, however, and the Greek poleis spent that time preparing for the worst. The discovery of rich silver deposits on Mount Laurium gave Athens a sudden surplus of wealth. It was first suggested that this be divided among all the citizens of Athens, but the Athenian leader Themistocles was able to persuade the polis to invest in a large navy instead. When the Persians came again in 480 B.C., they had to face a strong naval power and also, for the first time, a Greece united, in the Panhellenic League under the leadership of Sparta.

The Greeks did well to brace themselves, for Xerxes had amassed the full resources of the Persian Empire against them. In addition, he was able to render many of the cities on the periphery of Greece worse than useless to their mainland counterparts. Ionia was under Persian control, and polis after polis in northern Greece submitted to Persian demands and added their forces to the Persian army. In the west, Xerxes probably formed an alliance with Carthage to obtain Carthaginian support by means of an attack on Sicily and southern Italy. The Greek colonies there would be of no help to the Panhellenic League.

The size of the Persian force necessitated a land route; the Hellespont was bridged with ships to allow the army to cross into Europe. A mighty fleet helped to provision the army. In the year 480 B.C., the Persians swept down the Greek mainland and the fleet arrived off Euboea. The Greeks decided to attempt to stop the Persian advance on land at the narrow pass at Thermopylae. It was the responsibility of the Spartans to defend this pass, but, once again, the festival of Apollo interfered, permitting the dispatch of only King Leonidas and the three hundred men of his royal guard. Leonidas was supported by perhaps seven thousand allied troops, but when his position was outflanked by the Persians, he sent them away and remained with his small force as a suicide rear guard. Displaying the highest ideal of Spartan courage, the small force stood its ground against the huge Persian army and perished to the last man. Although the Spartans held out for several days, the Persians finally moved out onto the Attic plain.

At the same time, the Persian fleet, still formidable despite the loss of about six hundred vessels in two disastrous storms, came down the coast to join the army at Athens. Sparta and the other Peloponnesian cities wanted to retreat behind fortifications on the Isthmus of Corinth, but the Athenians refused. They abandoned the city of Athens and the Attic countryside to the ravages of the invading army, removing the population to the island of Salamis. The brilliant Athenian leader, Themistocles, enticed the huge Persian fleet into the narrow waters between Salamis and the mainland. When the Greek and Persian fleets engaged in battle, the vast number of Persian ships caused chaos and disarray, and the smaller Athenian force easily out-maneuvered the cumbersome Persian fleet. The battle of Salamis lasted all day, but at sundown the Persians were totally defeated.

Leaving a hand-picked force of perhaps seventy-five thousand professional soldiers under his commander Mardonius, Xerxes returned to Asia with the remainder of his army. The following summer, Mardonius swept across the Greek mainland and invaded Attica again, but Spartan courage at the battle of Plataea in 479 B.C. finally defeated the invaders. At the same time, the Greeks defeated the Persians at Mycale, on the shores of Asia Minor, freeing Ionia from Persian control. Since the western Greek colonies had been able to withstand the onslaught of Carthage, the entire Greek world was left free and unmolested, for a while at least.

* * *

There was, of course, no certainty that the Persians would not be back; they had been repulsed and even driven out of a vast portion of the Mediterranean, but the bases of their power were still untouched. The Greeks, in fact, expected another attack and lost no time preparing for it. It was obvious that the first essential was unity, but unity among the myriad independent poleis of the Aegean world seemed unattainable. Each polis was, insofar as possible, a self-contained and self-sufficient economic and social unit, separated from the others by variations in custom, dialect, and religious practices. These conditions encouraged the natural autonomy and competitiveness of the poleis rather than their interdependence; long-term cooperation would require very unusual circumstances. In this case, the Persian threat seemed to provide the necessary incentive, and Athens, the emergent naval power of the Aegean, was ready to provide the essential leadership.

Sparta and Athens—unquestionably the two most powerful Greek states and the natural leaders in any military enterprise—differed somewhat in their approaches to the Persian threat. Sparta was, as always, conservative and defensive. It put great faith in the wall across the Isthmus of Corinth, which was built during the war. From behind this wall, the Spartan army hoped to hold off a Persian invasion and save the Peloponnesus. But the success of this plan also required command of the seas to ensure that the wall could not be outflanked. To this end, Sparta and its allies withdrew the bulk of their forces from the Greek fleet, although certain Spartan forces did remain in the field. The Spartan defense solution had little to offer the Greeks north of the Peloponnesus, on the islands of the Aegean Sea, or on the coast of Asia

Minor; Athens, on the other hand, had trading interests throughout the Greek world, which it was determined to protect.

In 478 B.C., delegates of the Aegean Greek states met to form a defensive alliance—the Delian League. A levy on all members, of either ships or an equivalent amount of money, was used to finance a large fleet, which, under Athenian command, was to protect all members. The treasury of the league was established at Delos, and it was decided that an assembly would meet once a year, each polis having one vote. In actuality, the league was not much more than a paper alliance, except that Athens had exclusive control over the navy.

Athens was a very effective leader of the Delian League. It cleared the Aegean Sea of pirates, making trading safe at last. It adopted a rather aggressive policy toward Persia, and, at every opportunity, pushed the Persians back from the eastern shores of the Aegean Sea. Finally, after Athens had lost two fleets trying to help an Egyptian revolt against Persia, the two great powers were able to agree on a line of demarcation. Persia and Athens concluded the Truce of Callias in 449 B.C.

Persia was having trouble elsewhere in its empire and was glad to be relieved of Greek pressure on its borders. The Athenians, meanwhile, were happy to devote themselves to maintaining the league, which was rapidly becoming an empire. Secession from the league was prohibited, and the treasury was moved to Athens and incorporated into the Athenian treasury. Most member states were required to contribute money rather than ships, thus assuring Athenian control over the type and number of league vessels. (At the time this decision was made, most of the allied states preferred to send money, since that was easier than providing ships.) All disputes involving Athens had to be tried in Athenian courts, and Athens often interfered in league members' local politics, usually in favor of democratic factions. The league assembly, which had never functioned effectively, stopped meeting at all, and, finally, Athens attempted to standardize coinage and weights among members. Some of the money that Athens obtained from the Delian League was applied to the construction on the Acropolis. The establishment of Athenian bases throughout the Aegean was an index of Athenian dominance. The members of the expanding Athenian empire were rapidly being transformed into quasi-independent states. Athens had become a world power.

* * *

What had become of the quiet Attic farming community of the seventh century? The rural Attic countryside continued to exist—never more than one third of the population of Attica lived in the city of Athens— but it now had in its midst a bustling cosmopolitan metropolis. Athens became the center of the Greek world. Not only did Athenian ships dominate the Mediterranean, but poets, artists, intellectuals, artisans, people of all sorts, flocked to the city. The income from expanding trade, from the empire, and from the silver mines of Mount Laurium flowed into Athens, swelling private and public coffers.

In many ways, Athens was a new city, most of all in appearance. Twice, the Athenians had seen portions of their city razed by the Persians. The first task undertaken by the Athenians returning from the Persian Wars was the construction of a formidable wall, first around the city itself and then around Piraeus (the Athenian port five miles away). Then long walls were built, connecting Athens with Piraeus to provide Athens with ready and protected access to the sea. Having secured the city, the Athenians turned their attention to the reconstruction of the Acropolis. Funds from the Athenian treasury and from the treasury of the Delian League were used to underwrite contracts with sculptors, architects, artisans, contractors—the best in the Greek world. In an incredibly short time, the Parthenon and other temples and public buildings were constructed on the Acropolis, a monument to the preeminence of Athens and to the commitment of Athenian culture to artistic excellence.

In contrast to the city's public buildings, the private dwelling of an Athenian was astonishingly simple and unadorned, even if he was a rich man. This was indicative of the simplicity that permeated the life of an Athenian, including his dress and diet as well as his home. In fact, extravagance was looked down upon and sometimes, as in the case of the regulation against expensive funerals, even prohibited by law.

The Athenian household comprised the citizen's wife, his children, and, if he was wealthy enough, perhaps a few slaves. The slaves did household work, accompanied their master shopping to carry home his purchases, and did other menial chores. If the Athenian citizen was an artisan or small manufacturer (there was no large-scale production in Athens), he might have a few slaves working for him. If he was a farmer, he might have tenants doing the work, or, in a few cases,

slaves. But slaves were not used extensively by the average citizen. They were not economical in the typical simple household, and most Athenians worked in their factories or on their farms either alone or with only a few slaves. With the exception of those who worked in the silver mines, the slaves of Athens, who made up about 25 percent of the population in the fifth century, were well treated; in fact, it was said that they could hardly be distinguished from freemen.

The wife of the Athenian, his daughters, his sons under the age of seven, and his female slaves spent most of their time in the women's quarters. The wife ran the household, but she took little part in the life outside it; she seldom went out in public or took part in any social life. When the Athenian got together with his friends, the only females present were likely to be hetaerae, or professional courtesans. The widespread practice of bisexuality also tended to minimize the role of wives in the social affairs of the Athenians. True friendship was between equals, and women were considered naturally inferior, not only legally but intellectually and emotionally as well.

When an Athenian boy reached the age of seven, he left the women's quarters to take his place in the male, public world of the polis. If he was the son of a poor man, he was educated in the occupation of his father—the extent of his formal education was a private matter, not a concern of the state. The son of a wealthy man received instruction in reading, writing, calculating, music and harmony, and Homer and the lyric poets; equally important, he underwent rigorous physical training. Sons of well-to-do citizens were trained in the art of warfare, either as heavily armed infantrymen or, if they were very wealthy, as members of the cavalry. Sons of poorer citizens would either serve in the lightly armed infantry or possibly row in the navy. After two years of military service (which became compulsory in the late fourth century B.C.), the young Athenian citizen was ready to assume his full place in the life of the polis.

Unlike all other groups in the state—foreigners (*metics*), those born of foreigners, slaves, women, and children—the 40,000 to 45,000 Athenian citizens were responsible for the direction of the affairs of the state, and for its defense. The burden rested on *all* citizens. By the middle of the fifth century B.C., the Athenian polis was governed by perhaps the most direct democracy that has ever existed. Its fundamental

assumption was that, in a total population of 250,000, roughly 40,000 men, taken from all sorts of income levels, could, in concert, make all decisions affecting the state and carry them out effectively.

The Assembly met frequently and on a regular basis, and all citizens were free to attend and to speak. Proposals were voted on by all who were present at the Assembly. The Assembly could examine every aspect of government, and from its decisions there was no appeal; its will was taken to be the will of the polis. The Assembly decided the policies and activities of the state and scrutinized the performance of all public officials, who were regularly required to render an accounting to the Assembly. Anyone in charge of public funds—from Phidias, the sculptor who worked on the Parthenon, to Pericles, the politician—might at any time be called to give an account. Generals could be punished with exile for faulty leadership in battle.

Even these stern measures were not considered sufficient to secure the polis from subversion. The Athenians devised a means to suppress any person whose activities endangered the polis, even though he could not be classified as incompetent or treasonous. At specified times, the Assembly could decide to hold an ostracism. Every citizen could then write on a ballot the name of anyone he thought dangerous to the state. Any man who received more than six thousand votes was sent into exile for ten years, but he was not dishonored, nor did he lose his property. On many occasions in its history, the Athenian demos thus rid itself of men who had become so powerful that they represented a threat to the independence of the state.

The executive organ of the Assembly was the Council, which was composed of five hundred members (fifty from each tribe) chosen by lot. Anyone could serve on the Council, but no man was eligible to serve more than two one-year terms during his lifetime. It was likely, therefore, that any Athenian citizen who really desired the office would serve at least once. The Council was divided into committees, at least one of which was always in session, which meant that its members ate and slept in the public buildings during their time in office. Each day a president was chosen by lot from the committee on duty to serve as chairman of either the committee, the Council, or the Assembly, whichever was in session. An Athenian chosen for this duty could serve only once; for his one day he was the head of the Athenian state. Most

of the work of government was carried on by the committees of the Assembly.

The only important officers in the state not chosen by lot were the board of ten generals, one from each tribe, who were in charge of the military operations of the polis. They were chosen by the Assembly for one-year terms and could be reelected any number of times. A general held a very powerful position that combined military and political pre-eminence; but he could be removed from office by the Assembly. Thus, while generals often served a number of consecutive terms, a man could find himself a general one day and an ordinary cavalryman the next.

It was a fundamental Athenian belief that the greater the number of people who discussed and considered the affairs of state, the more likely that the decisions made would be just. For the Athenians, justice meant freedom from the influence of private and particular interests and from the corruption of the public weal, which would surely result if those interests prevailed. The will of all the people was supposed to represent what was best for all the people, and the most complete expression of this will would lead to the public good.

The Athenian legal system illustrates the depth of their belief in this principle. Law, the basis of right action, was decided upon by the will of the Assembly. The administration of law was also entrusted to all the citizens. Juries were chosen by lot, and they varied in size from 101 to 1001, depending on the importance of the case. Magistrates merely prepared the case for the jury; then both sides were heard. The plaintiff and the defendant had to appear in person and present their own cases, although they could hire speech writers. There was no appeal from the jury's decision on the case, since the jury was held not merely to represent the polis; for the purposes of the case at hand, it *was* the polis.

How could a miscellaneous body of 40,000 men, rich and poor, stupid and intelligent in varying degrees, govern not only themselves but a metropolis of about 250,000 people and an empire of about five hundred separate poleis, and carry on an effective and consistent foreign policy toward both Sparta and Persia? The Athenians had no large bureaucracy, no permanent or semipermanent executive. Why did not factions, indecision, incompetence, and apathy render such a system as

ineffective in practice as it is unwieldy on paper? The fact is that the Athenian government did have problems. At times, it was rash; for brief periods, factions did threaten to undermine it. For the most part, however, it was an effective system, and the polis and the empire were well governed. Persia was kept at a distance, and, for a time at least, Sparta was held in check.

Such a system could not have functioned without sound and effective leadership, and a number of very able leaders did, in fact, emerge in Athens. They did not hold office as heads of state, but they were the men to whom the Assembly listened and whose judgment was trusted. The greatest Athenian leader was Pericles, a member of an old aristocratic family, who was the de facto leader of the Athenian government from about 443 B.C. to his death in 429 B.C. During that period, he served as chairman of the board of ten generals, but, in fact, he decided and carried out most of the policies of the Athenian state, with the support of the Assembly. Other leaders emerged as his allies; some opposed him. Although Pericles once received a heavy fine from the Assembly, and his authority was never absolute in Athenian government, his party was certainly paramount. It was Pericles who advocated building the Parthenon and other public buildings on the Acropolis, and it was Pericles who determined Athenian policy toward Sparta. His patronage of artists and intellectuals helped make Athens the cultural center of the world. His death during a plague epidemic was a great blow to Athenian democracy, for no one was ever able to fill his place.

In addition to able leadership, there was another, perhaps more significant, base upon which Athenian democracy rested. Since the state was governed by the direct participation of all citizens, its nature was that of a conglomeration of miscellaneous human atoms; but then Athens was no mere city. It was a polis; its citizens felt themselves to be integral parts of a unified community that possessed and adhered to a specific set of high ideals and ambitious aspirations. The polis permeated the life of every individual. An Athenian was a member of the polis by birth, and the other citizens were his kinsmen, theoretically at least. His gods were the polis gods, and his crime could bring punishment to the entire polis. The polis was an object of personal pride: the glories of Athens—the empire, the Acropolis, the festival of Dionysus—all were

the personal glories of each Athenian. While his community allowed him great personal freedom, no individual ever imagined that he had any meaningful identity outside the polis. The Athenian embraced the values and ideals fostered and respected by the polis as his own; he thought of himself—as Aristotle was to say—as a "polis being."

In his famous "Funeral Oration," Pericles outlined the concept of citizenship that made the Athenian polis unique:

> *We cultivate refinement without extravagance and knowledge without effemi-*
> *nacy; wealth we employ more for use than for show, and place the real disgrace*
> *of poverty not in owning to the fact but in declining the struggle against it.*
> *Our public men have, besides politics, their private affairs to attend to, and*
> *our ordinary citizens, though occupied with the pursuits of industry, are still*
> *fair judges of public matters; for, unlike any other nation, regarding him who*
> *takes no part in these duties not as unambitious but as useless, we Athenians*
> *are able to judge all events even if we cannot originate them, and instead of*
> *looking on discussion as a stumbling block in the way of action, we think it an*
> *indispensable preliminary to any wise action at all . . .*
>
> *In short, I say that as a city we are the school of Hellas; while I doubt if*
> *the world can produce a man, who, where he has only himself to depend upon,*
> *is equal to so many emergencies, and graced by so happy a versatility as the*
> *Athenian.*

The Athenian democracy of fifth-century Greece succeeded because it was heir to the democratic institutions of Cleisthenes, which it implemented by generations of political experience, and also because it possessed a set of ideals that allowed its citizens to cooperate and to decide great issues wisely—ideals that somehow produced and preserved a community of men we can admire but not altogether explain.

* * *

Athens had become the unquestioned leader of the Greek world: its fleet was by far the most powerful in Greece, and its army was widely respected; its pottery drove the pottery of other Greek cities out of markets all over the Mediterranean; it was the intellectual and cultural tutor of all Hellenes. The most important thing to Athens was the preservation of the empire, which was essential not only for the tribute that financed the great Athenian fleet but also as a market for

Athenian goods. The Athenians had not been satisfied to leave the Delian League a mere defensive alliance. As the Persian menace receded, the essential disunity of the Greeks reasserted itself, and it became clearly impossible to sustain an alliance without compulsion. Ultimately, the Athenians felt the necessity to use force to prohibit secession from the league and to limit independent action on the part of states that were increasingly subject to Athens. Member states came to have freedom of decision only in purely local matters, and the league was turned into a sort of Athenian-centered imperial common market.

The maintenance and expansion of the empire became a central concern of Athenian policy. Pericles formulated the policy toward the empire, and the Assembly supported him in it. Although the members of the empire complained of Athenian incursions on their independence, on the whole, they remained loyal to Athenian leadership. This was not the case, however, with the states Athens had eclipsed in the early fifth century. Sparta and Corinth, in particular, fiercely resented the growth of Athenian power; to them, the Athenian empire was at once an annoyance, an insult, and a menace. Their consistent opposition to the Athenian democracy had been interrupted only by the Persian Wars. The cessation of anti-Athenian pressures did not bring a permanent peace but only a fifteen-year truce between the antagonists, beginning in 446 B.C.

The increased opposition to the threat of imminent Athenian hegemony eventually solidified, under Spartan leadership, in the Peloponnesian League. In this league, each member state formed an individual alliance with Sparta; there was no overall organization to which all members were subject. Although Sparta saw to it that most of its allies had oligarchical constitutions, it made no attempt to turn the league into an empire. Indeed, Sparta claimed that it led the fight for the freedom and autonomy of all Greek poleis. Spartan power rested on its army, which was still the best in Greece. An unstable balance of power had evolved: Sparta controlled the land while Athens controlled the seas.

In the years between 446 and 431 B.C., the two sides aligned themselves. No longer was Greece composed of about fifteen hundred small communities, each with its private quarrels and its own circle of allies and friends. Neutrality was difficult to maintain, particularly

after the Athenians undertook a serious expansion to the west—to Sicily and Italy, which, since they supplied both a source of grain and a ready market for Corinthian goods, were the bases of Corinthian prosperity. Athens also closed all markets in the Athenian empire to the goods of Megara, one of Corinth's allies. Antagonism between the two sides finally led to Spartan demands that Athens grant concessions to Corinth. Pericles persuaded the Athenian Assembly that compliance would only convince Sparta of Athens's weakness and that more demands would surely follow.

In 431 B.C. the Spartan army marched on Athens. The Athenian army was no match for them, and Pericles convinced the Athenians to abandon the Attic countryside to the invaders, just as they had done during the Persian Wars. The two thirds of the Athenian population who dwelt outside the city had to crowd inside the walls of Athens and watch as the invaders destroyed neighboring towns and fields. The cramped quarters made life difficult enough, but when the plague struck in 429 B.C., the results were devastating. The plague destroyed a large portion of the Athenian population, including Pericles, whose leadership was primarily responsible for controlling rival factions within Athens and who was the mastermind behind Athenian policy.

Yet, in spite of the destruction of their crops, the loss of about a quarter of their population, and the death of Pericles, the Athenians persevered—and not without success. They continued to control the sea, and their fleet ravaged the coastal cities of the Peloponnesus and allowed the Athenians to maintain control over their empire. At one point, using lightly armed bowmen, they were even able to defeat a Spartan army on land.

The Athenians also managed to find leaders—competent generals and statesmen whose judgment the Assembly trusted—although none could compare with Pericles either in the brilliance of his policy or in the loyalty he commanded. Now, however, for the first time, leadership was given not to scions of the old Athenian aristocracy but to men who gained eminence by their wealth and ability. The most important of these new leaders was Cleon, a wealthy manufacturer. He was a good speaker and a fair general, but he had neither the brilliance nor the good breeding of Pericles. The well-born, landholding aristocracy despised him.

Alcibiades, the aristocratic leader of the opposition in Athens, pressed for an active anti-Spartan policy. In 415 B.C. Alcibiades and his followers succeeded in getting the Athenians to vote for the provisioning of a huge fleet to invade the Sicilian city of Syracuse, an independent state that had been colonized by Corinth. If Syracuse fell into Athenian hands, the balance of power would shift considerably toward the Athenian side in any future conflicts with Sparta and the Peloponnesian League. Everything pointed to an Athenian victory, and so the expedition was judged to be a good risk.

But Alcibiades, the originator of the expedition and its only effective leader, had powerful enemies in Athens, and, once again, factional politics interfered with Athenian policy. The night before the expedition embarked, a number of religious statues were defaced. Athens was in an uproar. After the fleet had sailed, Alcibiades' enemies accused him of participating in the sacrilegious crime, and he was recalled for trial. He fled to Sparta, where he rendered great service to his country's most dangerous enemy.

The Athenian fleet was left with only inept and unenthusiastic leadership. Nicias, who had originally opposed the expedition, would neither lead it effectively nor withdraw. Meanwhile, Alcibiades persuaded the Spartans to reinforce Syracuse while the Athenians dallied. Finally, the Athenians, staking everything on the success of their expedition, sent another large force to reinforce the original one. They failed to take Syracuse, and, even worse, when the enemy took the offensive against their fleet, the Athenians were twice defeated. The Syracusans reinforced the metal plating on the bows of their ships and sank ship after ship by ramming into them head-on. The Athenian fleet was completely destroyed, and only a handful of Athenians survived death or enslavement to return to Athens.

Athens never recovered from the disaster at Syracuse. It had invested a large part of its total military force in the expedition and had lost it all. The democracy was demoralized, and political chaos prevailed. The Spartans and their allies, acting on the advice of the bitter Alcibiades, were able to blockade Athens on land, finally cutting the city off from its mines on Mount Laurium. Impoverished and beset on every side by powerful enemies, Athens now had to fight for survival. Desperate measures and great sacrifices on the part of the citi-

zens prolonged the war for nine years. In order to outfit a fleet, the Athenians had to melt down the gold and silver plating from the temples and statues on the Acropolis.

This time, when Athens launched another fleet, the Spartans could not defeat it. Sparta was finally forced to turn to Persia for gold to underwrite a victory; the price was the surrender of Asia Minor to the Persians. Blockaded on land by the Spartan army and at sea by a fleet bought with Persian money, Athens surrendered in 404 B.C. It had to tear down its walls to the Piraeus and give up its empire. The Spartans did not destroy the city, but Athenian hegemony was gone forever.

The war cost Athens more than its empire, more than its walls to the Piraeus. The disastrous course and outcome of the war cost Athenian democracy its self-confidence and its self-respect. Athens was now constantly threatened with revolt or subversion—an atmosphere in which the ideals of rational debate, of moderation and humanity, could hardly flourish. The city was demoralized by fear. In too many instances, the democracy responded to this crisis in ways that were neither rational nor humane.

The wartime treatment meted out to members of the empire is evidence of this change. When the island of Melos, which had committed no offense, refused to renounce its neutrality, the Athenians decided that moderation would be interpreted as weakness and took the position that justice belongs to the stronger. When their siege of the island was successful, they destroyed the Melians and replaced them with Athenian colonists.

Although the empire on the whole remained nominally loyal to Athens throughout the war, some revolts among the allies caused serious difficulties, and the Athenians became increasingly aware of their dependence on the empire for tribute, and of the tenuous nature of their hold over it. The exigencies of war forced them, on occasion, to exercise power with the same disregard for justice that the Spartans demonstrated in dealing with their own subject helots. Yet, in spite of these lapses, the Athenian empire was generally popular among its members, since it brought protection and prosperity as well as war-inspired arbitrariness in rule.

The long and exhausting Peloponnesian War and its culmination in bitter defeat generated much social and political conflict in Athens. The old aristocracy was successfully challenged by rich merchants and

traders, whose claim to power was founded on wealth and expertise in the arts of war and government rather than on family. Furthermore, the war had been fought largely in the newcomers' interest. The aristocracy, after all, did not share the merchants' critical concern for empire or the expansion of trade. After the death of Pericles, factional controversy frequently threatened to extinguish the democracy entirely. After the defeat by Sparta, a narrow oligarchy—the Thirty Tyrants—was able to grasp power with Spartan backing, and a reign of terror ensued. The democracy was finally restored, but its harmony and self-confidence had been permanently impaired.

Not only were there chaotic factional disputes among the Athenian citizenry, but the old way of life itself was challenged. Alcibiades, for example, had gained power and become an important leader even though he flouted the customs of old Athens: he made a reckless display of wealth, gave himself over to revelry with his comrades, and befriended intellectuals like Socrates, who seemed to embody the challenges to the old beliefs. Although there was no proof that Alcibiades had defaced religious statues, he was a very likely suspect; his whole style of life offended the Athenians. Yet his skill was appreciated, and he did return to Athens in 408 B.C. The loss of the naval battle of Nutium in 406 B.C., however, put him in disgrace once again; he lost all influence, failed to be reelected by the Assembly, fled to the Hellespont, and died in exile.

The trial of the philosopher Socrates, which is reported in Plato's *Apology*, was one of several prosecutions of intellectuals and artists. These prosecutions were precipitated, in part, by the anxiety of the Athenian citizens, who watched the old harmony and simplicity of polis life break up under the stresses of military defeat and social conflict. The old optimism, which had instilled harmony and inspired the buoyant Athenian spirit, now seemed to disintegrate, as an apparently endless war induced demoralization and decay. Athenian democracy continued to exist in the fourth century, but it lacked both the harmony of outlook and the brilliant leadership that had allowed it for a time to come so close to achieving the ideal political community.

* * *

The Athenian polis was a community that involved more than the political, social, and economic lives of its citizens. It was the center of cultural life as well, and its achievements in the arts are as singular in

the history of Western civilization as those in the political realm. Building upon the foundations laid by Homer and other writers and artists of early Greece, the Athenians developed a culture of astonishing brilliance. They adopted a few basic forms of expression and raised them to heights never since surpassed. If we are to understand the nature of their achievement, we must examine both the gradual evolution of those forms of expression and their place in the lives of the Athenians.

The cultural life of classical Athens was intimately connected with the religion of the polis; by the fifth century, all major avenues of artistic expression were in some way bound up with public religious observance. What had been family religious cults became polis cults, and the conception of the gods formalized in literature by Hesiod and Homer became the official religious view of the state. Thus, to understand Athenian religion, we must look first at its origins in the religious traditions of the Dark Ages (1100–800 B.C.) and at the attempts to institutionalize these traditions in the succeeding period.

Greek religion originated as an alloy of the beliefs and rituals of a number of cultural groups, and it always maintained the eclectic character that marked its beginnings. Just as other aspects of Mycenaean civilization showed the influence of native (pre-Greek), Indo-European, and Minoan cultural forms, so the gods of the classical Greek pantheon were drawn from these same cultures, served a variety of functions, and were worshipped according to a variety of rites. The Zeus of the Dark Ages possessed attributes traceable to such diverse sources as an Indo-European sky god, Cretan bull worship, and local pre-Greek cults. In addition to the practices and beliefs that accumulated in the worship of particular gods, the Dark Ages were characterized by a belief in ghosts, spirits of the dead, and any number of other supernatural powers. Worship of a Mother Earth goddess was also common. And because there were many local variations of particular deities, the number of gods—not to mention the vast horde of other supernatural forces—was multiplied. The specific practices and beliefs that prevailed in any one place were largely determined by historical circumstance. Each locality had its special body of gods, heroes, and rituals on which it depended to protect its army in battle, to ensure the regular and beneficial workings of nature, and to dilute and render

tolerable the fears and anxieties that always threatened to overwhelm primitive man.

The process of religious development by which the religion of the tribe or family was transformed into the religion of the polis was shaped by two fundamental trends. The major trend was toward the gradual absorption by the state of the religious beliefs and practices of the family and locality; however, there were always some aspects of religious observances left entirely up to the household or the individual. Second, the polis tended to adopt the more rational and aristocratic versions of the gods as they were presented by Homer and by Hesiod in his systematic *Theogony* (or account of the gods' origins).

Greek religion never incorporated a code of behavior or a coherent body of theological beliefs. It was, rather, a large conglomeration of myths, of stories that accounted for particular phenomena. For example, the explanation for the changing of the seasons was given in the story of Kore (Persephone), who was abducted by Hades to the underworld. Kore's mother, Demeter, goddess of crops, was overcome by sadness and wandered the barren earth until Zeus pacified her by arranging that her daughter would spend only part of the year with Hades and part with her. Thus, the earth was barren for part of the year, but when Kore returned to her mother every spring, life returned to the earth. The myth became associated with a particular place— Eleusis—and Demeter became the goddess of immortality as well. Every year, the return of Kore was celebrated with sacrifices and other ceremonies. When Eleusis, located on the Attic plain near Athens, was absorbed into the Athenian polis, the festival of Demeter became an Athenian holiday featuring an annual procession from Eleusis to Athens, animal sacrifices, and initiations into the Eleusinian mysteries. The mysteries involved purification of the initiate and his visions, while in a state of ecstasy, of some mysterious revelation. Thus, the myth gave rise to a state festival and a private religious experience, both of which incorporated the hope of some sort of immortality.

Another type of religious cult operated primarily outside the state, although not wholly without its recognition and specific involvement. These cults were characterized by wild, ecstatic behavior on the part of participants, behavior that might include hallucinations, orgies, and the sacrifice of animals and even sometimes of human beings. The typ-

ical cult of this sort was the worship of Dionysus, god of wine and fertility. Its participants were from all levels of society, even including slaves, and the ritual, carried out at night, apparently consisted mainly of wild orgiastic dancing to music. Dancers wound their way across the mountainsides in a frenzy, the object of which apparently was to lose oneself, to escape from reality. These aspects of the cult were frowned upon by the polis, and wherever the rites of Dionysus spread, there was some opposition from the authorities. Nevertheless, this cult and others like it were popular throughout the Greek world. The cult of Dionysus was eventually taken over by the polis of Athens and transformed into a solemn religious festival that featured the recitation of choral odes. In time, these odes developed into full-scale plays; the festivals thus gave birth to classical Greek tragedy. Still, the orgiastic dimensions of Dionysian worship continued to exist outside the state cult and without its sanction.

One of the most important aspects of polis religion was the worship of heroes. The idea of hero-veneration grew naturally out of the Greek view that a man's immortality consisted mainly in how he was remembered by other men. Thus, it was an important duty of the polis to honor its heroes. The spirit of the hero, as of all ancestors, resided in his tomb, which thus had to be properly revered. In return, the hero, through his spirit, could help protect the polis. The dead Athenian hero Theseus, for instance, was said to have been seen fighting in the Athenian ranks against the Persians at the Battle of Marathon. Neglect of a hero, however, could bring disaster to a polis.

Although most religious observances took place within the polis, there were Panhellenic religious institutions in which all Greeks participated. The most important of these was the Delphic oracle, located at Delphi in central Greece. The Greeks believed that northerners had brought Apollo to Delphi, where he established his oracle and then shared it with Dionysus, who took possession during the three winter months when Apollo was absent. The god spoke through a priestess, who, in a trance, answered questions asked by official emissaries from the Greek cities. The oracle was also visited by common people with personal problems and by foreign emissaries from Asia. Apollo was the god of justice, and the oracle gave advice that ranged from instructing poleis when and where they should send out colonies to telling mur-

derers whether and how they could purify themselves. Lycurgus was thought to have received his Spartan constitution from the oracle, and many cities took care to gain the advice of the oracle whenever new laws were promulgated. In addition, in each polis, emissaries from the oracle acted as overseers of all religious observances in their polis. They saw that rituals were duly followed and that crimes were expiated in the correct manner, and they gave advice when the proper course of action for the polis was in doubt. When the matter was especially serious, the emissaries were sent to the oracle for advice directly from Apollo himself.

The Delphic oracle was a powerful political influence at many different times in Greek history, but it was never established as a real or consistent authority. Its messages were often unclear or ambiguous. There is, for example, the famous case of Croesus, king of the Lydians, who consulted the oracle about whether to go to war with Persia. The oracle said that if he went to war, he would destroy a great empire. When he lost the war, he sent emissaries to castigate the oracle for its false prophecy; but they were told that Croesus had forgotten to ask which empire he would destroy, the Persians' or his own. The oracle could also pick the wrong side. During the Persian wars, for instance, it advised all comers to surrender to the Persians. Even though the Greeks were victorious, the oracle somehow managed to keep its respected position in the Greek world.

All these facets of Greek religion were parts of an amorphous, heterogeneous body of myths, cults, rituals, and beliefs, which grew up side by side in various localities in a haphazard fashion. Such a religious climate could find room—along with its huge number of gods and goddesses—for a conglomeration of ideas about supernatural phenomena. Conceptions of the afterlife and the underworld, for instance, varied widely, and there were vastly divergent notions about such fundamental beliefs as the nature of the spirits of the dead and the location of the underworld itself. Nothing was excluded simply because it was incompatible with any existing deity or tale. Greek religion could and did absorb anything that interested and attracted the Greeks.

It is only within this framework that we can comprehend the achievement of Homer and Hesiod. Working in the midst of this complex and often contradictory body of myth, both poets attempted

to formulate and describe an ordered conception of the gods and their relationship to man. Homer gave the gods a dwelling place (Olympus), a father king (Zeus), and assigned them a place in the hierarchy of beings in the universe. Gods were like men, except that they were physically flawless, immortal, and able to foresee human events; in short, they were men perfected. Because of their superior nature, they exercised power over human events in much the same way that the nobles of the Dark Ages possessed authority over the commoners, beings inferior to them. The gods' anger could breed affliction for man, while their blessing promised success. In Homer, the gods were ever present in human affairs, especially at moments of human decision. They might speak aloud to a man, divert a spear to save his life, or put in a personal appearance at any time and in almost any guise. Above all, the gods were to be seen at work in actions that surpassed the normal behavior of man. Transcendent wrath, unusual bravery, or a display of miraculous strength were hints that the gods had intervened. In addition, the gods had control over natural forces and could bring them to bear either for or against a man. Sailors, for instance, had to be careful to retain the good will of Poseidon, god of the sea. It was Poseidon, who, when offended by Odysseus, delayed his passage home. Zeus not only exercised his persuasive thunderbolt at certain decisive moments but also dispensed good and evil fortune variously to each man at birth.

In Homer, there is never any question as to whether one should believe in the gods; nor is obedience to the divine will ever questioned. The will of the gods was inescapable, and therefore it simply could not be ignored. If punishment was not visited upon a man who insulted the gods, it would surely strike his progeny. But assuming that a man did not unknowingly commit an offense against a divinity, it was possible, if one observed the proper rituals and behaved properly, to remain on good terms with the gods. To behave correctly was to act in accord with one's nature. Just as a commoner could be humiliated for speaking out of turn in the Assembly, so the suitors in the *Odyssey* could be punished for behavior inappropriate to their position.

The ideal man never forgot his humanity and his mortality, but, at the same time, he had to emulate the gods. The gods were supposedly deserving of this emulation by reason of their perfection (although the

myths are full of instances where the gods lie, cheat, commit adultery, and, generally, act in less than a godlike fashion). A hero was a man who possessed godlike qualities, and he was given immortality in the only way that was meaningful or appealing to the Greeks. To live forever in the memory of one's polis was the incentive to proper human action. The gods looked with favor upon lofty human behavior; in fact, in one case in Greek history, that of Heracles, the gods found a man so worthy that they accepted him as a god. Heracles represented the closest thing the Greeks ever had to a universal symbol of a hero, and he belonged to all the Greeks.

Homer created the Greek image of the gods and gave them personality and function. It remained for Hesiod, in his *Theogony*, to attempt to systematize the family of deities and depict the genealogy of the gods and their roles. His system was Greek, of course, but it shows some Near Eastern influences. Hesiod's major contribution (in his *Works and Days*) was to delineate the explicit conception that the gods were a moral force. He achieved this by making them champions of justice.

The Greek polis adopted Homer's and Hesiod's conceptions of the gods, and, despite the variety of local practices, a distinctive Greek religion was developed. This religion was always complex and never consistent in all its details; still, its view of man and the world lies at the center of Greek culture.

* * *

The Greek hero was very close to the gods, and physical perfection was an important heroic attribute. A man who, by hard work, training, and dedication had attained the physical beauty and harmony of a work of art was accepted as a hero, and his prowess was believed to be pleasing to the gods. If an "athlete" is defined as one who participates in a trial of strength for its own sake, then the Greeks were the first athletes. Games and sports between athletes were offered to the gods, and, early in Greek history, they became an important part of certain religious festivals.

The greatest of the Greek festivals took place at Olympia every four years and attracted, from all over Greece, athletes who attended under a sacred truce that overrode political differences. Worthiness to compete was essential; the contestants had to swear that they had

trained according to the requirements and that they would compete according to the rules. The events included chariot and horse racing, foot racing, jumping, boxing, and wrestling, and they were interspersed with sacrifices to the gods, with religious processions, and with celebration. Feasts and revelry marked the occasion as one of national rejoicing; men from all over Greece hailed the opportunity to express their delight in the beauty and power of man.

The Greek view of man was reflected in the art and architecture of classical Greece, which developed out of artistic forms that had first emerged in the Dark Ages. Changes in conception and technique, stimulated by the reopening of contacts with the Near East and by improved conditions within Greece itself, led to a fundamental reshaping of the art of the earlier period. The most important changes were the utilization of stone in buildings and sculpture and the elevation of the human figure to the central place in Greek art.

The introduction of the use of stone rather than wood in temple construction was a sign of improved technology and of regained social and political stability. It was also indicative of the growing importance of the polis community in Greece. Throughout the history of classical Greece, the only large structures were public buildings, and by far the most important of these were the temples that each polis constructed for its religious observances. Temples were usually erected in honor of the gods and sometimes of dead heroes, but never to living individuals. In fact, Phidias, the greatest sculptor of Periclean Athens, was once tried for sacrilege on the grounds that his own likeness and that of Pericles could be recognized in a scene he had created on the shield alongside the cult statue of Athena in the Parthenon.

By the sixth century, the Greeks had adopted a building plan that set the basic features of all Greek temples: the steps of the base provided the foundation for the columns, fluted and topped with a capital, upon which rested a raised roof; inside the temple was the room in which the image of the god or goddess was kept. Virtually all temples were rectangular in shape and retained these basic elements. (The Erechtheum, on the Acropolis at Athens, is a striking exception.) Variations occurred in the style of the columns, which were at first topped with Doric capitals, as in the Parthenon, but later with capitals in the more ornate Ionic and Corinthian styles as well. The frieze above

the columns was decorated with scenes depicting famous or character-istic actions of men and gods, as was the space in the triangle formed by the roof.

The other major artistic innovation of the early classical period was the introduction of human figures, which now became the central concern in artistic representation. Pottery in the Dark Ages had been painted in geometric designs. Now, partly due to Near Eastern influ-ence, artists began to paint figures of humans, animals, and supernat-ural monsters on their vases. The development of the technique of painting the background of the vase black and leaving the figures in the red of the clay allowed painters to make much more complicated and realistic representations than had been possible with the black fig-ures of the past, which were little more than silhouettes.

Greek artistic concentration on the human figure produced the greatest achievements in sculpture. At the end of the Dark Ages, sculpture of figures in stone appeared for the first time—rigid and blocklike, in the Egyptian style. Gradually, however, the human fig-ure was emancipated from the block out of which it was carved and given the graceful and free form that characterized classical Greek sculpture. The careful symmetry that gave the Egyptian style its rigid-ity was replaced by a balanced asymmetry that endowed the stone image with a sense of poise and motion. The ideal of the Greek sculp-tor became the portrayal of the perfect human form (whether of a god or a mortal) in a characteristic pose. Closest approximations to this ideal were typically either a nude male figure, often an athlete or a god, or the representation of a maiden or goddess clothed with softly draped garments that revealed the beauty of the figure beneath. Similar standards were applied to the figures carved in bold relief on the friezes of temples and even to the statues of maidens that some-times served as the columns of temples.

We say that the subject in Greek art was realistically represented not because a statue was an exact replica of an actual model, but rather because it incorporated, from a variety of particular models, those qualities that are essential and permanent, and most beautiful and excellent in their nature. The parts of a statue or temple were always subordinate to the effect of the whole. Even the space the artist left unfilled was calculated to contribute to the total effect. The geometric

conception that had dominated early vase-painting was transformed by the classical artist to help him achieve a balanced and harmonious work. The Greeks arrived at an ideal proportion for the parts of the human body and for the ratio of the length of a temple's sides to its height, but these were always subject to the sense of grace and dynamism that characterized Greek objects of art. Thus, no line in the Parthenon is perfectly straight; neither is the distance between its columns exactly regular. The slight deviations from strict mathematical proportion and regularity contribute to the grace, subtlety, and harmony of the artistic effect.

The Greeks' concern for mathematical spatial relationships was only one expression of the sense of overall propriety that was a guiding principle for their art. This sensibility also led Greek artists and architects to apply criteria of style, setting, and demeanor that reveal what they thought was proper and correct for each particular subject. A Greek temple did not reflect the glory of the polis in a blatant and presumptuous way, but rather in its appropriateness to its task, which was to give proper honor to the gods through its excellence. It was also the function of Greek art to portray that which is distinctive to man— not only his ideal physical form but the dignity and restraint that should characterize his actions. The artist was not concerned with the particular or transitional in human personality, nor with a man, but with the very essence of what is human. Thus, classical art performed what the Greeks considered a religious function not only in its repeated portrayal of gods and scenes from religious mythology but also in its more important representation of what was ideal for human emulation. The world presented to the Greeks in classical art was not submerged in primitive superstition; it was a rational world of dignity and proportion.

* * *

The classical Greek artistic ideal was expressed in language as well as in mute stone. Poetry in the early period underwent a development that in many ways paralleled that in the visual arts. Soon after the introduction of writing, the dominance of epic poetry gave way to a period of experimentation with new forms and meters. In the two centuries after Homer, the most important form was lyric poetry—that is, poetry composed to be sung by an individual or by a chorus to the accompaniment of the lyre.

The new poetry tended to be very personal in nature, especially when it was meant for an individual performer. The poet, for instance, might tell how he threw away his shield when retreating from battle— better to lose one's shield than one's life. One of the best-known lyric poets was Sappho, one of the few great female literary figures of the ancient world. Sappho's large body of love poetry is illustrative of the worlds of difference, in both content and form, between this type of poetry and the earlier epics.

Lyric poetry also took the form of choral odes, written to be performed at private celebrations, like weddings, or at public festivals. The greatest of the poets who wrote choral works of this nature was Pindar, most famous for his "victory odes." He traveled to various cities in Greece, accepting commissions from governments or from private parties to immortalize the deeds of their athletic heroes in verse. Although these choral odes dealt mainly with the victor and his victory, they also contained Pindar's views on life and the gods.

The seminal development in the history of Greek poetry was the evolution of the choral odes performed at the festival of Dionysus at Athens. Originally, the odes were about the god Dionysus and took the form of a dialogue between the chorus and the chorus leader. When the poet Thespis, in the late sixth century B.C., allowed the choral leader to impersonate the character whose actions he had formerly just reported, drama was born. At about the same time, the tyrant Pisistratus initiated a drama contest at the annual festival. Officials chosen by the state selected three tragedians to submit plays to be performed before the Athenian populace. (Later, a competition was also held for comedies.) Each tragedian submitted a trilogy of tragedies and a satyr play (although no satyr plays have survived) to be performed consecutively, without intermission. In the afternoons, comedies were presented. Each of ten judges, one from each tribe, wrote his choice of the best tragedian on a ballot. Five of the ballots were then drawn by lot, and the tragedian who received the most votes received an honorary award. The production of the plays involved very large numbers of men and boys (women did not participate) and extensive rehearsals. The enterprise was financed by rich sponsors chosen by the state; drama, like everything else, was a polis affair.

Tragedy became very popular all over Greece, but the Athenian festival, where no play could be performed twice, was the greatest stimu-

lus for the creation of new plays. Of all the playwrights who submitted tragedies, the works of only three have survived: Aeschylus, Sophocles, and Euripides. In their plays, we can see how the old poetic tradition was transformed to give expression to the classical Athenian ideal.

Aeschylus, the earliest of the three tragedians whose works survived, began writing in the early fifth century B.C. By adding a second actor to the single choral leader, he brought tragedy into existence as true drama. Dialogue between individual characters was now possible—particularly since each of the single actors could portray more than one character—and the intricacy and subtlety of the plays were vastly increased. The use of a third and, occasionally, a fourth actor, and the reduction of the role of the chorus in later tragedies by other dramatists did not alter the essential flexibility of the form worked out by Aeschylus. The subject matter of his plays ranged from the myths of Greek religion to contemporary events, like the Persian Wars. The purpose of his drama was not to tell a story but to explore a problem. For example, Aeschylus took as a subject the story of King Agamemnon—how he returned victorious from Troy only to be killed by his unfaithful wife, and how Orestes, their son, avenged his father by killing his mother. In the three plays that make up the *Oresteia*, Aeschylus used the old legend in a new way. The climax of his tragedy, *The Eumenides* (the final play in the trilogy), dramatizes the conflict between the Furies, who represent the old tradition of personal revenge, and Apollo, who represents human justice. Orestes is saved from torment at the hands of the Furies by the public tribunal at Athens established by the goddess Athena: the people of Athens will henceforth try every case of homicide, and family blood feuds will be ended once and for all. The Furies are pacified and convinced by Athena no more

> To set within my city's walls man against man
> With self-destructive boldness, kin defying kin.
> Let war be with the stranger, at the stranger's gate . . .[1]

Aeschylus' purpose was not to describe a series of interesting events nor to portray the character of Orestes. He took for his subject the

[1] Translated by P. Vellacott.

problem of justice, the cessation of the destructive and never-ending series of retributions for murder with more murder. His answer to this problem was the divinely ordained but essentially human institution of law.

Sophocles was younger than Aeschylus but still his contemporary, and, often, his rival at the annual contest. In his earliest extant play, *Ajax*, the Sophoclean conception of tragedy is evident. In the play, the army of the Achaeans has voted to give the armor of the dead Achilles to Odysseus rather than to Ajax. Overcome with anger born of injured pride, Ajax decides to murder all the leaders of the army. But the goddess Athena diverts him with madness, and he kills the army's animals, thinking they are the generals. A failure, and debased by his action, Ajax commits suicide. Agamemnon and Menelaus, the leaders of the army, forbid the burial of the body. It is Odysseus, Ajax's archenemy, who convinces the generals that the greatness of Ajax requires that he be properly buried in spite of his crimes. This Odysseus is not the clever man found in Homer but a truly wise and just hero. He recognizes his common humanity with Ajax, his enemy:

> *I think of him, yet also of myself;*
> *For I see the true state of all us that live—*
> *We are dim shapes, no more, and weightless shadow.*

He is also conscious of the demands of justice:

> *It would be wrong to do him injury;*
> *In acting so, you'd not be injuring him—*
> *Rather the gods' laws. It's a foul thing to hurt*
> *A valiant man in death, though he was your enemy.*[1]

Through his contrast of Ajax's primitive concept of honor with Odysseus's higher ideal, Sophocles was able to contrast sharply two human attitudes.

In the play *Oedipus Rex*, Sophocles went even further in his exploration of human character. Before the action of the play begins, King Oedipus, through an inescapable fate, commits two terrible crimes: he

[1] Translated by Richard Lattimore.

inadvertently kills his father and marries his mother. The action of the play revolves around the gradual unfolding of Oedipus's past before his eyes, until the immensity of his guilt (the fulfillment of the horrible prophecies of which he had always been aware) drives him to blind himself. Tragically, it is his own uncompromising pursuit of the truth that illuminates his gruesome past. Although he is repeatedly warned not to hasten his fate by uncovering the truth, Oedipus presses his inquiries in the false and presumptuous hope that the truth will give him control of his destiny. This is hubris—the excessive pride that leads a man to believe that he can do something that is denied to him by his very humanity. To the Greeks, hubris was crime greater than patricide or incest. Oedipus's punishment is to wander the earth as an exiled beggar, unable to see anything around him but forever conscious of the reality he dared to expose. Having looked upon the truth, Oedipus has fulfilled the great evil forecast for him, and, ironically, in the course of trying to escape his fate, he has been its aggressive agent.

Both these plays illustrate Sophocles' conception that tragedy is played out within the individual. In *Ajax*, the character of the hero is revealed by the reactions of others to him—his brother, his concubine, his son, Odysseus, and the leaders of the army. In *Oedipus Rex*, the character of the tragic hero is revealed by the reports of other characters about his past life, a past whose meaning has been hidden from him. Given the order of the universe, each character is fated to pay the penalties for his own crimes—to suffer because of the limitations of his own nature.

Euripides had yet another approach to tragedy, differing from that of Aeschylus or Sophocles. In his play *Hippolytus*, for example, the tragedy stems from the unbalanced personality of the tragic hero. Hippolytus worships Artemis, the goddess of chastity, to the exclusion of Aphrodite, goddess of love. Aphrodite avenges herself by making his stepmother, Phaedra, fall in love with him. Phaedra kills herself in despair, claiming in a note to Theseus, her husband and Hippolytus' father, that his son had raped her. In his anger, Theseus calls down the wrath of Poseidon, god of the sea, who kills Hippolytus. In this play, all three major characters sin against the gods: Phaedra through her excessive passion, Hippolytus through his excessive purity and his devotion to one goddess to the exclusion of another, and Theseus

through his excessive anger. Each of the three represents an extreme in human character. These extremes are also reflected in the gods—Aphrodite, Artemis, and Poseidon—who represent psychological forces that possess man against his will.

In general, the classical tragedians took their material from traditional Greek mythology, but they altered that material to suit their purpose—to convey, in a dramatic way, the moral and rational potentialities of man. For example, Orestes, who, in mythology, was the prototype of the honorable avenger, was used by Aeschylus as the subject for a play whose theme is really the futility of private vengeance rather than the preservation of honor. In the play *Ajax*, Sophocles transformed Odysseus from the Homeric trickster into a truly wise man and used Ajax to exemplify a conception of honor far in advance of that of Achilles in the *Iliad*. In his epics, Homer characterized the gods in terms of their private jealousies; but in Euripides' *Hippolytus*, the gods were enlarged and abstracted to become embodiments of universal psychological forces.

Modern readers and theatergoers often find it difficult to identify or sympathize with the tragic heroes of classical Greek drama. This difficulty may arise in part because the plays are highly stylized depictions of otherwise familiar human situations. They were designed to produce awe and terror in their contemporary audiences; the viewers were meant to be stirred to look at their own lives and characters. To a modern society, less self-conscious about the moral content of action, the tragic heroes may appear pretentious. But the elevated language and classical dramatic trappings, such as the chorus and verse dialogue, are merely devices used to illuminate the tragic heroes' struggle with fundamental human issues. Aeschylus' *Prometheus Bound*, for instance, begins with the personification of power and force chaining Prometheus, the personification of reason, to a cliff at the end of the world. Prometheus' tragic flaw—even though he is a demigod—is his insistence that reason be unfettered. To this end, he has given mankind fire (and reason), which, he feels, is man's by right. For this act, Zeus (who stands for arbitrary will) condemns him to spend eternity in chains—fettered forever.

The struggle of reason against power and will is no more a settled issue today than it was in Aeschylus' time. The grand scale on which

the drama is acted out, the mythical and heroic characters (who appear quite strange to modern readers), the titanic conflicts—these are only devices that were perfectly suited to the cultural milieu of the classical dramatist. He fashioned these strict forms to create highly compelling artistic statements and explorations of persistent human problems. It is significant that religious celebrations provided the sole occasions at which the Greek tragedians engaged in their unique and complete exposition of the dimensions of the human mind and of man's relationship to man, the gods, and fate. While retaining much of the content of the Greek tradition, they created a new view of man. They demonstrated in the most moving and immediate fashion the greatness and the limitations of the human condition—a goal pursued from that time to this by dramatists, philosophers, and theologians.

* * *

Greek art and drama, in their exploration of human nature, were but two ways of looking at the world as part of a rational order of things. The dramatists had adapted the old myths to their new purposes, but some men began to question the myths themselves. The simultaneous development of history and science initiated a new way of looking at the past and the present, a way that differed fundamentally from the mythological approach of Homer and Hesiod. Men began to observe the world as something to be investigated and explained in general terms.

The study of history began as an attempt to explore the world. As communications grew up between various parts of the world, the contradictions between different peoples' views of reality became apparent. It was his appreciation of this fact that led Hecataeus of Miletus to travel throughout the civilized world to see it for himself, since he found the stories of the Greeks "ridiculous." He wrote a record of his travels, the *Histories*, which was, actually, a sort of travelogue describing what he found at the various places he visited. He also made a map of the then-known world.

His successor in time and in method was Herodotus of Halicarnassus, who is known as the "Father of History." He conceived the project of recording the history of the Persian Wars, which he then recited in serial form at the Olympic Games. Herodotus wrote not in poetry but in prose, and he did more than merely recall the myths about the wars and retell the popular stories. In order to relate cor-

rectly the history of the wars, he felt compelled to describe the enemy, the Persians, both in the past and present. His method was to travel throughout the Persian world (practically the entire known world outside Greece), collecting information and recording the history and customs of each people he visited. Inasmuch as he had no personal memory of the Persian Wars (he was born after the battle of Salamis), he pieced together his history of the conflict from the testimony of participants or their children, and from the reports that had been preserved. Herodotus did not judge the validity of his evidence—nor, perhaps, did he have the obsession with accuracy that is the hallmark of much modern historiography; so when he came across two or more contradictory accounts, he related them in juxtaposition and left the rest up to the reader.

Herodotus' methodology and the inaccuracy of his sources left his work full of conflicting accounts and factual errors that only more certain and systematic historical inquiry in later eras could correct. But the very idea of comparing and contrasting a variety of accounts was in itself revolutionary, since it meant that contradictions and absurdities could no longer simply be ignored. Before Herodotus, men made no effort to present or reconcile opposing versions of the same story; they merely believed the version that suited their particular needs and characterized all other versions as falsehood. Herodotus acknowledged that all versions of a story, even the enemy's account, or others at variance with one's own cherished viewpoint, ought at least to be given a hearing. While Herodotus was somewhat credulous and deficient in critical powers, what is impressive is his breadth of vision and his humanity, which induced him to gather information about the whole diversified world as it was known at that time. Subsequent Greek and Roman historians lacked his cosmopolitan attitude.

The greatest Greek historical work was the history of the Peloponnesian War written by Thucydides, who was an adult when the war began, and a prominent participant in it. He devoted his life to recording a faithful account of the great events he had experienced. His attitude toward history is illustrated in the introduction to his great work:

> *With reference to the narrative of events, far from permitting myself to derive it from the first source that came to hand, I did not even trust my own impres-*

sions, but it rests partly on what I saw myself, partly on what others saw for me, the accuracy of the report being always tried by the most severe and detailed tests possible . . . The absence of romance in my history will, I fear, detract somewhat from its interest; but if it be judged useful by those inquirers who desire an exact knowledge of the past as an aid to the interpretation of the future, which in the course of human things must resemble the past if it does not reflect it, I shall be content. In fine, I have written my work, not as an essay which is to win the applause of the moment, but as a possession for all time.

Thucydides' opinion of the cause of the war is as sophisticated as his historical method: "The growth of the power of Athens, and the alarm which this inspired in Lacedaemon, made war inevitable."

Thucydides left the world of myth completely behind: he explained events solely in terms of human motivations and human actions. When he discussed the coming of the plague to Athens, he described the general symptoms and the social results of the disease. He then recounted how an oracle's prediction was distorted by many so that it was supposed to have foretold the disease. He dismissed this tale, saying: "The people made their recollection fit in with their suffering." In another circumstance, he says, they would have remembered the oracle another way.

* * *

Thucydides was just one of a large group of intellectuals who lived in the Greek world in the fifth century. Most of them, unlike Thucydides, were primarily concerned with explaining the nature of the universe in physical terms. The outcome of their inquiries was the discovery of abstract thinking and the birth of philosophical thought.

The early philosopher-scientists, beginning with Thales of Miletus, rejected myth and anthropomorphic gods as ultimate causes of events. Instead, they began to look for explanations in material terms. They tried to find the basic substance out of which all other materials were formed: Thales thought it was water, others said it was air or fire or earth. The Pythagoreans, an influential group of theorists that emerged among the Greeks in southern Italy, founded both a mystical sect, which believed in reincarnation, and a philosophical school, which asserted that the principle of all things was number.

Instead of thinking in terms of elements, such as air and water, they reduced reality to spatial units that could be understood logically and mathematically. They regarded the point, the line, and the plane, as the constituents of reality, and they were therefore the first to think of reality in purely abstract terms.

For thinkers such as Heraclitus, change (the basic element in human sensory experience) was the result of external motion acting in accordance with the inner, constant reason (*Logos*) in the universe. Parmenides extended this idea to assert that there were two separate realities: the way of Truth, which was external to human experience and could be grasped only through the uncompromising application of reason; and the way of Seeming, which could be perceived by the senses but was a false way. Zeno, who lived in the middle of the fifth century B.C., perpetuated the Parmenidian tradition in his argument for the unity of the universe by showing through a paradox that plurality was logically impossible. Plurality must be limited, since "things may be just as many as they are, no more, no less." At the same time, "If there is a plurality, the [number of] things that are infinite; for there will always be other things between the things that are, and yet others between those others." He used similar arguments to prove that motion and change were impossible. This meant that reality was immutable and, at least theoretically, rationally accessible to human comprehension.

The writers who followed Parmenides and Zeno got around the objection that plurality cannot evolve from unity by positing an ulti- mate plurality. Empedocles held that there were four elements—fire, air, earth, and water—and that these were moved by Love and Strife. Man could perceive these because he had the senses to experience each element. Anaxagoras, who was Pericles' teacher, carried the idea far- ther when he held that creation came from an infinite number of seeds containing the elements of all things in their diversity. Ultimately, Leucippus and Democritus combined the idea of a basic material with the Pythagorean idea that reality is composed of geometric units. They held that all things were made up of indivisible units, called atoms, which were all similar, and that different combinations of these led to the apparent differences in nature. According to different thinkers, the particular combinations were ordered by a divine Mind or were the

result of chance, but the scientific dimensions of the Greek analysis of reality was firmly established.

The development of abstract thought had far-reaching implications. The gods of the polis, still to a large extent the Homeric, anthropomorphic gods, had no place in such systems, which explained the universe in purely physical terms. The same was true for the conventional ideas of morality: what had seemed the transcendent laws of the polis given to men by the gods were now no more than conventions that could be changed. There grew up in Athens, among some thinkers, the idea that the laws of nature—what was thought to be naturally good for man—might actually be in conflict with the laws of the polis.

In addition, the knowledge of the intellectuals was specialized and highly abstract, quite outside the normal Greek educational system. It did not even seem useful to society. Most of the early philosophers conducted rudimentary experiments and made minor inventions. But technology advanced relatively little after the sixth century B.C. in Greece, and the theoretical achievements of the scientists were seldom put to socially or economically beneficial uses. Medicine was a partial exception, and the Hippocratic school was quite advanced in its investigation into the causes of disease. In spite of this, the Greeks generally put as much faith in the worship of the healing god Asclepius as in scientific medicine. Clearly, the social utility of science had a limited impact in classical times, and this was out of keeping with the traditional needs and expectations of the polis.

On the whole, science and philosophy remained pastimes for aristocrats, a world apart from the experience and the concerns of the rest of society. In the fifth century, there was a movement designed to overcome this aloofness. Formerly, such high education as was necessary for philosophic thought was conveyed by means of a purely private relationship between a wise man and the younger pupils he happened to gather around him. Then, a new group, the Sophists, began to offer education to anyone—for a price. Furthermore, they would not waste their pupils' time with speculation for its own sake on such high-minded abstractions as Zeno's inquiries. Education was to be put to use in society; it was to help the educated man get on in the world. Since they believed that there was no absolute truth, the

Sophists and their pupils did not seek truth but that which was to their advantage. Sophists were trained in methods of rhetoric and argument, not to pursue the truth but to win arguments—especially in the Athenian Assembly, where the most convincing speaker carried the day. Thus, along with theoretical logic, the Greeks also invented practical logic-chopping.

* * *

The reaction of the Athenian citizen who felt his ideals challenged by the crassness and professionalism of the Sophists was to lump Sophists, scientists, and philosophers into one group. Aristophanes, the greatest of the Athenian writers of comedy, illustrates this tendency. In his play *The Clouds*, he makes the philosopher Socrates both an atheist and a Sophist—although he was neither—who peddles "unjust logic" to anyone who will buy it. At one point, he has Socrates say, "Zeus! What Zeus? Are you mad? There is no Zeus . . . Henceforward, following our example, you will recognize no other gods but Chaos, the Clouds, and the Tongue, these three alone." Later in the play, one of Socrates' young pupils beats his father. When his father protests that it is against the law, the young man says:

> *Was not the legislator who carried this law a man like you and me? In those days, he got men to believe him; then why should not I, too, have the right to establish for the future a new law, allowing children to beat their fathers in turn?*

Aristophanes' satire reflects the conservative opinion of the Athenian who valued the old simplicity, the old morality, and viewed all innovators as subversives.

Socrates himself, however, opposed both the natural scientists and the Sophists. He found the conclusions of the philosophers about the nature of the universe unsatisfying. They were interested in finding the process by which things came to be. This they did in purely physical terms, seeking some ultimate substance and, in some cases, a primal Mind that had initiated motion. But Socrates did not merely want to know the succession of physical changes that had resulted in the present order; he wanted to know *why* things were ordered as they were. He sought not what substance things came from but what pur-

pose they served. It appeared to him that the world must be ordered to fulfill some moral end.

Socrates turned the tools of science and logic to the examination of man. The subject of his search was the nature of the good (that which was appropriate to man's nature and to the nature of the universe), since he believed that if man knew the good, he would pursue it. Socrates asserted that man would not commit an act that he felt to be wrong; evil conduct was the consequence of ignorance. In order to search out the good, Socrates spent his life in discussion with anyone who was interested in his questions. His method was rigorous self-examination; the first prerequisite for good action was to "know thyself." Socrates argued that "the unexamined life is not worth living." He felt that every individual and social belief had to be examined and justified by reason, and no subject, including the gods and the law, was exempt from his ceaseless inquiries. This attitude, as well as his association with controversial figures such as Alcibiades and Critias, one of the Thirty Tyrants, made Socrates a prime target for the criticism of the traditionalists, like Aristophanes, who felt threatened by what they saw as the breakdown of the old Athenian morality at the end of the Peloponnesian War. Socrates was tried for corrupting the youth of Athens and for not believing in the gods of the polis (although, in fact, he carried out all the customary religious observances). The Athenian jury condemned him to death by poison from his own hand. Although he could have escaped into exile, Socrates chose to execute the sentence. He refused the dishonor of fleeing from the laws of his polis, even when they were used unjustly against him.

Socrates left no written record of his teachings, but his greatest pupil, Plato, made Socrates the major speaker in many of his dialogues. Although we probably get a somewhat prejudiced view of Socrates in the dialogues, it is likely that the general outlines of his philosophy are presented. Plato went beyond his teacher. His inquiry began with ethics, but, at one point or another, he considered most of the questions that have been of concern to philosophers since his time. All of Western philosophy, as the eminent twentieth-century thinker A. N. Whitehead has said, is but "a series of footnotes to Plato."

Plato grew up during the last years of the Peloponnesian War and was a young man when Socrates was condemned by the state. At an

early age, he entered a life of writing and teaching, after a period of involvement in the politics of both Athens and Syracuse. He had witnessed the Athenian democracy at its worst, during the postwar period, and his concern for discovering the essentials of a well-ordered state never left him. In what may have been his last work, *The Laws*, he attempted to draw up a constitution of the "best possible" state, with a view toward putting it into actual practice.

Plato's view of the correct ordering of the ideal state is best seen in *The Republic*, in which Socrates discusses the nature of justice with three Sophists. Since justice is found only in the good state, he has to begin by outlining what sort of state that might be. Plato's conception of the ideal form of government was derived from his view of the nature of man. The human soul had a three-part nature comprised of wisdom, honor, and appetite. Whichever characteristic predominated determined the nature of each particular man. The best man was governed by reason or wisdom, the worst by his appetites; only the former could be truly free or truly happy. States governed by democracy were not immune to the rule of appetite. Governments devoted to the pursuit of honor he called "timocracies."

The ideal state would be governed by wisdom. It would be characterized by true justice—that is, everyone fulfilling his function within a harmonious whole. Those people controlled by the appetitive soul would provide the labor of the state, while those who were governed by the search for honor would defend it and perform executive functions. The wise would rule as philosophers and kings.

Wisdom did not consist of expertise in governmental affairs; it was rather the ability to perceive the good. (Plato, like Socrates, believed that those who knew the good would do it.) This ability could be achieved by those few men who possessed the best sort of soul and who underwent long years of education—rigorous physical, as well as philosophical, training.

For Plato, knowledge involved going beyond particular transitory objects, which can be perceived with the senses, to the ultimate reality in the universe—the world of pure ideas. Reality was not contained in those things which come into being and pass away, but rather in eternal forms, which, although they resemble the things we see, are outside time and space. Everything that exists—that can be seen and

felt—was for Plato but an imperfect reflection of its ideal form. The material world takes on a permanent shape only insofar as it "participates" in (draws upon the reality of) the eternal idea. And yet the things that exist in the world as we see it are only as shadows on the walls of a cave compared to the real (i.e., the transcendent and eternal) world of pure ideas. Beyond the particular pure forms, there is one highest form, the idea of the Good, "the source of all things beautiful and right," that surpasses and encompasses them all and can only be attained by a mystical experience, or a "flight of the soul." It is the knowledge of this transcendent reality that separates the truly wise man from the rest of mankind.

Unlike Socrates, Plato established a formal school, the Academy, where he lectured throughout the latter part of his life. His greatest pupil was Aristotle. After Plato's death, Aristotle began increasingly to diverge from his master's doctrines, and the basis of this disagreement was Plato's doctrine of ideal forms. Aristotle came to believe that all reality can be perceived with the senses; for Aristotle, there were no perfect forms outside time and space. Instead, Aristotle held that the image we have of a class of objects is no more than a generalization based on all the particular objects in that class that we have perceived.

In accordance with the empirical attitude, Aristotle believed there was no essence of the state, no perfect form of justice. If we want to determine the nature of the best state, we must carefully compare all the states that exist and see which of their qualities help them to maintain smooth functioning and which tend toward instability. Aristotle and his students collected and studied the constitutions of more than one hundred and fifty states before he decided what the best (not the ideal) constitution of a state should be. He held that there were naturally three types of government: rule of one, or monarchy, which tended to become tyranny; rule of the few, or oligarchy, which easily turned into timocracy; and rule of the many, or democracy, which tended to degenerate into anarchy. Aristotle decided that the most stable, and, therefore, the best, form of government was a mixture of the three extremes in a balanced constitution.

In Aristotle's view, the goal of both the state and of the individual life was human happiness. In his conception of happiness, Aristotle was governed by the Greek ideal of moderation. Excess of pleasure

would ultimately bring as much unhappiness as pain itself. The best life, like the best state, was characterized by balance and harmony. The happiest man was he who spent his life in contemplation; the philosopher fulfilled man's highest potential and was therefore the happiest of men.

In all his investigations, Aristotle's method was based on observation and experiment, and he applied himself to almost all possible fields of inquiry. Through collection and examination of specimens, he and his students undertook an extensive biological classification. The definition and categorization of all aspects of physics, astronomy, logic, metaphysics, and even poetry, also occupied his attention. In every field, his contribution was not surpassed for many centuries.

Plato had answered Socrates' objection to the natural philosophers—that they could answer *how* things happened but not *why*—with his idea of the eternal and perfect transcendent forms. Aristotle then countered with the concept of the perfect Unmoved Mover, which set the universe in motion yet itself remained unchanged. Since it was perfect, all things desired it; therefore, it was both the originator of the universe and its justification.

When Aristotle died, his students at the Lyceum carefully compiled their lecture notes, and it is in this version that many of his works have survived. However, none of Aristotle's many students was equal to his teacher. Aristotle was the last of the great classical Greek philosophers. Both Plato and Aristotle, who wrote after the Peloponnesian War, had tried to find solutions to the moral, political, and philosophical problems presented by the tottering polis system. But it was Aristotle's most famous pupil, Alexander the Great, who would complete the destruction of the political and cultural world of the Greek polis.

* * *

The Greeks, and particularly Athenians of the fifth century B.C., were founders of Western culture, because they were the first people to think critically about the dimensions of human nature. The Greek view of life was to be challenged in some crucial aspects by doctrines stemming from other cultures that contributed to the shaping of Western civilization, particularly the Hebrew and Christian cultures. But these alternative views of life could never eradicate the Greek her-

itage. On the contrary, the best these other systems could do was to adapt the Greek heritage and mold it into a novel synthesis. Unlike the Jews and Christians, the Greeks lacked a divine revelation that spelled out an elaborate philosophy of life. Greek thinkers had to begin by examining human experience, and they constantly went back to human experience, in order to collect the data for reflecting on the realities of human life. "Know thyself" was the prime injunction of Greek thought.

When the Greek considered himself and the observable world, he was impressed by the fact that nature was an ordered structure, a great chain of being, that rose from the purely physical and inchoate to the purely intellectual and perfectly formed. In the middle of this linked structure of existence was man, at once physical and intellectual, somewhere between formlessness and perfect form. This middle position was at once man's glory and his agony. He was part of the physical world and yet participated in pure mind.

Man's centricity in the chain of being, and the ambiguity of his condition—how like a god, yet how mortal—are the assumptions that underlie all of Greek tragedy. This is the theme of which the poets sing: to be so close to godlike immortality and yet, like the physical world, to be so vulnerable to mutability and decay. In Sophocles' lament:

> . . . *Only to gods in heaven*
> *Comes no old age, nor death of anything.*
> *All else is turmoiled by our master Time.*
> *The earth's strength fades, and manhood's glory fades,*
> *Faith dies, and unfaith blossoms like a flower.*[1]

Against this pessimistic conclusion, the philosophers stressed the intellectual and, therefore, eternal aspects of human nature that somehow can prevail over chaos, decay, and mortality. In a doctrine that was to become central to Christian thought, Plato defined man as "a living and mortal creature," who is "a composition of soul and body." The soul is temporarily held within the "earthly frame" of the body,

[1] Translated by Gilbert Murray.

but it comes originally from the divine, and to the divine—"the Very Being . . . the intangible essence"—it will return if properly nurtured. Aristotle avoids Plato's flamboyant mysticism, but for all his cautious empiricism and academic precision, he comes to much the same optimistic conclusion about the possibilities of human nature:

> *We should not listen to those who tell us that . . . mortals should think like mortals, but we should achieve immortality as we may, and strain every nerve to live by the highest things in us . . . Man finds the life of Reason best, since in it he finds his true nature.*

The philosophers' doctrines came late in the development of Athenian thought, when the polis was undergoing great upheavals and tottering to its extinction as a political community. To the best minds of the polis in its best days—the poets—the philosophers' emphasis on the unlimited possibilities of the human mind and their promises of immortality through union with Divine Mind or Reason would have seemed dangerous arrogance, going beyond the conditions of humanity known from experience. The ambiguous character of human nature—man's greatness and his weakness, the uncertainty of how much he can do, although he can do much—this is more central to the Greek view of life. The impassioned conservatism of Aeschylus, writing in the middle decade of the fifth century B.C., gets closer to this central Greek view. Aeschylus is forever warning man not to go beyond the possibilities of his nature, not to equate himself proudly with the gods. Remember, says Aeschylus, in one of his cryptic aphorisms, that

> *Righteousness is a shining in the smoke of mean houses.*

The "just man" for Aeschylus is always conscious of human limitations; he knows that man cannot do what the gods can dare. Aeschylus reminds his audiences continually of "necessity's yoke" and asserts that "wisdom comes alone through suffering." Man must not overreach himself. The gods (or, as we might say, the order of the universe) will strike down arrogance, that "sinful Daring."

Rome

*A*lthough the great Hellenistic kingdoms dominated the ancient Near East politically as well as culturally, competition among the three kingdoms in the eastern Mediterranean neutralized their influence and allowed even small states like Rhodes to attain substantial power and prosperity. Hellenistic political expansion toward the west was inhibited by the presence there of vigorous states. Throughout the period of Greek predominance in the Mediterranean, the power exercised by the rulers of Italy and northern Africa limited the extent of Greek colonization. When Phoenician maritime control in the western Mediterranean declined, Carthage, itself originally a Phoenician colony, took its place and ruled without effective opposition. The tribal states of the Italian peninsula also competed with the Greeks in the west, and, in Sicily and southern Italy, these people fought the Greek colonists for control of the land as well as the sea.

The earliest foes of the Greeks in Italy were the Etruscans. Although they possessed a relatively sophisticated culture themselves—a culture marked by organization, good technology, and considerable literacy—the Etruscans learned much from the Greeks while fighting them. Gradually, the Etruscans established dominion over much of Italy and developed a flourishing international trade. Fusion of the Etruscan cultural heritage with that of other Italian tribes and, most important, with that of the Greeks resulted in a distinctive, highly developed artistic style that later had significant influence on Italian cultural history.

It was probably the Etruscans who established Rome as a city. The hills that became the site of the city of Rome were inhabited by several Latin tribes (one of which was later called the Romans), and on these hills was a group of villages, not yet a city as such. Under Etruscan

overlordship, the villages of this loose federation of tribes were transformed into a city ruled by an Etruscan king. From the institutions created during this monarchical period, the Roman city-state emerged. The nature of the government of the kingdom is only vaguely known. It appears that the king, assisted by a senate of tribal elders who possessed advisory powers, exercised military, legal, and religious functions. An assembly of men capable of bearing arms played a largely passive role in government, though it may, in fact, have elected the monarch.

About 500 B.C., the Latin tribes of Rome divested themselves of the Etruscan monarchy, and, over the next two centuries, they fashioned that form of government we know as the Roman Republic. Its main characteristics were an executive branch consisting of elected officials; ruling oligarchy; written public law; and an administrative structure capable of governing the state efficiently. The result was a complex but effective governmental system.

<p style="text-align:center">* * *</p>

Supreme political, military, and legal power in Rome was exercised by two annually elected officials—the consuls. In them, the Republic invested the imperium—that is, the ultimate legitimate authority— which had been previously attached to the now-deposed kings. In the early Republic, the consuls and the Senate, over which they presided, all belonged to a very narrow hereditary oligarchy known as the patrician class.

The patrician families traced their lineage to the original Roman tribes. Because the Roman Republic, like the earlier Roman kingdom, was at first an elaborate system of tribal government, those Romans who were not members of patrician families were excluded from political power. This situation seemed only right to the patricians, who considered Rome their creation and preserve. To the other class of Romans—the plebeians—the logic of the patrician claim to exclusive control of the Republic was less than persuasive. The plebeian class comprised all those who belonged to Roman families not considered noble, or who were members of non-Roman tribes that had dwelt in Rome for generations. The plebeians were Roman citizens and shared with the patricians the obligations of citizenship—most important being service in the Roman army—but the tribal and familial origins

and operations of early Republican government precluded plebeian participation.

The prime motif of the first two centuries of the Republic was the struggle of the plebeian class to gain some kind of parity with the patricians. Their principal weapon was the threat of secession; they prepared (and, several times, actually carried out) a complete with- drawal from Rome in order to establish a new state of their own nearby. The patricians were most responsive to this kind of pressure, because plebeians made up the bulk of the military force of Rome. Therefore, at the end of the fifth and during the fourth century B.C., the patricians made a number of important concessions. The most important plebeian victories were represented by the publication of the fundamental laws of Rome in the Twelve Tables, stating the ple- beians' right to be elected to the higher offices of the state, to marry into the patrician families, and to elect tribunes—a new kind of public official whose sole duty was to protect plebeians against the power of other officials. Each tribune was a sort of walking Bill of Rights, a sacrosanct person who could be entreated to veto the actions of any officer of the state—even the consuls, even the Senate.

These gains were only a beginning, but they were essential if the plebeians were to keep pace with the great families whose wealth and influence were increasing with the growth of Rome and the refinement of its organs of government. Rome was still run by an oligarchy, although a broader one, whose influence and position in the state were unique. Once the plebeians were granted access to high office, the prime vehicle for oligarchic domination of Rome proved to be the Senate.

The Senate became the most important organ of Roman govern- ment. Since it was composed of those who had served in high adminis- trative posts, the vast majority of its members were from a few old and distinguished families. As the plebeians gained status in the state, membership in the Senate had less and less to do with being plebeian or patrician but depended rather on relationship to the most ancient and influential families. Patricians and wealthy plebeians, bound together by mutual interest, formed what was, in effect, an exclusive alliance. Only rarely could a "new man," from outside these families, gain one of the highest offices in the state, even if he had the backing of powerful aristocrats.

The Senate was powerful not only because it contained the most distinguished statesmen in Rome but because membership was for life. Elected magistrates—the executive and administrative officers—served for one year or, at most, a few. Only the Senate could consistently carry out any long-term policy. Furthermore, the Senate controlled the finances of state, and international affairs, and these rapidly became the most important aspects of government.

Popular assemblies could check the power of the Senate in some cases, but, more often, were dominated by it. The two important popular bodies were the Centuriate Assembly and the Tribal Assembly, which ratified acts of state and elected the important magistrates. The Centuriate Assembly was based upon the elements of the army (centuries), and, in it, the wealthy classes almost always could outvote the others. Political maneuvering played a part, but wealth had greater influence simply because, in the early Republican army, those who could afford the best equipment were more often called for service. The Tribal Assembly was based upon regional grouping in Rome and was more responsive to the less influential classes. The power of the Tribal Assembly grew over the years until finally, after 287 B.C., its decisions—the *plebiscitum*—made binding law for all Romans, even without ratification by the Senate.

This change enormously increased the legislative role of the average citizen; combined with the creation of the tribunate, it meant that power in Rome was no longer a monopoly of the few. Nonetheless, initiative and prestige remained with the Senate. Executive authority was in the hands of elected officials who were still usually from the upper classes. The scions of great families pursued careers in service to the state, careers that usually culminated in appointment to the Senate.

As the Republic flourished, its citizens preferred to create new state offices or to change, almost imperceptibly, the functions of old institutions rather than to overthrow the fundamentals of traditional Roman law and custom. The new offices indicated the growing complexity of the Roman state. The office of censor was established to take a census of the citizens in order to determine their property qualifications for service in the various and differently equipped elements of the army, to assign contracts for public works, and to bar the ineligible from membership in the Senate. One of the most important offices established early in the fourth century B.C. was the praetorship. The praetors, sec-

ond in power only to the consuls, were the chief Roman judicial officials, responsible for interpreting the law. The interpretations set down by the praetors became an important source of Roman law, supplementing the laws recorded in the Twelve Tables and the unwritten Roman legal traditions. Praetors also had military functions.

The quaestors were at first assistants to the consuls, who served as paymasters for the army. But as Rome grew and the financial machinery of the state became more complex, the quaestors became the officials in charge of tax collection and recordkeeping for the state. The position of quaestor was usually the first held by a Roman who aspired to high office. It possessed no imperium, required hard work, and was a test of a man's devotion to the state and to government service.

The development of the public institutions of the Roman state was paralleled by a change in the position of the individual in society. Primitive Italian society was tribal. Each tribe was made up of a group of families that could (at least in theory) claim a common ancestor, and each tribe had, in its orbit, a group of clients, men who were "protected" by the tribe. Property belonged to the tribe as a whole, and, in war and politics, the clan acted as a unit. In the early Republic, however, the Roman army was reorganized and restructured according to an altered concept of the individual. It was organized not on the old tribal basis but, instead, in units called "centuries," and it was supported by the property of the individual soldiers.

The original Roman Republican army was no more than a variation of the Greek phalanx. The richest and best-equipped citizens brought horses (thus their title *equites,* literally "horsemen") and constituted the cavalry. The centuries of foot soldiers filled their various ranks with the poorer and more scantily equipped soldiers, to whom were assigned positions farther back in the ranks of the phalanx, in keeping with their less effective arms and armament. The poorest men, who could not arm themselves at all, were called proletarians and did not serve in the army. Because it was based on this military system, the Centuriate Assembly gave preference to the wealthy men of the front ranks, who were more often called for service. The growth of a system of private ownership of property, and the emergence of the individual family (rather than the tribe as a whole) as the basic unit of society, are reflected in this change. The father, or paterfamilias, now exercised the

authority—including the power of life and death—that formerly had belonged to the tribe.

The founding of the Republic brought important changes in religion. The primitive religion of the Latins and Etruscans envisaged a world full of spirits and powers that had to be propitiated by sacrifice and prayer. Although Roman religion, as it developed in the Republic, never lost its undercurrent of superstition and taboo, it became more and more a state religion, centered in temples that incorporated various Latin, Etruscan, and Greek religious ideas. Thus, Janus, previously a household god who guarded the door, became the guardian of a sacred gateway through which Roman armies marched to war. The gate was closed only in peacetime. Vesta, the goddess of the hearth, was honored in state temples where Vestal Virgins guarded the eternal fire. Mars, originally an agricultural god, now played an important role in state worship as the god of war. It was on the field of Mars outside Rome that Roman armies assembled.

Temples on the Greek model were erected in honor of the gods, who also tended to take on the anthropomorphic characteristics of the Greek divinities. A very important aspect of Roman religious organization was the group of priestly colleges associated with the temples. The members of the colleges were learned senior citizens. One group, the augurs, consulted the auspices—or omens—which were believed to foretell the future. The government could not take action, nor could war be waged, if the auspices were bad. The pontiffs constituted another priestly college. As guardians of religious law and the state archives, they effectively controlled jurisprudence. The pontiffs may at first have interpreted the meaning of the laws that were inscribed on the tablets entrusted to their keeping, but, by the period of the late Republic, this judicial function was certainly outside their province. A third priestly college was composed of the keepers of the Sibylline Books, an ancient collection of statements by Greek oracles, which, in the Republican period, were thought to hold the secret of Rome's destiny.

By the end of the Republic, secular political officials were able to bypass the religious institutions. During the Punic Wars against Carthage, for instance, the sacred chickens refused to eat—an omen that was supposed to prohibit the movement of the Roman navy. But the commander ordered the chickens thrown into the sea—thus

demonstrating that religious observance had become only a meaning-less formality for the state, though the tradition of obedience to the father (and therefore to the magistrate), which was derived from obedi-ence to the gods, remained strong.

Neither religious ritual nor religious institutions dominated the moral and political life of the Romans. At the heart of Roman beliefs, and Roman political and military strength as well, was devotion to one's family. The worship of ancestors was an integral aspect of fam-ily life. Virtue, for the Romans, consisted in the upholding of family honor. This meant perseverance and honesty, attention to duty, courage on the battlefield, and serious application to the obligations of state service. A man was the incarnation and current bearer of his fam-ily's honor. To fail, to be craven, dishonest, or even inefficient, marked all his forebears with infamy. Just as their deeds and their name hon-ored him, so did his deeds or misdeeds accrue to their eternal account.

The early Republican period witnessed the application of this morality to the state as well. The state or commonwealth of Rome was the *res publica*, "the public thing." This entity, which encompassed all Romans, called forth the same unquestioning devotion that was lav-ished upon the family. The efficiency and success of Roman arms and Roman government may be traced directly to the citizen's efforts to serve his family and his state with honor and glory.

Rome thus provides a case of remarkable political consensus. There were antagonism and bitter conflicts over power and the opera-tion of the state machinery, but these were confined to those elements of society that were trying to gain a larger share in the operation of the state or to place themselves closer to the centers of privilege and posi-tion. The social wars and class conflicts of the Republican era were not revolutions to overthrow the state; they were power struggles among groups devoted to the *res publica* as such. This meant that few opposed the idea or the pursuit of Roman perpetuation and aggrandizement. It was virtual unanimity on this score that supplied the strength and focused the purpose of Roman expansion, and thus helped to bring about Rome's conquest of Italy and the Mediterranean world.

* * *

The rest of Italy, except for the Greek cities in the south, continued to reflect the original diversity of the peoples inhabiting the peninsula.

Etruscan power had declined steadily as Rome's had risen, and more than thirty different tribal-political groups surrounded the young Roman state. During the fourth century, Rome subjected all of them to Roman authority, defeating or forming alliances with every one. As Rome engaged the Etruscans and Samnites for control of an ever-widening area of Italy, the old loose alliance of cities that had characterized Roman foreign relations was abolished. In its place, Rome created new forms of alliance with the other Italian states. Some cities were partially incorporated into Rome and received so-called "Latin rights." These included the preservation of their own constitutions, the right to own land in Rome, equal status in Roman courts, and the privilege of marriage and trade with Romans, but not the right to take part in Roman politics.

Other allies had "Italian rights" that permitted them to retain local governments but did not allow them to pursue independent foreign policies or grant them social and economic liberties on a par with those of Romans and Latins. In those areas most difficult to control, where the local population was most resistant or backward, Rome established colonies of citizens who retained full Roman rights in their new homes. These colonies were extremely successful in subjugating the frontier regions, where they acted as effective military and political bastions of Roman authority. With other Italian cities, Rome formed alliances that involved little more than the obligation to supply troops in time of war.

Thus, Rome gradually assured the allegiance of other Italian states. The system was severely tried before Roman control of Italy was secured, but it met the test, demonstrating an originality and flexibility in foreign affairs that would be essential in the era of Rome's Mediterranean conquests.

In 280 B.C. the Greek cities of southern Italy invited Pyrrhus of Epirus to come over and lead an army against the rising Roman state. Pyrrhus, well-equipped and an able general, accepted the opportunity to increase his power. Using the Greek cities as a base of operations, he invaded Italy in the hope of breaking up the Roman system of alliances and thereby isolating Rome. Although Pyrrhus won several important battles, his losses were great (hence, "Pyrrhic victory": win the battle, but lose the war), and he failed to break down the allegiance of the

Italian cities. Unable to invade Rome or even to harm the Republic significantly, he returned to Greece a failure. One of the first important victims of Roman tenacity, Pyrrhus left Rome in control of virtually the entire Italian peninsula.

* * *

The other great power in the Mediterranean world was the North African state of Carthage, which had constantly extended its empire and trading connections around the Mediterranean since the time of Etruscan domination of Italy. Carthage was a western buffer against the spread of Egyptian power in North Africa and against the Greek cities of Sicily and southern Italy. Carthage and Rome were natural allies against the Hellenistic kingdoms and the Greek cities of the eastern Mediterranean, and for a long time maintained cordial relations. But war between the two powers broke out in 264 B.C., and their enmity did not finally cease until 146 B.C., when the city of Carthage itself was completely destroyed. In the intervening years, the Romans and Carthaginians fought three exhausting wars. Rome was, at first, much the weaker of the two, but, during the course of the Punic Wars (so named from the Latin word for the Phoenicians, who settled Carthage), a powerful Roman army and navy were developed. When it took over the imperial possessions of Carthage, Rome became a major Mediterranean power.

The first of the three Punic Wars (264–241 B.C.) broke out when Roman intervention in Sicily provoked a declaration of war by Carthage. Rome was a land power, and Carthage controlled the sea when the war began, but Rome saw the need for a navy and constructed one in an incredibly short time, training rowing crews on land while the ships were being built. Rome triumphed at sea—largely because of tactical innovations by the Roman fleet—but the main cause of the North African defeat was a lack of interest in the war on the part of powerful interests in Carthage, which, at a crucial point in the war, allowed a large part of the Carthaginian forces to be withdrawn to support expansion in Africa.

The Carthaginian defeat gave a significant impetus to Roman expansion in the Mediterranean and led to an important development in Roman government. Now, for the first time, Rome was a naval power, and, also for the first time, it controlled territories outside Italy.

Sicily and Sardinia were taken over as part of the indemnity exacted from Carthage, but Rome could not administer them in the manner that had worked so well in Italy. These islands had long been part of the Carthaginian Empire, and Rome was compelled to treat them as imperial possessions, governed by praetors who were empowered to rule and administer according to their own discretion. Thus appeared the first Roman provinces; they were different from the colonies and allied states, since they were more completely dominated by Rome, and they served as models for future imperial administration.

The power of Carthage was still far from destroyed. In spite of the defeat, a succession of brilliant generals considerably extended Carthaginian influence, particularly in fertile and strategic Spain. The Second Punic War was not long in coming. In this war, which lasted from 218 to 201 B.C., Rome itself was threatened for the first time since Pyrrhus had invaded Italy. The general in charge of the Carthaginian forces was Hannibal, to whose military genius the conquest of Spain was due. Using Spain as his point of departure, he invaded Italy from the north, crossing the Alps with his large army. It was Hannibal's plan to break up the alliance system by which Rome controlled Italy, to use Italy as a base of operations, and, with the aid of reinforcements brought by sea, to conquer Rome itself. For a time, Hannibal seemed invincible. He traversed the length of Italy, and the Romans lost disastrously whenever they faced him in battle. But, in spite of the Carthaginians' victories and their bases at Capua and Tarentum, most of the Italian cities held firm in their allegiance to Rome, and Hannibal was unable to destroy Roman determination to resist. Hannibal's superiority in the field forced the Romans to play a waiting game, which finally paid off. The government at Carthage failed to provide him with sufficient reinforcements, and the Roman armies defeated Carthaginian forces in Spain and destroyed a relief army commanded by Hannibal's brother, whose head they subsequently tossed into Hannibal's camp.

The final Roman blow to Carthage was the invasion of North Africa, a strike that forced Hannibal to return home in order to defend Carthage itself. His opponent, the Roman general Scipio, was a serious student of Hannibal's tactics, and the Carthaginians were annihilated at the Battle of Zama. Carthage was forced to surrender, and extremely

harsh peace terms effectively ended its power. In addition to paying a large indemnity, Carthage lost its entire empire outside Africa and was forbidden to raise an army without Roman permission.

Rome took over all of the Carthaginian Empire in western Europe, and, though the task of effectively subjecting Spain to Roman authority remained, Rome was clearly in control of the western Mediterranean. When Carthage was forced to raise an army to defend itself against a rival African state, the Romans invaded for the third time, besieged Carthage, and finally crushed it. The Romans destroyed the city itself (146 B.C.), killed and enslaved many of the inhabitants, and added the Carthaginian territories in Africa to the growing sphere of Roman domination in the western Mediterranean.

* * *

In the intervals between the three Punic Wars, Roman armies were not inactive. The sacred gateway of the god Janus remained open as Roman armies marched through it to the east as well as to the west. Roman intervention in the Hellenistic world, at first a series of minor police actions, was rapidly escalated to the level of a full-scale invasion bent on the destruction of any Hellenistic kingdom that might challenge Roman interests. The first Roman interventions in the Near East were aimed at the Macedonian state—the closest of the kingdoms as well as the one whose Alexandrian heritage made it appear the most dangerous. The Romans defeated the Macedonians, collected an indemnity, and then withdrew, demanding that the Macedonians guarantee the independence of the Greek cities.

Such leniency typified the first stage of Rome's relations with defeated Mediterranean enemies, just as ruthless ferocity marked the following stage. Roman rule, which generally supported the status quo, or rule by rich landholders, was hated, and a revolt brought on the Macedonian War of 171–167 B.C. When the Macedonians and their Greek allies were defeated, many cities were destroyed, their treasure sent to Rome, and their populations killed or sold into slavery. In addition, the right of the Greek cities to form leagues was eventually denied. The Macedonian state was divided into four separate republics, which were in fact under Roman control. In the future, Rome would cruelly suppress any attempt at revolt on the part of the Greek world. Greek independence ended.

A similar policy was followed with regard to the Seleucid Empire in western Asia. Using the services of Hannibal, who had escaped execution only by exiling himself from Carthage, the Syrian rulers attempted to halt the spread of Roman power. They, too, were decisively defeated, although their domains were not immediately converted into Roman provinces. Hellenistic kings were forced to serve Roman interests, and any attempt to organize wide-scale military action of any kind provoked immediate reprisals by Roman legions.

By the middle of the second century B.C., half a century of Roman intervention and the incessant power struggle among the three great Hellenistic monarchies left the Hellenistic world in a state of economic and political chaos. The Romans did not exercise systematic political control, or allow anyone else to do so. The population declined disastrously, especially in Greece. Families with more than two or three children were a great rarity. (The exposure of infants was practiced on a wide scale, to limit the size of families.) Constant warfare and the desire of each kingdom to be economically self-sufficient diminished trade. In addition, the cruelty of Roman reprisals for resistance often destroyed important trade centers, and trade relations and political institutions suffered frequent severe dislocations. The earliest phase of Roman imperialism in the east was, therefore, mainly destructive, and Rome was widely hated throughout the Hellenistic world.

By 140 B.C., the Roman Republic was the greatest power between Spain and the Euphrates. Although it did not actually govern or even effectively control all the land in between, there was no power in the world that had proved capable of standing for long against the might of the Roman army. The Roman Republic had not formally been enlarged by the annexation of territory outside of Italy, but, through armies, diplomats, tax collectors, and administrators in the conquered lands, it controlled the public affairs of millions of people scattered throughout the Mediterranean world. The agency through which this vast domain was controlled was still the Roman Republic and its citizens. On paper, the Roman state had changed little in its essentials. In actuality, the Rome of the last half of the second century B.C. bore little resemblance to the Rome that had trembled before the army of Pyrrhus in the third century.

* * *

In every respect, Rome had become a giant. The Roman Republic was too large and too diverse to be called a city-state any longer; and the city itself was now a sprawling metropolis, as was fitting for the political and economic center of a vast empire. Its growth had kept pace with the expansion of Roman power in Italy and the Mediterranean world, and, in the first century B.C., its population was about one million. The citizens of allied states—at first only Latins and Italians—settled in Rome to gain readier access to the expanding prosperity of the Roman state. And the city's population was swelled by other immigrants: some had taken refuge there from the depredations of Hannibal's army, and some had come because successful small-scale farming was now all but impossible in the areas closest to the city. The acquisition of more distant territories and greater international influence made Rome a magnet attracting merchants and traders, soldiers on leave and veterans mustered out with nowhere else to seek their living, and opportunists from every corner of the world. In addition to the large proletariat, most of whose members were unemployed, there were many slaves, the property of the prosperous.

The growth of the city produced enormous municipal problems that called for the expenditure of much money, effort, and administrative skill. Housing for the poor, better sanitation, and some sort of policing had to be provided. These projects made it possible for Rome to support such a vast population, and later measures sought to provide cheap or even free food.

Thus the city of Rome became a sprawling, multiracial community, encompassing some of the wealthiest and some of the poorest people in the world. The streets were usually crowded and dirty, and passage through them at night was a mortally dangerous affair. The litter of a wealthy nobleman, borne above the crowd on the shoulders of his slaves, might pass convoys of goods from distant parts of the empire. The hustle and bustle of the city might be disturbed by a riot, often one with political implications. The death of an important man, the report of an unfortunate turn of events abroad, or a food shortage could bring together a mob at a moment's notice. Crowds were also quickly attracted by the plays, festivals, and games that played an increasing role in city life. Rome was a place of excitement, opportunity, and frequent danger. It was clearly the hub of the world.

The large Roman proletariat came not only from the far reaches of the Empire; it was also composed of Roman citizens whose roots were in the small farms that had dotted the Italian countryside. By the end of the second century B.C., the system of small farming by individual citizen-soldiers had given way to large plantations (latifundia), worked mainly by slave labor. These plantations had come into being partly because rich men made more profit by running extensive farms worked by gangs of slaves than did independent farmers practicing intensive, small-scale agriculture. Another important factor in their development was the deterioration of the farming land that had been suitable for grain production in large portions of central Italy. This deterioration was due partly to soil exhaustion and partly to the terrible devastation caused by Hannibal's army and by the scorched-earth policy of the Roman defenders in the Second Punic War. Extensive cultivation of vineyard and olive trees and the raising of cattle were all that this land was now good for, and such pursuits were best carried out by slave labor. The wealthy men purchased the farms of small landowners and combined them into the huge latifundia.

The small Italian farmer was becoming obsolete. Now he swelled the size of the crowds who consumed imported grain (principally from North Africa) and lived in the wood-frame tenements that pushed against each other on the back streets of Rome. The Roman government was confronted with the problem of feeding a huge population of unemployed.

The government also had the problem of maintaining the strength of the army. The old ideal of the Roman soldier—a farmer who traded his plow for a sword when a crisis arose, and returned in a few days or weeks to harvest his crops—was no longer attainable. There were fewer and fewer citizen-farmers to fill the ranks. Campaigns often went on for years, and the number of legions in the Roman army rose steadily in proportion to Rome's military commitments around the Mediterranean. Rome needed a huge army capable of constant service in distant places for long periods. Such an army rapidly became more and more important in the political affairs of Rome.

Every general faced the problem of paying off his troops at the end of a campaign. The usual practice had been to settle the troops on Italian land, but the spread of huge plantations meant that very little

land was now available. Once released from long years of duty abroad, many soldiers stayed in the provinces, but others, who had no land (after a fifteen-to-twenty-year tour of duty, many would have lost all taste for farming anyway), returned to swell the population of the Roman metropolis.

Since the practice of using citizen-soldiers, or of properly rewarding them after service, could no longer be continued, the Roman army was eventually transformed to meet the requirements of world power. The professional army that was developed in the first century B.C. was largely the creation of the often-elected consul Marius. Arms were standardized, tactical innovations introduced, recruitment and length of service revolutionized, and the composition of the forces totally changed. All foot soldiers now carried a stabbing sword, which was very useful in vicious hand-to-hand combat, and a short javelin—a missile of great effectiveness in siege operations. These standardized weapons and the division of the legions into cohorts gave the army combat units whose mobility matched their lethal strength. Soldiers were recruited from most classes and areas of the Republic, and served with one legion for sixteen years.

The Republican citizen-soldier had lavished his loyalty on the state, and his reliability had been based upon his devotion to the honor of his name, his family, and his country. Now this fervor was equaled by the loyalty of the Roman professional soldiers to their commanders, their comrades-in-arms, and the legions in which they served. Discipline was harsh, but rewards for valor were given as swiftly as was punishment for failure in duty. The soldiers felt they could depend on one another; their communal spirit translated itself into a conviction that Roman armies were invincible. And such sentiments were enhanced by the knowledge that conquered territories would be plundered and booty supplied to all who had brought about the victory. It was a confident and efficient force. This was the army that completed the conquest of the Mediterranean world, the army of Caesar and Augustus, the enforcer of the imperial *Pax Romana*, or Roman peace.

Rome's victories abroad fed a steady stream of slaves and political prisoners in Rome. Not only were plantations run on slave labor, but slaves were used extensively in the elaborate households of the Roman upper class. Captured foreigners from the Hellenistic world were espe-

cially in demand, since many of them were more highly educated than their masters—the historian Polybius (ca. 200–ca. 118 B.C.), for example, was a Greek hostage held at Rome along with the sons of other prominent Athenian families. Such men formed a major vehicle through which the Hellenistic culture of the Near East penetrated all aspects of Roman society.

* * *

Greek culture had been an important influence on the Etruscans and Carthaginians, and since Rome had had prolonged contact with these peoples, there had already been a long tradition of Roman assimilation of Hellenistic ideas. But with the conquest of the Near East by the Roman armies, the trickle of Hellenistic culture turned into a veritable flood. The conquered eastern states had a highly developed, flourishing culture based on centuries of tradition, a vast literature, and a large and active intelligentsia concentrated in cities like Athens, Rhodes, and Alexandria. The Romans had nothing like it in either quantity or quality. They fought and governed brilliantly, but they had little original literature or philosophy, and their art, though possessed of considerable vitality, was largely derivative. The acceptance of Greek culture was opposed by many aristocratic Romans, who associated it with the corruption of Roman morals and with the changes that contact with the Near East had wrought in Roman politics. But resistance was useless; the attraction the rich Hellenistic culture held for the Roman aristocracy was irresistible.

The Greek language was not only the literary language of the age; it was the language of diplomacy. More and more in the next century, a truly educated Roman would know Greek as well as Latin. Roman children in upper-class homes had Greek tutors, and when they learned to read, they learned Greek and Latin simultaneously. At the same time, Greek texts were constantly being translated into Latin. The young Roman of the late Republic studied both Latin works and Greek classics such as Homer's epics.

Greek philosophy dominated the outlook of the Roman educated class. The greatest of the philosophers of the Republic was Lucretius (ca. 96–55 B.C.), who adopted the views of Greek Epicureanism in his Latin poem "On the Nature of Things." Through his explication of the atomist view of the universe, he hoped to free man from the fetters

of superstitious religious belief. But, for the Roman aristocracy, Epicureanism was too much a philosophy of withdrawal and individualism. Stoicism, with its emphasis on the ethical duties of the individual in society, was much more compatible with the Roman ideal of public service, and, consequently, this philosophy was eagerly accepted by the Romans of the late Republic and early Empire. It suited the political and military needs of the Romans as well as their predisposition to loyal service. The Stoic ethic of unemotional acceptance of effort and trial permitted a man to rise above his limitations and persevere in the face of all difficulties.

It was Cicero (106–43 B.C.) who articulated much of Republican Stoicism. Although a "new man," he was a consul and also a member of the Senate, where he applied the principles of Greek rhetoric and became one of the most famous public speakers in history. When his political fortunes were at a low ebb, he retired to his country estates to write. He viewed the success of the Roman Republic in the light of Greek political theory about the viability of mixed governments composed of monarchic, oligarchic, and democratic elements, and he described the ideal Roman politician in Stoic terms.

For Cicero, the ideal, noblest Roman was the man who spent his life in service to the state. Men whose interests were wholly private, or whose ambitions were essentially personal, were small men. Cicero praised education and lauded the acquisition of literary skill not for their own sake but for their contributions to the qualities of mind and spirit that a man needed to function as an effective leader of society. Cicero's ideal became the basis of European humanism and, thus, the theoretical touchstone for the education of the governing classes of Europe for almost two thousand years.

The works of the poet Catullus (ca. 84–54 B.C.) present an evocative counterbalance to the idealism, public-mindedness, and optimism of Cicero and most other Roman writers. Catullus exposes a side of Roman life and Roman feelings that we seldom encounter. The many Europeans who for centuries celebrated the virtues of Stoic Rome usually sidestepped the sentiments of Catullus, whose views seemed to deny much of what they liked to think was the totality of the Roman spirit.

Catullus's poems reveal the existence of a vein of pessimism, individualism, deep personal feeling, and self-indulgent eroticism, that seems quite out of keeping with the traditional vision of self-sacrificing

Roman will. His morality is cast exclusively in the context of this world and this time. It recognizes the mortality of man, the tenuousness of his control over his world, and the fatuousness of elaborate idealism. One short poem of Catullus gives us a taste of what was surely a position taken by many Romans, both of the Republic and the early Empire:

Let us live, my Lesbia,
And let us love,
And let us value at not a penny
All the words of crabbed greybeards.

The sun can set and the sun can rise again,
But as for us mortals,
When once our little day is done,
There is but one eternal night for sleeping.[1]

Many aspects of Greek culture were molded to fit Roman social ideals. Treatises on husbandry supplemented the philosophical works of major Roman writers, because, ideally, the Roman gentleman was a gentleman farmer. Similarly, the study of rhetoric, largely devoted to logic and literature in Hellenistic society, was applied by the Romans to the study of law. Greek law, based on the concept of equity, did not demand a detailed study of precedent and documentary evidence as did Roman law, which depended on custom and tradition in addition to equity. The Roman gentleman, therefore, learned the dialectical method of argument not in order to debate on the nature of reality but primarily to elucidate the intricacies of Roman law.

The work of late Republican writers steadily increased in quantity and became more varied in its forms and interests until, at last, in the early imperial period, it merged with the literature of the Augustan Age. Perhaps the best-known writer, although more famous for his nonliterary exploits, is Julius Caesar (100–44 B.C.). In his *Commentaries on the Gallic Wars*, Caesar tells us much about the kind of man he was. His writing—and the very fact that he undertook it at all—demonstrates qualities of vigor and purposeful intellectuality admirably fitting in a Roman leader. His direct, matter-of-fact exposition makes it clear that here is a man who

[1] Translated by N. F. Cantor.

would drive himself, his army, and his nation to the limit, carrying all before him. Caesar typifies an important strain in the Republican Roman character: a toughness, practicality, and seriousness that allowed the Romans to get the big jobs done.

Caesar's *Commentaries* gives his view of one such big job, the conquest of Gaul. The vast territory that extended from the Mediterranean to the English Channel to the Rhine was inhabited by fierce and able Celtic tribes. The tenacity of their resistance to Caesar was tremendous, though only a shadow of what it might have been if the tribes had been able to smooth over their differences and unite against the Romans. Still, Gaul fell to Caesar only after long, bitter, and costly campaigning. Another contribution of the *Commentaries* is the account of the strong bonds between the commander and his troops. It is clear that the old Republican legions were now virtually the personal forces of their generals, giving the army cohesion and effectiveness in the service of Rome, but ultimately supplying the vehicle for the Republic's destruction; the professional, battle-hardened armies that followed these charismatic figures would be more faithful to their generals than to the state.

At one extreme of the late-Republican literary spectrum were the works of the comic dramatists Plautus and Terence. Plautus's plays, which catered to the desire of Roman audiences for broad slapstick, were marked by great gusto in celebration of life. Plautus wrote in the tradition of Aristophanes, and his comic vision was echoed in the works of Rabelais and Shakespeare. Terence, on the other hand, found his inspiration in the mannered plays of Menander and the so-called New Comedy. His work was more reserved and subtle than the broad and bawdy productions of Plautus. It was indicative of something in the Roman disposition that Plautus was by far the more popular. Perhaps the Romans were somehow expressing their deep need for respite from the growing seriousness of imperial responsibilities.

The writing of the conservative Cato the Elder (234–149 B.C.) represented the strong anti-imperial and even xenophobic strain in Republican Rome. Cato demanded a return to the public-mindedness and self-sacrifice of the early Republic—a pure and golden era not yet contaminated by the foreign influences, which Cato blamed for sapping Rome's vigor and corrupting its institutions. The historian

Polybius represented the opposite impulse in Roman life. He was a Greek and an intellectual—two things Cato scorned. But Polybius worked for Romans and wrote Roman history. And he helped evolve the concept of *humanitas*—the idea of the brotherhood of all men—which is one of the most important legacies stemming from Rome's conquest of the Mediterranean world.

Expansion deepened and enriched the Roman cultural experience, but it also brought about a great tension between the simpler, early Roman ideals and sophisticated foreign attitudes. In culture, as in politics, the acquisition of empire put great strains upon the ability of the Romans to digest all they had swallowed.

* * *

In education, the Romans discarded the Greek emphasis on dancing and music, these being considered too frivolous and effeminate for a Roman gentleman. Science and mathematics were often considered irrelevant as well. Instead, the son of a Roman aristocrat supplemented his Greek education by observing the Senate, in preparation for the day when he would be making important decisions as a member of that body. His military education was likewise based on practical participation. The young gentleman would spend a year on campaign in the ranks of the Roman army before moving on to a more responsible position. In later campaigns, he would serve as an officer.

The seat in the Roman Senate that the young member of the Roman aristocracy hoped someday to fill was the reward for a long apprenticeship in public service, for all men who had served as high state officials were made senators. The future senator would begin as a minor assistant of an administrator, and his political career would be marked by his advance from office to office until—elected for a one-year term by the assembly of Roman citizens—he held a praetorship or consulship. He might well spend one year in Rome, the next abroad, on campaign at the head of an army or in charge of some province. It was during his service abroad, as the administrator of conquered territory, or the governor of an established province, that the young man could make his fortune. There was fabulous wealth to be had in the provinces, especially in the rich cities of the Near East.

With the establishment of many distant provinces, imperial administration by Republican Rome entered a new stage. Rome had

begun its imperial adventure with alliances and colonies; now Rome ruled its conquered territories through officials who governed with almost regal powers. These men had to staff and maintain their own administrations, and the bureaucracy thus evolved did not resemble any modern, state-paid administration. Its members were supported by, and owed their loyalties to, the provincial governor, who paid their salaries and gave them a chance to profit by exploiting whatever opportunities the resources of the province provided. The provinces were not only taxed to support the Roman state; they were drained of their wealth by administrators set on gaining as much as possible from their powerful but temporary positions.

Having reached the proper age after serving his term abroad, the Roman aristocrat was ready to enter the Senate. Since virtually nothing in the Rome of the second and first centuries B.C. could move without the voting of funds by the Senate, and since the Senate had complete power in foreign affairs, the youthful senator was a part of the most powerful body in the entire Mediterranean world.

But by the end of the second century B.C., the power of the Senate was no longer unchallenged. A powerful class had arisen to threaten its position—the *equites*, or Roman knights. The wealthy families to which the *equites* belonged amassed their fortunes through trade, tax collection, and large-scale farming. Outside the narrow oligarchy of the fifteen to twenty "best" *gentes*—or clans—that had almost exclusively provided the members of the Senate, the knights pursued their own private interest—the acquisition of money—and, in time, represented a threat to the political power of the senatorial aristocracy. Conflicts between the two groups were a prime characteristic of Roman political life in the next century.

The senatorial families were extremely protective of their status and privileges. They had long been a self-perpetuating oligarchy; for generations, their members had served as magistrates and then senators, only to shepherd their children through the same cycle. But the composition of this class had very gradually altered. By the first century B.C., very few ancient patrician families remained. Most senatorial families had achieved their position through service in high office and, no doubt conscious of their own rise, were suspicious of such incursions by others. "New men" were very rare in Roman government and

were always looked down upon, but there had been vast changes in power and wealth in the Roman state, and the Senate came more and more into conflict with other groups in the population. Dissatisfaction among the *equites* and the dispossessed lower classes of Rome generated a constant challenge to the monopoly of political life held by the Senate.

The conflict was exacerbated by those members of the Senate who acted in ways that did not further the general interests of the state. The Senate was the only body empowered to judge the behavior of the administrators of provincial affairs, but there was in fact no effective way to control the conduct of senators or senatorial appointees abroad. Extortion of funds from the provinces was commonplace, and it proved disastrous for the local economies. Furthermore, the rapid turnover of administrative personnel—terms were normally one or two years, seldom more than five—meant it was impossible for long-term policies in the outlying parts of the empire to be carried out effectively.

The Senate also found itself at odds with the Roman army. The commanders of the legions usually requested senatorial grants of land and money for their troops, and bargaining and resistance by the senators bred distaste and malice toward the men in the Senate as well as the institution itself. Because contending parties in the state—senatorial aristocrats, knightly commercial interests, and popular factions— sought the support of various military leaders, the army ultimately became the arbiter of political affairs.

* * *

Our view of the last century of the Roman Republic has long been conditioned by the works of early Roman imperial writers—the epic poet Virgil, the historian Livy, and others. These men give us a highly romanticized picture of their country, its leaders, and its people. Modern research and attention to the actual events that destroyed the Republic and brought the empire into being have revealed a brutal and selfish power struggle that contrasts sharply with the idealized version presented by the early imperial commentators. They naturally wished to describe an empire that evolved from the glories of the Republic, not one that assumed power because the republican system had failed. The realities of late-Republican political and social life are both darker and more human than Livy's and Virgil's idealized world,

in which selfless, noble figures fashion an imperial vision out of the stable elements of the Republic.

The most pressing problem for the Republic in the last years of the second century B.C. was to reconcile the various factions in the Roman state. The state was encountering grave social, economic, and political problems that each faction used as a wedge with which to separate its opponents from the centers of political power. The central issues were the questions of redistributing the land of Italy in small farms, extending citizenship to the inhabitants of Italy, reforming the administration of the provinces, and providing cheaper grain for the Roman proletariat. Around these, the disputes raged. The dissatisfied elements in the state—the Roman proletariat, the army, the *equites*— became the tools of various factions. A century of political chaos and internal warfare in Rome and Italy was the result.

In these social conflicts and struggles for political power it was often difficult to determine which side truly represented the people or the best interests of the state. The men who put forward some of the most progressive legislation, who apparently sought social melioration for the majority of Romans, could also be the most high-handed and brutal and might well have the support of the most self-seeking elements in the state. This was especially true of the alliance of the popular party leaders with the knightly commercial classes. The wealthy *equites* had little real interest in improving the lot of the poor. They sought only to oust senatorial appointees from lucrative provincial offices, to maintain their own positions as prime contractors and tax collectors in the provinces, and to be free of senatorial interference in their exploitation of these lands.

The first great crisis arose in the period between 133 and 122 B.C., when two brothers who belonged to a prominent plebeian family, Tiberius and Gaius Gracchi, attempted to introduce important social and economic reforms with the support of the Roman Assembly. They proposed, among other things, that a commission be set up to redistribute part of the land in Italy among small farmers. To this end, they established a commission to determine what land the state had a right to expropriate. Tiberius, who first proposed the program, was murdered. But his land program had gone into effect and continued with considerable success, settling some seventy thousand formerly landless

people on confiscated property. Ten years later, the demands for reform were renewed by Gaius, the younger brother. Gaius was actively supported by the *equites* and, during his period of power, gave considerable influence to these commercial and antisenatorial interests, particularly by placing effective provincial administration in their hands.

Gaius advocated the establishment of a maximum price on grain in Rome in order to safeguard the poor against famine. He also called for reform of the military system and the extension of the vote to all Italy, and established commercial, as distinct from agricultural, colonies for proletarians whose farming skills were negligible. Like his brother, Gaius was probably murdered by the supporters of the Senate (he may, however, have committed suicide), and, in the next few years, the effects of his program were largely reversed.

The next great defender of the popular cause was Marius, a soldier from outside the senatorial aristocracy who sought to gain power. His political ineptness was compensated for by his brilliance as a general; his troops exhibited a fanatical personal loyalty to him. It was Marius who had created Rome's first standing professional army with professional commanders. In addition, he recruited his army from all classes of the population, including proletarians without property, who had formerly been denied service in the army. Because of his many great military victories and his espousal of the democratic cause, Marius attained the consulship on seven separate occasions. But his administrative incompetence was as great as his military skill, and his only lasting contribution to Rome was a legacy of a savage and chaotic struggle for political power.

In the years 90–88 B.C., all non-Roman Italy rose against Rome in a bloody revolt—the so-called Social War—that shook the state to its foundations. The basis for the Italian complaints was that the expansion, prosperity, and power of Rome had been purchased with the blood of Italian soldiers in service to a republic in which they and their people had no effective role. Rome was able to put down the revolt with great difficulty and only after granting citizenship to more than five hundred thousand non-Roman inhabitants of the Italian peninsula.

Half a century of popular revolt wrought great changes in the power of the Senate, and the old ruling oligarchy was gravely threat-

ened by the course of events. Its members found a champion in Sulla, who led a movement of violent reaction to antisenatorial advances. Sulla defeated the popular party in battle, then subjected Rome to a reign of terror aimed at sweeping away the opponents of the senatorial party. He instituted "reforms" designed to restore the ancient position of the Senate, but he almost doubled its size, thereby giving places to the *equites* who had abandoned the popular cause and wanted to be equal with the great families.

* * *

The attempt to preserve, in an altered form, the senatorial monopoly on political power did not quiet social unrest. The last decades of the Republic were punctuated by political conflict and chaos on an unprecedented scale. The first of several great reformers to attack Sulla's reactionary contributions to the Roman constitution was Pompey (106–48 B.C.). Like Marius and Sulla, he gained power through his position as a great military leader rather than from the backing of the Senate or the Assembly. Pompey's subjugation of the Near East established him as Rome's greatest soldier. The Near East was transformed into Roman provinces and thus given its first extended period of peace and security in centuries. Pompey's victories and efficient organization of the empire extended Roman power and increased its income from tribute.

When Pompey returned to Rome from his conquests on the eastern frontiers of the Mediterranean world, he was thwarted and insulted by the Senate, and especially by Cicero, who had become the spokesman for the senatorial party. Enraged, Pompey sought to gain fulfillment of his demands by assuming a power greater than that of the Senate. He struck a bargain with Julius Caesar and Caesar's patron Crassus— probably the richest man in Rome. Together they formed the First Triumvirate, relying on Pompey's fame, Crassus's money, and Caesar's political skill. They managed to have Caesar elected consul in 59 B.C., and he implemented their program. Pompey's establishment of new provinces in the east was ratified, and his troops were rewarded with lands. The triumvirs exercised power over several provinces with freer hands than any before them. The alliance was strengthened by Pompey's marriage to Caesar's daughter, Julia. But when Caesar carried out his conquest of Gaul and his invasions of Britain, he seemed to be challenging Pompey's position as Rome's greatest general, even to the

extent of reproducing in the west Pompey's victories in the east. Caesar's refusal to disband his army and return alone to Rome from Gaul set the stage for a showdown between him and Pompey.

Meanwhile, Crassus had led a Roman army to distant Parthia, beyond the Caspian Sea, and to the greatest Roman defeat since Hannibal. His death left Caesar and Pompey the two real leaders of Rome, and their struggle dwarfed the squabbles of the Senate and the various Roman political factions. Julia's death left the two with no personal ties, and two brilliant generals now led the greatest armies in history against one another, the prize to be mastery of the world. Caesar won the decisive battle of Pharsalus, in Greece, in 48 B.C., and the fleeing Pompey was killed in Egypt by the order of Ptolemy XII, probably in an effort to ingratiate himself with Caesar and, thus, keep his domain safe. The extent of Caesar's power, and the absence of anyone who even approached his stature, made him the de facto unchallenged ruler of the Mediterranean world.

Caesar stayed in Egypt for several years, ostensibly to consolidate his power there, but also to dally with Cleopatra, the remaining Ptolemaic monarch of Egypt, then about eighteen. She bore him a son named Caesarion, and, although they never married (since Caesar had a wife back in Rome), this was his only living child. Events in Rome called him back in 45 B.C.

When he returned to Rome, Caesar gathered into his own hands the powers of the major Republican officials: consul, praetor, tribune, and dictator—the ancient title of sole magistrate, which had been granted in the past for very short periods of emergency, and rarely used. When, in 44 B.C., Caesar was made dictator for life, he was an absolute monarch in everything but name. He combined in his person the leadership of the state and the army and possessed all the authority needed to fulfill his roles. No one could stand against him. After securing the empire, he set about reconstructing the state. He completed the unification of Rome with the rest of Italy and, with the addition of provincials and former centurions, increased the Senate to nine hundred members, a move that made it at once more representative, less self-conscious, and weaker. He attempted to solve the problem of the dispossessed in Rome by the colonization of over a hundred thousand people in the provinces, and he reformed provincial administration. He even revised the calendar. Caesar was about to undertake an even more

far-reaching reform of the state when he was killed in 44 B.C. by sena-
torial opponents who feared the continuation of his dictatorial powers.

Once again, control of the Roman state was decided by civil war.
At first, it seemed that Mark Anthony, one of Caesar's lieutenants and
a popular figure, would be able to reconcile the Republican and
Caesarian factions. His principal opponent was Caesar's adopted heir,
Octavian, a very young man, completely untried in either politics or
war, and vastly underrated by Mark Anthony. Octavian had initially
supported the Republican faction, but switched sides and joined Mark
Anthony and the general Marcus Lepidus to form the Second
Triumvirate. The three crushed their chief opponents—Cassius and
Brutus, the principal conspirators against Caesar—at the Battle of
Philippi in 42 B.C. The two effective triumvirs divided jurisdiction
over Rome's domains: Mark Anthony received the responsibility for
the wealthy eastern provinces, and Octavian took charge of restoring
order in Rome. But their unity, meant to be sealed by the marriage of
Octavian's sister to Mark Anthony, was short-lived.

Although Mark Anthony appeared to be the more powerful and
the more popular of the two men, the youthful Octavian was an ambi-
tious and shrewd politician, who understood very early the value of
propaganda and dissimulation. He set about building his power in
Rome and, at the same time, launched a vicious campaign against
Mark Anthony. Mark Anthony's marriage to the Egyptian ruler
Cleopatra gave Octavian the opening he needed. Alliance with Egypt
was unpopular enough, but Mark Anthony had also divorced his
Roman wife to marry the Egyptian queen, and, in the face of this dou-
ble betrayal, Octavian was able to win the loyalty of the old Caesarian
party. Although Mark Anthony was still by far the more experienced
general, at the naval battle at Actium, in 31 B.C., the forces of
Octavian were successful. Mark Anthony returned to Egypt, where he
and Cleopatra committed suicide.

The death of Mark Anthony wiped out the only significant obsta-
cle to Octavian's assumption of power, and he was able to put an end to
the factional struggle that had characterized Roman politics for a cen-
tury. In sole control of the effective power of the state, he was able to
hold himself above the warring factions and bring peace to Rome. He
took the appellation Augustus Caesar, but preferred never to assume
the constitutional or titular designation of dictator or head of state.

Instead, he referred to himself as *princeps* (first citizen), and he called his government a *principate*, rather than an empire, purely a semantic distinction. He restored the appearance of constitutionality and shared his power with the Senate. The Senate was given the task of managing Italy and those provinces that were peaceful, while Augustus took those that were troublesome—thus maintaining effective control of the army.

But it was not merely his unchallenged command of the army that gave Augustus control of the state. He was the constitutional embodiment of all Republican political authority. Rather than claiming monarchical prerogatives, he took over—much as had Julius Caesar— all the powers of the Republican magistrates and thus could curb the Senate and Assembly while ruling as the legal holder of Rome's imperium. Once in control, Augustus set out to reconstruct the Roman state, to adjust the machinery of government to the tasks it was called upon to undertake, and to establish peace throughout the territories under Roman rule. The brilliance of his leadership established the Roman Empire on a firm and lasting basis, with the result that the Mediterranean world knew two hundred years of peace and stability—the *Pax Romana*—under the hegemony of the Roman state.

The achievement of Augustus and his creation of the empire constituted the final act in the drama of the Roman Republic's political failure. The institutions and machinery of the Republic were simply inadequate to cope with the realities of Roman expansion and the social, economic, and military problems Rome's successes had called into being. The republican structure had developed in the narrower contexts of the old city-state and Italy; for governance of the world, a more unified and less finely balanced system was required. The growing power of the state and the strength of the army could too easily come under the sway of charismatic leaders. When such men finally liquidated each other, the survivor—Augustus, now thirty-five—was eagerly accepted as sole ruler by the war-weary and anxious population. The only alternative to imperial rule seemed to be a continuation of the civil wars that had marred the final decades of the Republic. The Romans chose the practical solution: conversion of a faltering republican system into an effective imperial state.

* * *

The most significant and enduring heritage that the Roman Empire left to later centuries was the fact that it had existed. To all subsequent

generations of European civilization, at least up to the late eighteenth century, the Roman Empire was a golden age of peace and political unity, which men fondly looked back at and intermittently dreamed of reviving. The *Pax Romana* became a model for human aspiration.

This view of the Roman Empire was by no means entirely the product of man's habitual romanticizing of the past; it was carefully fostered by the ruling elite of the empire itself and eloquently proclaimed in Latin literature. Because of the importance of the Latin classics in education up to the twentieth century, the *Pax Romana* was a vision that Europeans absorbed in their schooling. Augustus Caesar's court poet Virgil, in his *Fourth Eclogue*, proclaimed the glories of the Caesarian empire in messianic terms:

> *Now the last age is coming . . .*
> *The great circle of the centuries begins again*
> *Justice, the Virgin, has returned to earth . . .*
> *The golden race will rise . . .*
> *We shall lose all traces of the old guilt*
> *And the world learn to forget fear . . .*[1]

Like all educated citizens of the empire, Virgil believed that the reign of Augustus Caesar had inaugurated the last and incomparably best age of mankind; this is where history would stop. The worldly-wise Horace, writing in Augustus's reign, shared this vision: "While Caesar stands guard, peace is assured, the peace no power can break."

The state art of the empire consciously set out to educate the masses in this political faith—and incidentally evoked Roman grandeur to the astonished and admiring eyes of later eras. The dome of the Pantheon, like the marvelous Roman roads and aqueducts, flaunted the unequaled engineering skill and wealth of the Roman masters. The statue of Winged Victory, executed in the didactic style that was to be imitated by all subsequent authoritarian regimes, advertised the invincibility of Roman arms and the concomitant blessings of the *Pax Romana*. On the statues that stood in the forums of cities all over western Europe, and around the shores of the Mediterranean, and on coins that circulated throughout the empire,

[1] Translated by James Laughlin.

the formidable yet benign likeness of the emperor served as a constant reminder of what Rome had done for mankind.

And, for some emperors, service to mankind was a matter of honest concern. Marcus Aurelius, in particular, could be viewed as the embodiment of Plato's ideal of a philosopher-king. Constantly preoccupied with defense of the frontiers and internal peace and order, he was a grave and generous ruler who wanted to treat all men according to "the natural law of fellowship with benevolence and justice." He believed that "the world is in a manner a state" and that "to care for all men is according to man's nature."

The *Pax Romana* was far from being a mere excuse for the world rule of the Roman aristocracy. The Romans did provide stability, order, and social peace. The ruling elite did accept the Stoic ideal of universal brotherhood. Its members readily intermarried with the peoples they conquered, producing a new provincial aristocracy out of this union. The Roman Empire was the most harmonious and successful multiracial society the world has ever known. The old Roman aristocracy was not free from racial prejudice, but, gradually, in practice, the aristocrats overcame these feelings; by the early third century B.C. all free people in the empire enjoyed the full benefits of Roman citizenship.

Roman law protected this citizenship eagerly, and Roman jurists created a legal system that, to the present day, underlies the law of all the continental states of Europe, from France to Russia. The basis of Roman jurisprudence is the concept of equity; the law of the state is the reflection of natural law—that is, it is based on rational moral principles, and it aims to provide equitable justice to all men. Cicero expressed this doctrine with definitive eloquence:

> *We should derive the origin of justice from law, for law is a natural force, it is the thinking mind of the man of practical wisdom, it is the standard of justice and injustice . . . Law is right reason . . . Those who share law, share justice also.*[1]

It is in "practical wisdom" that the Romans excelled, and much that is beneficent and valuable in the subsequent development of European law and politics was derived from the imperial world. But

[1] Translated by Paul McKendrick.

the Roman heritage is ambiguous and complex; much that is authoritarian and violent was also a Roman legacy. Roman law aimed at justice and equity, but it was the equity and justice that the emperor decreed by fiat. Roman jurists declared that the people had irrevocably surrendered their legislative power to the emperor and that the emperor's will was law. The Roman Colosseum was an architectural and engineering marvel, but it was used to entertain the masses with gladiatorial contests and public executions. To these proletarian audiences, classical culture and Roman citizenship meant nothing. Humanity would suffer, and still suffers, terrible agonies from the Roman doctrine that might makes right. The historian Tacitus, writing at the end of the first century, and still loyal to the old Republican ideal, etches in acid phrases the underside of the Roman peace:

> *Rome of old explored the limits of freedom; we have plumbed the depths of slavery, robbed even of the interchange of ideas by the secret police.*[1]

The most pervasive and enduring Roman legacy was the aristocratic way of life. Ruling classes in Western civilization have imitated this Roman model up to the present day. Drawing in part upon the Greek and Hellenistic sources, the Roman elite created a way of living that we still think of as the way to live well—it is, at least, the way the rich still live. It is a distinctive mixture, this aristocratic mode, a combination of the intellectual and material, a blending of power and high culture. The town house and the country villa; servants, lavish entertaining, and feasting; frank enjoyment of sex; a careful education in a purely nonscientific curriculum; patronage of the arts; religion marked by formal ritual but totally lacking in spiritual calling; intense devotion to the family as an institution; reverence for old men but no regard for children as individuals; patriotism and public service; travel and games; endowment of municipal buildings and services; this is the way of life that the Latin classics describe and extol; this is the mode that subsequent European aristocracies and their imitators, the upper-middle class, cherished. Its effect on Western society and culture, for better and for worse, has been incalculable.

[1] Translated by H. Mattingly.

One aspect of the Roman heritage was the product of the fourth century, when the empire was harassed by internal problems and external enemies. In response, the government was reorganized, empire and church coalesced, and the doctrines and institutions of sacred kingship, adapted from Hellenistic civilization and, particularly, from Egypt, were employed to buttress the declining loyalty of the population of the Mediterranean world toward the emperor. Absorbed directly by the medieval kingdoms, sacred kingship became the standard European political doctrine up to the end of the seventeenth century.

This reinvigorated Oriental doctrine of the divine right of kings was proclaimed in works of art that tried to convey the value of the monarchy to a society that was losing its faith in the *Pax Romana.* The growing tendency in fourth-century art—away from classical naturalism in the direction of medieval symbolism and a nonrepresentational style—was partly the consequence of a general shift away from classical values, and partly the result of a simple impoverishment in technique. But the new style, like the sacred kingship, was also intended to give the masses of the Roman world an immediate sense of imperial strength and virtue in the face of a catastrophic decline in public spirit. Both were products of the proletarianization of Roman culture.

Although the earliest Christians were not, like the Hebrews, direct enemies of the Roman order, they were internal exiles from it. They were interested only in man's soul, not in his social status; and, for them, the only power and law that mattered was God's. The early Christians thought they were the true chosen ones, the Spiritual Israel, and, as such, they took over and perpetuated the Biblical doctrine of the providential direction of history toward the Last Judgment, which, they thought, was imminent. The most important belief to Western civilization handed down from earliest Christianity was that the meek and humble would inherit the earth, and that what counted in the world was the individual's love of and faith in God. Against imperial majesty and public power, the art of the catacombs raises the humble images of the Good Shepherd and the Madonna, the Messiah and His mother. Apostolic Christianity is the source of the perpetual egalitarian and millennial yearnings in Western civilization.

A quite different set of ideas was imparted to subsequent centuries by the imperial Church of the fourth and fifth centuries. The

Church was now hierarchical—possessing a ranked order that, in the early Church, had been absent or potential only—and it supported the Greco-Roman doctrine of the great chain of being in the universe and the justice of the hierarchical organization of society. The Church Triumphant, having come out of the catacombs, now enjoyed the fruit of its triumphs. The basilica of the bishop was held to be at least equal to the palace of the emperor, and all the beauty and skill that the Roman world still commanded was now dedicated to the building and decoration of churches. The bishop was no longer a humble shepherd; he sat on a magnificent ivory throne, as befitted the earthly representative of Christ, who was now viewed as the supreme emperor of the universe.

The imperial Church now predominated over the apostolic Church—Christian majesty and power over love and simple faith—but it did not, could not, eradicate it. From this tension between union with the world and rejection of it came not only the wellspring of the medieval era that was to follow, but the main theme in the whole history of the Church to the present day. Saint Augustine—an African mystic who had a profound mastery of the classical tradition—identified this tension and tried to resolve it. The Church, Augustine wrote, availed itself of the peace of earth, all the best that classical culture and the Roman Empire had to offer. But the only thing that ultimately mattered was the heavenly city, whose nature was internal and spiritual, and whose history was made up of the relationship of the individual to God.

CHAPTER THIRTEEN

Christian Thought

*T*here are at least fifty volumes containing the main statements of Christian thought from 200 to 500 A.D. There are good, difficult books that survey this forest of ideas and emotions. But how to present in a small number of pages these antique Christian ideas in a manner that is clear, informed, and interesting? I have done so by focusing on the key thinker of the period, St. Augustine (d. 430), through imagined conversations between Augustine and his contemporaries.

* * *

"I knew you a long time ago," said Vincent to Augustine, "when we were boys growing up in that pleasant little city of Thagaste near Carthage, under the North African sun. Remember all that fuss when you were a little boy and you crept into someone's orchard and stole some pears? I read your *Confessions* a few years ago and I was amused that you used this innocent juvenile happening to illustrate the doctrine of original sin. I just think we were children having a good time. Also, I remember when you were—what?—around twenty and you professed to having become a Manichee and your mother, a devout Christian lady if there ever was one, locked you out of the house."

Vincent laughed heartily, but only a quick smile passed Bishop Augustine's thin lips. "Yes, that is true. My mother, the blessed Monica of sainted memory, indeed, locked me out of the house. My father was a pagan and couldn't understand what all the fuss was about. He thought the lockout looked bad in front of the neighbors, and, with our declining circumstances, my sad, class-conscious father thought we appeared shameful already. But my dear mother didn't keep me out of the house for long. She had a vision in which Christ told her that before long I would abandon the Manichees and become a

baptized Christian, which was for so many years her heart's desire. And so it happened. But, in my case, I was never more than on the fringes of the Manichee community. I was never taken in by all that astrology and faith-healing they went in for. I always suspected that their leaders, the Perfects, who made such a show of piety, beyond their pure exteriors weren't so perfect. I noticed more than one of them late in the evening, walking down the street in the company of a prostitute. I was a Manichee for a while because I was obsessed with the problem of evil and the Manichees had a simple, although, of course, false, solution to the problem of evil. I kept wondering that if God is good and omnipotent, why is there evil in the world? The Manichees had an obvious rude answer: there are two gods, the God of Light and the God of Darkness, and the God of Darkness creates the evil in the world."

Vincent saw an opportunity to make a critical remark about Augustine's interpretations of Christian doctrine.

"I suppose, Augustine, you know that some of your Christian critics say you are really still a Manichee, that their dualism is still prevalent in your teaching and preaching, lying just beneath a thin surface veneer and still shaping your mentality. It is said that you are still obsessed with the problem of evil. While you later came up with an explanation for the existence of evil derived from the Neoplatonists—evil is a falling away from the good that God creates, a perversion of the good creation—they say at heart you are still inclined, like the Manichees, to divide mankind into two absolutely separate communities, the Heavenly City and the Earthly City. What's the difference between that and the idea of the Children of Light and the Children of Darkness? It is said that you have the hateful disposition of a Manichee, that you are a great hater, Augustine, that you are deficient in Christian charity that finds good in every human being as God's creature. They say you are always disposed early on, in any debate, to divide humanity up into the good and the bad, and consign the bad to darkness, like the Manichees."

Augustine wiped the sweat from his face. He was fifty-seven years old and had been bishop of Hippo for two decades. He was a thin, short, wiry man, with swarthy, almost black complexion, and a scraggly beard and thinning gray hair. It was a blazing-hot August day in the year 415 A.D. Augustine and Vincent were sitting in Bishop

Augustine's cluttered little study next to the rundown, ramshackle cathedral in the provincial port city of Hippo, in what is today Algeria, near the present Tunisian border.

Vincent was blond and fair-skinned. He was a Latin, the descendant of Roman colonists who had come to North Africa two centuries earlier and had prospered there, contributing to making the coastal region of what is today Tunisia and northern Algeria one of the richest parts of the Roman Empire. Here great cities had risen, pressed against the inland mountains and the desert on the horizon. Here, around 200 A.D., arose a fierce kind of Latin Christianity—puritanical, demanding, pessimistic.

The native Berber population—people today vaguely called Arab, from their language—had taken to the new religion and, particularly, to the more intellectual Pauline strand within it. They had embraced its fiery zeal, as in later centuries they were to espouse Muslim fundamentalism. Augustine was a Berber.

Yet these North African Christians were not fundamentalists in today's meaning of the term—devout believers who stand upon the literal text of Holy Scriptures. The Berbers also absorbed the Latin language and the Graeco-Roman heritage and its complex, especially Platonic, traditions. Out of these diverse sources, not least of which was their own non-Latin ethnicity, they created, in the hot sun and in the face of the powerful winds blowing down from the mountains and along the harbor basins like Hippo, a fused, integrated kind of militant Catholicism that, through Augustine principally but not exclusively, would have a profound impact on the ethos of the early Middle Ages.

The last thing we would want to believe if we were searching for the cultural forces shaping the sensibility of the European Middle Ages is that the Church in North Africa was marginal or idiosyncratic. It was, in fact, mainstream. It was the cultural crucible of Latin Christianity.

Augustine had closed the shutters against the fierce afternoon African sun. He had been impatient to get rid of his visitor and get back to work on the treatise he was writing at the urging of many other Catholic bishops. This book was supposed to explain the theological and moral significance of the sacking of Rome by the Visigoths

five years earlier. It was supposed to respond to the claims of aristo-
cratic pagans that Rome, far from being rewarded—as the Christian
bishops had exultantly predicted—for becoming a Christian state and
for dismantling the altars to the old polytheistic gods, had fallen to
German invaders in Christian days.

Less than 10 percent of the population of the Roman Empire in the
early fifth century A.D. was still pagan, but the old polytheism had elo-
quent spokesmen among some of the aristocratic families in Italy. They
taunted the Christians with the fact that Rome had fallen in the Christian
era, and the bishops were embarrassed by this claim. Although the
Visigoths had withdrawn from Rome after a few days, the shock to
Christian morale remained.

The bishops expected Augustine, their most renowned theorist, to
respond to the pagan taunts and explain the Visigothic disaster and
the steady political decline of the empire in terms of a Christian phi-
losophy of history that would make the members of the Church still
feel good about this painful development. It was not an easy task that
Augustine had undertaken.

* * *

The lengthy manuscript Augustine was composing lay open on his
desk, and, once in a while, as Vincent talked, he would take a furtive
glance at the page open before him. Augustine was used to writing
long and complex theoretical works in the midst of the hard labor and
constant pressure of being a Catholic bishop in a provincial North
African town. He engaged constantly in the resolution of judicial dis-
putes in and among Christian families, which alone took up many
hours each week. On top of preparing and delivering sermons for
which he was famous throughout the Latin-speaking world, he gave
counsel to troubled members of his community, and trouble was esca-
lating rapidly as Roman Africa's economic and political structure dete-
riorated, and he kept up a stream of correspondence with bishops all
over the Mediterranean on a host of issues. Augustine was very much a
hands-on bishop. He had very little assistance beyond an overworked
secretary.

Augustine offered Vincent a glass of tepid water, took a sip him-
self, and then moved his chair closer to that of his visitor. Until
Vincent's last accusing remark that Augustine was a crypto-Manichee,
or a suggestion to that effect, he had been emotionally uninvolved in

the conversation with this fellow North African priest whom he hadn't seen for more than three decades. Now, suddenly, his eyes glistened and his mouth was set with determination.

Augustine chose his words carefully and he switched from the Punic vernacular, in which the conversation had begun, to ecclesiastical Latin, a language in which he felt more comfortable engaging in intellectual debate.

"Malicious or stupid people attribute things to me I never said. Because my teaching envisages two communities among mankind, and so do the Manichees, that doesn't make me a Manichee. I never divided mankind into two absolute, inflexible communities, as the Manichees have done. I said that *mystically* there were Two Cities, the Heavenly and the Earthly. But their membership lists are not engraved forever in stone. Membership can shift from day to day, hour to hour. When we get up in the morning, we may feel we are in one of the Two Cities, but by nightfall, we may feel we are really in the other. From day to day, moment to moment, individuals switch from one to the other. I hate members of the Earthly City but I don't know who specifically they are, although, granted, in a few instances I have a strong suspicion about that. Only God knows who belongs to each of the Two Cities, and only at the end of time at the Last Judgment will the membership lists be revealed. The Manichees, on the other hand, are convinced they know who are the Children of Light—they are—and the Children of Darkness—everyone else—and they act accordingly. This is, indeed, a false and hateful religion. It is not my belief. Tell me, Vincent, do you think I am a Manichee?"

"No, I do not," said Vincent. "But I have read some of your books and I can see how others have come to that erroneous conclusion. What concerns me about your theology and moral teachings is not that they are Manichean. They are not. Obviously you do not, like the vile Manichees, believe in the existence of two gods. What concerns me is the constant theme in your writings of man's depravity, of the determining stamp of Adam and Eve's rebellion against God—the original sin—upon human nature, and the absolute conviction you have of man's incapacity to do right and live decently and respectfully without divine intervention. This isn't Manichean dualism, of course. But your gloomy predestinarian doctrine and incessant stress upon human depravity signifies a hostile, extremely pessimistic view of human nature that, practically, is almost as

hostile to humanity as the Manichean view. I cannot understand why human nature seems so bad to you, why human reason seems so incapacitated, why human sexuality signifies only corruption and irrationality and evil, why the human body is such a thoroughly rotten vessel, in your eyes. I find most people quite decent and well intentioned. I find human reason able to address itself to a lot of valuable undertakings. I find human sexuality an expression of love as well as lust. Given the guidance of the Christian faith and the counsel of our priests and bishops, I don't see what there is to be so worried about with regard to the prospects for morality and the meriting of God's love and achieving of the immortality He offers through the Son and Holy Spirit. I find Christianity a pretty cheerful religion. I can't understand all this gloom and doom you are endlessly involved in."

Augustine's eyes flashed with anger. He raised his voice and almost shouted across the little room.

"Well, Vincent, you sound like that dreadful, silly, ignorant British priest Pelagius with his persiflage about freedom of the will and easy attainment of the good life and heavenly reward—a religion for middle-class matrons and recently converted pagan lords. I can't abide it. I know that many bishops subscribe to Pelagianism and preach it in their churches. But it is not the true Christian faith. St. Paul taught that by our own efforts we cannot merit God's love. We can only be sanctified, made whole and holy, by faith. But it is the faith that God gives to some and not to others. *We can't love God unless He loves us first.* And every day I see practical confirmation of Paul's teaching. Just look at the rottenness and depravity, the violence and terror, the corruption and devastation all around us. As for sexuality, I have found that it extinguishes reason and allows the sloppy, stinking, ever-deteriorating body to absorb and corrupt the mind. Sexuality is human depravity and the importance of reason carried to their extremes. Sexuality signifies the nightmare sleep of reason, the loss of control over our lives. So this is why you are here, Vincent? To join the other bishops in throwing the simple-minded propositions of that abominable British priest, Pelagius, in my face? Why did you bother to make the trip from your town? Why not send me a mean and supercilious letter, like all the other magnates and millionaires who have rushed to support Pelagius, as well they might, because he has promised them the keys to the Kingdom of Heaven in exchange for a

little bit of charity and church attendance and the utterance of pieties on appropriate occasions?"

Vincent regretted arousing Augustine in this manner.

"As you have just acknowledged, Pelagius's doctrine of freedom of the will and attaining of heaven and God's love through human merit—this doctrine is widely held by the bishops. It is sad to see that you, Augustine, the Church's greatest theorist and most eloquent writer, put yourself at the marginal extreme and propound a view of human nature in which many hear overtones of the Manichean hatred for mankind."

Augustine spoke more calmly now.

"Some people, Vincent, talk as though I invented the problem of predestination and free will, as though I concocted this theological conundrum for my intellectual delectation as some sort of game. But it is right there in the Hebrew Bible, the Old Testament that is supposed to be the foundation of our faith. The old Hebrews speak of God's omnipotence and His determination of events in human life. At the same time, the Bible says we must do good, we have the freedom to do good, and if we do not, we will be punished. The Hebrews thus spoke of *both* predestination and freedom of the will. This left it to St. Paul, and me, to resolve the conflict, and we have done so. That it doesn't please the episcopal lounge lizards—that's not my fault. I am convinced of this: we are responsible for our own damnation but God is responsible for our salvation. That is the essence of the Christian faith. If you don't believe that, you are not a Christian. I didn't make this up. That is the message of the Old and New Testaments."

Vincent took a deep breath and looked directly at the severe little man with the dark face. "Augustine, I haven't taken a three-day trip to either denounce you as a Manichee or defend Pelagius. I apologize for having raised these matters. What I am here for is to represent the Donatists. You may have heard that I am a bishop in the Donatist Church. Thanks to your attacks upon us, we are in decline, but there are still millions of Donatists in Roman Africa. I have come to beg that you leave us in peace and especially that you cease calling upon the Roman governor to persecute us and force us to convert to the Catholic Church. Whatever you think of us, it seems strange that a thinker of your stature should advocate the use of force to alter religious beliefs."

"There is nothing strange about the matter," said Augustine.

For the last few minutes, he had already suspected from the conversation that Vincent was a Donatist. Many advocates of Pelagianism were also adherents of this heretical North African church. Augustine recalled that, for several years, he had been hearing that an important leader of the heretical North African Donatist Church was named Vincent, but he had not associated the name with the boyhood companion he had long ago lost contact with.

* * *

Now that Vincent had revealed the real purpose of his visit, Augustine was eager to confront the issue that Vincent had raised. Augustine had gone over it on paper and orally hundreds of times. He had spent more time in debate with and about the Donatists than any other matter in the two decades he had been bishop of Hippo. When Augustine started as bishop in 395 A.D., the Donatists in Hippo actually outnumbered the Catholics, and the Donatists included some rich and prominent people in their membership, although the majority of the Donatists were ordinary farmers from the grain-growing country that lay between Hippo on the Mediterranean coast and the menacing mountains of the Magreb in the interior.

All this time, the Donatist community in Hippo was a small one, due to Augustine's incessant forays against them and the help of the Roman authorities that he recruited. But elsewhere in Roman Africa, there were still substantial Donatist groups. Indeed, the Donatists would not entirely disappear until the Muslim conquest of North Africa in the seventh century A.D. inundated orthodox and heretical Christianity alike in what is today Tunisia and Algeria.

Almost by rote, Augustine summed up to Vincent his objections to Donatism, which took its name from one of the founders of this sectarian North African movement in the early fourth century A.D.

"The Donatists are the enemies of the idea of a Catholic Church, of a universal Christian community. A Catholic Church comprises *both* saints and sinners, those already called by God and those who are slaves of the Devil, as well as those whose destiny is not yet determined. The Church embraces in its membership both good and bad people and, perhaps more important, weak people who have repented many times. The Church incorporates the whole human race, so that the means of grace, the means of salvation that God in His love and wisdom offered

to all humanity through a believing community, through the sacrifice of His Son and sacraments of the Catholic Church, should be made accessible to all. This makes for a messy church but a necessary one, a church that fulfills the purpose of the Incarnation of Christ in a human being. Remember, the Church is not the Holy Spirit. It is not a pure thing. It is a mixed thing. The Church is only the earthly reflection of the Holy Spirit, like the shadows on the wall of Plato's famous cave, which only very crudely and in distant outline reflect the transcendent ideas. It is the Eternal Word become flesh, and again becoming flesh in each successive generation.

"I agree with the last sentence you have just propounded," interrupted Vincent. "That shows there is no sharp divide between us."

"But you Donatists," responded Augustine, "want the Church *at this very moment* to become purely the Holy Spirit. You want it immediately to consist only of saints, and only sparkling-clean ones among those! That is a sectarian, not a Catholic Church. Blasphemously assuming God's providential role in history, which postpones the separation of saints and sinners until the Last Judgment, you want *now*, this very moment, to create a church of saints alone. This kind of sectarian church would have small membership and modest resources. It would be feeble. It would have little power in society. It could not effectively carry out its missionary work, all the more important now that Germans, who must be converted as soon as possible, are in our midst. Since a small, sectarian church of saints alone could not offer the means of grace to all mankind, and since it would lack the personnel and funds to convert the Germans, the Donatists are recklessly selfish people. They want a church that is their own little club. They want to keep the Good News about salvation through Christ Jesus to themselves. We Catholics, following Saint Paul, want to open the Church's doors to everyone: Jew or Gentile, slave or free, Roman or German."

"Of course, so do we of the Donatist Church," said Vincent. "All are welcome as long as they have already received God's grace and are pure in spirit."

Augustine took a sip of tepid water and glowered at Vincent.

"That isn't what Saint Paul meant. He was creating a church, not an exclusive country club. I also oppose the Donatists, because they have a false position on the nature of the priesthood and the sacraments.

We, Catholics, believe that the sacraments—like baptism and the Eucharist—are always effective means of grace if the priest has been legally ordained, irrespective of the priest's personal life. Of course we want all priests to be saints, but we know that, human nature being what it is, many of the clergy will fall well short of perfection in their personal behavior. That doesn't bother us very much, because we know that it is the priest's ordained role, not his personal character, that makes the sacrament work, to make real what it signifies. The priest is Christ's surrogate when he offers the sacraments to the laity. You Donatists, however, insist that the ministration of the sacrament by a personally unworthy priest is invalid. If the priest isn't pure and holy, then the wine and bread in the Eucharist, in the Mass, don't mean anything, you claim. No transformation into Christ's blood and body has occurred. That view is a misunderstanding of the nature of the sacraments, which are Christ's, not the priest's. The latter is merely representing Christ. Your view of sacraments and priesthood leads to chaos—the incessant scrutiny of a priest's character and behavior by his parishioners, so he cannot get his work done."

"It is true," said Vincent, "that we Donatists demand very high standards of behavior and character from the clergy. They are supposed to be ministers of Christ. If the priests are not visibly spiritual people, the laity, the ordinary members of the Christian community, will become confused and demoralized."

Augustine was becoming angry and impatient with Vincent.

"That attitude may be suitable for a monastery, Vincent, but not for the Church's functioning in the world. Your view doubts the power of a loving God to communicate to all sorts of people, to realize His love for us through the Word. The idea of a Catholic Church is the operation of God's love and majesty in and through the ugliness, the violence, the disorder of actual human life."

"We want," said Vincent, "to separate the Church from the turmoil of society."

"On the contrary," responded Augustine, gesticulating with his right hand. "Donatism threatens constant turmoil in the Church. It will involve the purging of the priesthood and its reduction to a much smaller group. That means that the Church will lack the requisite number of priests to carry out its mission—God's mission of nourish-

ing and forgiving, a power to forgive that you somehow seem to limit. If the Donatists had their way, there would be chaos. Laymen would shop around incessantly, looking for a saintly priest. Holy men who prefer to withdraw from the world to communicate with Christ would have to be summoned back from the desert or be dragged out of caves and monasteries to serve as priests, because there would be a terrible shortage of saintly clergy. Everything about Donatism, whether viewed theoretically or practically, is wrong. That is why I oppose the Donatists so strenuously, even though personally they are good people whom I love. They threaten the stability of the Church and erode its capacity to play the transforming role in history and society that God has assigned it."

Vincent was taken aback by Augustine's onslaught. He had read some of Augustine's polemics against Donatism and he was familiar with the arguments. But hearing them in person and presented in such a vehement and unqualified manner made Vincent feel weak and inadequate.

"You and I have very different views of what the Christian Church should be, Augustine. Yours is a church of power and majesty; ours a church of piety and devotion. Yours is a universalist conception of the Church; ours is a sectarian one. Let us leave that issue aside. What I am here to protest is that you won't leave us alone, even though in Roman Africa the Catholics now have a substantial majority of the people, and the membership of the Donatist Church is fast declining. Yet you seek to obliterate us entirely by bringing in the state to impose forced conversion upon us. Consider the implications of what you are doing. You want to incorporate into the Catholic Church millions of people who don't want to be there. How will that contribute to the stability of the Church you value so highly? What kind of Catholic Church will it be, with so many unwilling members? Secondly, think of the long-term implications of your persecuting policy for relations between church and state. You are setting a precedent for the state to intervene in the Church's affairs. You are giving emperors and governors a thirst for power over the minds of men and women. Remember how before the first Christian emperor, Constantine, there was persecution of the Christian Church in many places, including here, in Africa. Remember how aggrieved we were when the Church was persecuted by Roman power, when the bishops were called upon to hand over the Holy Scriptures to Roman soldiers.

Now you are summoning the state back into matters of belief. Isn't it much wiser to keep the state out of the Church's affairs? What puzzles me also, Augustine, is your soft line on the Jews, as compared to the Donatists. You have expressed the view that force should not be used to convert the Jews. You let these Christ-killers off the hook, but you want to use political force against the Donatists, who are, like you, devout Christians of a high moral character."

"The Jews are a different case," said Augustine. "Jesus was born and died a Jew. Saint Paul was a Pharisee and a rabbi. I do not love the Jews. I hold them in contempt and hatred because they were offered the way of salvation and they rejected it. Yet, I have said: Leave the Jews alone. The Lord Himself will reckon with them. He alone will decide on their punishment. The Jews should not be allowed to prosper at Christian expense. But force should not be allowed to convert them. They had their chance to receive God's Word, and they refused. Now they will exist as a cursed race on the margin of society until the Last Judgment: that is my view. The Donatists, however, are the immediate responsibility of the Catholic Church here in North Africa. They are separatists and heretics, who sow confusion and impede the Church's mission in society. They are Christian heretics, and it is very much within the power of the Church to deal with them. The Lord said to His disciples: 'Compel them to come in.' We are doing what the Lord told His disciples to do. Nor have we come to this decision precipitously. We have contended against the Donatists for three generations. Now, to prevail, the Catholic Church must use the state's resources. Your generation is already lost. I think not so much of your generation. But I think of the children of the Donatists. They must be rescued from sectarian error."

"And whom are you rescuing today, Augustine?" said a woman's voice with a jocular lilt from the doorway of the bishop's study. Vincent turned to find a woman, dressed as a nun, whose dark facial features closely resembled Augustine's.

"This is my sister Placida," said Augustine impatiently. "She is the head of the convent attached to the cathedral. And this man, Placida, is Vincent, a boyhood friend, who is now, unfortunately, a Donatist bishop. He has come here to urge me to desist from requests to the state to help us against the Donatists."

"You have to understand my brother, Bishop Vincent," said Placida with just a faint note of mockery in her voice. "He is a man of absolute rectitude. He is an idealist in the Platonic sense. He believes that ideas exist to be realized on earth. He is a theorist who seeks the fulfillment of theory in practice. He does not compromise. He adheres to what he thinks is the right course, even if there are side effects involved that are worrisome and painful. I assure you that he is not prejudiced personally against the Donatists. He treats you the same way he treats everyone—severely. I, Augustine's own sister, have suffered from his rectitude. One of his principles is not to build new and elaborate ecclesiastical buildings. So he has done nothing to improve the cathedral of Hippo in the twenty years he has been here. While many other African bishops have raised money to erect magnificent new cathedrals, the building here is the same rundown, shabby structure he found when he arrived here. His idea of improving the cathedral is to put up paper posters on the walls, enjoining people to do this or that, making the interior look even more shabby. He has refused to do anything for me and the nuns by way of improving our domicile. It is old and dilapidated, overcrowded and uncomfortable."

Augustine looked annoyed with his sister. He and she had been having some bitter discussions recently about his parsimonious treatment of the nuns, and here she was, raising the matter of the nuns' quarters again, and in the presence of a comparative stranger, who was, furthermore, a Donatist bishop. This could set tongues wagging all the way to Carthage. But he was not willing to make any concessions to Placida.

"I am not a brick-and-mortar bishop," he said quietly. "I do not hold in high esteem my colleagues here in Roman Africa who make the raising of money by flattering the rich, and the erecting of impressive buildings with these funds the main point of their episcopates. As long as we have here a decent enough building in which to hold our services, that is cathedral enough for me. We must have our minds on more important things. You and your nuns have a place to live. That is enough."

Placida was now quite angry.

"I think, my dear brother," she said, "that you get your inflexible rectitude from our mother, Monica. You, the eldest of her three chil-

dren, were her favorite. She thought from very early on that you were a genius and would rise to high preferment in the empire. She spoiled you and allowed you to feel that any idea that came into your head was a good one. This led to a near disaster, when you foolishly joined up with the abominable Manichees."

* * *

"Well, we recovered from that soon enough," responded Augustine, a smile now on his lips. "Monica was a wonderful woman. I was fortunate to have such a good mother. I never thought much of my father—a pagan who was a business failure, a bad combination. Vincent, after I was in Italy for a few years, I lost my way. I was confused and depressed. My mother knew something was wrong, and crossed over from Africa to Italy. She took care of me, my soul as well as my body. She caressed me and comforted me and showed me what I must do. Join the Church, go into a retreat in a villa in one of the Alpine passes, and study to become learned in Christian theology and the Bible, just as I had previously mastered the Latin classics. Then she persuaded me to become a priest and go back to Africa and enter into clerical office. All this she guided me to do. She was coming back to Africa with me, but she died in an Italian port as we were about to take a ship across the Mediterranean. That was the saddest moment of my life. How happy she would have been to see me become a bishop. She was the best person I have ever known. Monica showed me that there is only one kind of life to live, a life of commitment to highest principles and service."

Vincent found himself in the middle of expression of a long-standing sibling rivalry, with deep overtones of psychological tension.

"I cannot share," said Placida, "my brother's feelings about our mother. May she rest in peace, but she was no saint. I found her a cold, calculating, distant woman. Remember, Augustine, how, when she came to Italy, she found you were living with a concubine and the son you had by that woman? Monica made you send them both away so she could get you affianced to a rich young woman of a good family, a union that was intended to advance your career, if you had gone through with it."

"Yes," said Augustine, somewhat defensively. "It happened as you said, Placida. But disposing of one's concubine in order to enter an advantageous marriage—that was commonly done. It was very much a

Roman, if not a Christian, thing to do. You may remember that Constantius, the father of the Emperor Constantine of blessed memory, abandoned Saint Helena, Constantine's mother and his concubine from the lower classes, in order to make a politically advantageous marriage. I am not proud of doing the same thing but Monica interfered to help me, after all. I never again saw the woman by whom I had my son, but I kept in touch with Adeodatus, the boy, for many years. He was a brilliant lad, but he died when he was seventeen. Maybe it was cruel of Monica to send away my little family, and weak of me to comply with her wishes in this matter. But there are things in life that are more important than domestic cares and private feelings, and my mother taught me to rise above such cares and feelings, and I have done so. It is to my mother I owe the realization that it is God's calling and the destiny of the Church that matters over personal involvements and private hopes. I have dedicated my episcopal career to my mother's memory. Not a day goes by that I fail to think of her. But now, in my old age, I wish I also had a son. I loved that boy deeply. I miss him more than ever now that I am old."

Augustine's and Placida's family rivalry and autobiographical comments had stimulated Vincent's memory and inspired his imagination. He thought he saw a way to lead the conversation in such a direction that he could appeal to Augustine's recollection of his youth on behalf of the Donatist position.

"I remember, Augustine, when we were in our early twenties and students together in Carthage, you and I and other members of our group—Alypius, now back in his African hometown of Thagaste as bishop, and Paulinus, now a bishop in Italy—we all made a vow together to live lives of the highest idealism and fullest rectitude. We regarded ourselves as the vanguard of a movement to reform corrupt and cruel Roman society and impose piety and justice upon the world. We would be a group of New Age activists who would change everything for the better. We would reject materialism and power and devote ourselves to purity and moral regeneration."

"Yes, I remember that," said Augustine, glad to have the conversation drift away from his sister's spiteful remarks about their mother.

"I wonder now if you think it was all worth it, Augustine," Vincent continued, "this commitment to a life of piety and justice.

After you went to Italy, you were very successful there as a student, and you were hailed as master of Latin rhetoric—so Alypius has told me—a new Cicero. You had a professorship in Milan, which was the road to high office in the imperial government and to a career in the law courts. You were affianced to a woman of a prominent family. Everything was set up for you to become one of the top people in the empire. Yet you suddenly gave it all up to become a Christian theorist, a priest, and, finally, a bishop. Was it worth it, Augustine, now that you look back? Was this the best road taken—best for yourself, your family, and for the Church and the empire?"

"I have thought about that occasionally, more now that I am getting older and know I don't have that many years left and I can look back and see my whole life laid out."

Placida intervened. She was relentless in bringing up Augustine's relationship with the mother she hated.

"It was our mother who made you give it all up and become a priest. After she made you abandon your concubine and your son, and got you engaged to that highborn lady, she became jealous of your fiancée. She thought she was going to lose you. It was Monica who persuaded you to give up the position and honor and marriage prospects you had worked so hard and brilliantly to gain."

"No, it wasn't as simple as that," said Augustine impatiently. "You weren't there, Placida. How would you know? That's just family gossip you are repeating again. Yes, Mother helped me make difficult decisions, but the initial break with my imperial career—that was already underway before she got to Italy. What happened, I think, was a very deep conflict between the unworldly ideals that our little group had been committed to back in Carthage—Vincent, that New Age activism, you called it—and the way of life as a rhetorician and mover and shaker in imperial circles I had become involved in. I was very unhappy in the midst of my success as a professor, and rubbing shoulders with the imperial big shots and attending dinners at the home of my upscale fiancée. I didn't feel good about it. I knew this was not what I wanted in life. In my depressed and anxious condition, I sought the help of the great Ambrose, bishop of Milan, who was not only the leader of the Church in northern Italy—he himself had come from the highest ranks of the Roman aristocracy. He had been imperial gover-

nor of Milan before he became archbishop. I had attended some of his sermons, and I had been impressed by the vigor of his thought, his high idealism, and, especially, by his splendid command of the Latin language. He was the first person I had known who could silently read Latin without moving his lips. I went to see Bishop Ambrose in his study and told him about my inner conflict. He didn't tell me what to do, what road to take, but he helped put my feelings in a broader historical and theoretical context."

"Ambrose was a remarkable person," said Vincent. "He combined the deepest spirituality with profound knowledge of the Roman traditions of law and government. He is a model for all bishops."

Augustine ignored this pious interruption. He was not inclined to go back to the issue of the nature of leadership in the Church. He was caught up in the excitement of telling again his conversion experience. He had written a whole book, *The Confessions*, on the subject, but he never tired of pulling this experience out of his preconscious and examining once again its significance. He could never exhaust for himself exploring the memory of this cardinal event in his life. He was in a kind of reverie now.

It was blazing hot in the little study. Vincent sipped the tepid water and felt faint. Beneath her nun's robes, Placida was also perspiring freely in the furnace of an African afternoon. Sweat poured down Augustine's face. His shirt was drenched. But he was oblivious to it all. He imagined once again that incomparable moment when he had thrown off wealth, power, and sex, and put himself into Christ, the defining moment of his life that shaped and energized and made meaningful everything he ever experienced and thought.

"I saw myself at that time as a symbolic figure caught up in the struggle between heavenly and earthly communities. I saw myself standing at not just a personal but at a social and cultural crossroads. I saw the decision I was making was a decision not just for myself, but for the reform movement, the New Age movement we had started back in Carthage, a decision for a whole generation of intellectuals and scholars. You see, when Emperor Constantine became a Christian early in the century, Bishop Eusebius of Caesarea, the historian of the early Church and Constantine's court theorist, proclaimed the unity of the destinies of the empire and the Church. He said their destinies would

be integrated to the end of time and that God would reward the empire for becoming Christian. He said there would be a golden age of wealth and power, and the Church should enjoy its imperial triumph. As time passed, many bishops became magnates, built huge churches and splendid houses for themselves, and traveled with entourages in fancy carriages like proud lords. I felt I had to reject this Christian triumphalism for two reasons. One, it was morally wrong. This was not the way Christ wanted His disciples to live. A bishop was a shepherd, and he was supposed to carry out Jesus' command to His disciples: 'Feed my sheep.' Gaining imperial wealth and power was not the way to do this. I felt I was going down the road to grandeur and secular power and it was the wrong way to go."

"You see, Augustine," interjected Vincent. "I told you there is no big difference between you and the Donatists. We, too, stress the dangers of wealth and power to the spiritual life."

<p align="center">* * *</p>

Augustine paid no attention to Vincent's bromide, but continued his excited soliloquy on the significance of his conversion experience.

"Secondly—and this is what Ambrose especially helped me to see—the destinies of the empire and the Church were not necessarily united to the end of time, as Eusebius had claimed. Three decades ago, when all this happened in my life, the empire was already in trouble. Already the government was in fiscal chaos. Already there weren't enough soldiers for the army. Already trade in the Mediterranean was declining, and beautiful cities along the coastline were getting poorer. I knew I had to break away from the Roman destiny. I realized that our little group back in Carthage had the right idea. I had to reject the selfish, decadent life of a professor, lawyer, and government bigwig, and dedicate myself to the Church and its people. And, of course, to do this, I had to be celibate. I couldn't have a wife and family. I had to escape from the burden of the body—for sexual satisfaction, for physical comfort. I had to live an ascetic life of service to the Church. That was the great upheaval I experienced; that was the great decision I made. I haven't regretted it. I think I took the right road. Anyway, God called me to this life. I was destined by God to be what I am. At a certain moment of extreme crisis and utter despair in my life, I heard the angelic voice of a child tell me to open the Bible and read, and there I found an injunction from Saint Paul to throw off the demonical

constraints of physical life and be born again as a follower of Christ. That voice was God's gift to me, and my conversion, my rebirth as a Christian, was God's doing. I am convinced of that, just as I am convinced that the whole history of mankind is foreordained by Divine Providence. Perhaps there was something in my conversion that was essentially anthropological, that was rooted in human nature. I turned to God in my moment of desperation and anguish just as mankind always turns toward its Maker when it needs comfort and strength. I was Everyman. Yet what happened to me was deeply personal as well. I can't explain it further than that."

Augustine had become agitated. His eyes were moist, and spittle was coming from the corner of his mouth. He leaned back in his chair, exhausted for the moment, as though some great force had issued from his mouth. Placida looked at him sympathetically, as if she knew how painful and strenuous it was for Augustine to get these words out.

Vincent saw his opening, the way the conversation might be directed back to the Donatist issue.

"Did Ambrose help you get started on your mission?" he said.

"I cannot recall that he did. He was too far above me and the little group around, men like Alypius and Paulinus. We went off entirely on our own. For a year or two, we lived together in a sort of commune, a sort of monastery, along with my mother, in a small villa on the shore of a beautiful mountain lake in the north of Italy. We studied and discussed, and mastered Christian doctrine and the Bible, and then we came down and began our careers in the Church. But we started at the bottom in the Church hierarchy, as simple priests. Nobody welcomed us particularly. Nobody praised us. We each individually undertook a life of service and piety."

"Augustine," said Vincent with an edge in his voice, "that is just what the Donatists want—a life of service and piety. We just want to be left alone to form our own churches and dedicate ourselves to the Christian life. And yet you won't leave us alone. You want to bring in the Roman state, from which you yourself separated, whose majesty and wealth you personally disavowed, to persecute us. It doesn't make sense."

"Yes, it does make sense," said Augustine calmly, "because our little group did not separate itself from the Church. Our life of service and piety was carried out within the context of the Latin Church. In a

way, we disavowed the institution of the empire but all the more we were dedicated to the institution of the Church. The Christian life is a personal thing but it is also a communal thing. It has to be lived within the community that Christ established for mankind, in which He brings His sacramental grace to everyone. I have never questioned the personal piety of the Donatists. Indeed, I regret their piety is not at the service of the Church now. That is one reason why I want to get them back by every means possible. But the Christian life is more than personal piety. It is the fulfillment of the Church's teachings, it is reception of the Church's sacraments, it is observing the discipline and good order that the Church demands. Even hermits and monks and saints—called as they are, individually, by God—they are still subject to the community of the Church and must still therefore obey their bishops."

There was a look of despair on Vincent's face. He knew that he would never persuade Augustine to leave the Donatists in peace. He admired this man but, at the same time, he was exasperated and angered. Augustine seemed such a bundle of contradictions, but contradictions that he had somehow resolved in his own mind so that he had an answer for everything.

"I came here today, Augustine," said Placida, seeing that Vincent had fallen silent, "to discuss with you that book you recommended, *The Seven Books Against the Pagans*, by that Spanish priest Orosius, a work that he dedicated to you. He exults over the decline of Rome; he separates completely the destiny of the empire and the Church; he celebrates the fall of Rome to the barbarians. In view of what you have been just saying about how and why you rejected an imperial career, I assume, Augustine, that you agree with Orosius's anti-imperial view of history."

Augustine responded without hesitation.

"I applaud Orosius's book, but I do not entirely agree with him. I am convinced that the sack of Rome five years ago by the Visigoths, even though they withdrew after a few days, was a signpost to the future. Rome is going down; its era is ending before the end of time, contrary to what Eusebius said. The Church must go on alone to continue its pilgrimage. Of that I am convinced, and, so far, I fully agree with Orosius. Yet I am more ambivalent than he is about Rome itself.

I do not cheer its demise as he does. Even though I am a native African and not a Latin, even though in my own life, at a critical juncture, I rejected a life of imperial service and preferment, I am more ambivalent about Rome than Orosius is—and many of the others of his younger generation are. I will miss the Roman Empire if I live to see its fall."

"I am surprised at you, Augustine," said Placida, smiling. "You used to thunder against the Romans. Are you getting soft and nostalgic in your old age? When you go for your evening walk along the harbor nowadays, do you recite to yourself the love song in Virgil's *Aeneid* about Aeneas and Dido, the African princess, and dream of the glory days of old Rome?"

She was teasing her brother now. Augustine flushed and tried to avoid Vincent's puzzled look.

"I will admit, when I walk along the harbor nowadays and look out upon the great sea, I wonder how long it will be as peaceful as it is today, what terror may be visited upon us soon from invaders crossing the Mediterranean, and how much, only a few years from now, we may wish that Roman power was still invincible."

"Donatists," said Vincent smugly, "will never forgive the Romans for their persecution and martyring of Christians."

There was a wistful, sad tone to Augustine's speech now.

"The Romans were never as noble as they claimed to be. Even the virtues of the Roman aristocracy, we might say, were only splendid vices. But splendid they were. I wouldn't portray all the emperors as monsters and terrorists, the way Orosius does. When Rome goes down, we shall miss its power and law; we shall hanker after the Roman order, which provided the earthly peace needed to go on the pilgrimage of the City of God. Who knows when we shall be able to teach the wild German kings to provide a Roman kind of law and order? It may take a long time. We shall also miss Roman learning, its wonderful language, its literature and philosophy. When I preach in the cathedral on Sundays, and when I speak in Latin rather than in the Punic vernacular, even though the hundreds of farmers standing there shoulder to shoulder, with their families, probably can't understand more than half of what I am saying in Latin, I know they feel inspired by the sheer beauty and force of the language. There is nothing like it

in the world. As time goes on, I think I agree more and more with Jerome, whose new translation of the Bible into Latin I once condemned as a waste of his time. I now see the need to rescue the Latin language and some parts of the Latin pagan heritage if the empire goes down. I now agree with Jerome that ours is a *Latin* church, and it must cultivate its Latinity if it is to function effectively. Whatever else happens, we need to continue to master the Latin language, much of the classical tradition, and the Roman law. We must save the best of Roman culture and put it to our uses in the Church if and when the Roman state is no more. Piety and service aren't enough. We need the tools of Roman civilization to do the work of the Church in society. We must be like the ancient Israelites who took what they needed from the Egyptians as they set out into the desert toward the Holy Land. We, too, must spoil the Egyptians, take from the pagan Romans what we need for the Church's work."

* * *

"Well, my dear, brilliant, difficult brother," said Placida, "your own book on the meaning of the fall of Rome that you are writing—*The City of God* I think you said you are calling it—will it then be different in argument from Orosius's book even though he fancies himself your disciple?"

"Orosius's theory of history is really much like Eusebius's. Eusebius said the Romans were good and deserved to triumph; Orosius says that the Romans were bad and deserved to perish. I think no state in itself, and no group of rulers, is either good or bad. When you take justice away from the state—and this quality of justice is only derived from political service to the Church—what is the state but a band of robbers? By that I mean that, in and of itself, the state is just the pragmatic exercise of sovereign force in society. Whether it is Babylon, or Rome, or the Goths, the state in itself is neither good nor bad. It is just a fact of nature, just an instrument for earthly peace, for law and order. I neither bewail nor exult in the fall of Rome. It isn't important in the long run. The only important thing in history is the pilgrimage of the City of God and that is a history no historian can write, because the City of God is a *mystical* community whose members are known only to God. Yet, in spite of all this, I will miss the Roman Empire, perhaps for old time's sake, because I was a dark African colonial and

yet the Romans always treated me well. Perhaps Virgil said something important. He said Rome's destiny was to lift up the humble and crush the proud. As a dark man from Africa, I was one of the humble."

* * *

In the summer of 429 A.D., the Vandals, a New Germanic people, much more fierce and primitive than the Goths, burst across the Straits of Gibraltar from Spain and rapidly conquered Roman Africa. The loss of Africa's grain, and the passing of command over the sea within the western Mediterranean to the Vandals, spelled final doom for the Roman Empire. Disintegration of the Latin-speaking half of the empire followed quickly.

In the autumn of 429 and the winter of 430, Bishop Augustine witnessed the sufferings of his people as impoverished and terrorized refugees crowded into Hippo. He insisted that no bishop in North Africa should leave his church and seek refuge elsewhere but that all bishops must stay with their communities, come what may, and give comfort and guidance to them. He did so until his death at Hippo in August of 430, as the Vandals were besieging the city.

In what was probably the last sermon he ever gave in Hippo's rickety, dusty old cathedral, Augustine offered this advice to his community:

> *Whoever does not want to fear, let him probe his inmost self. Do not just touch the surface; go down into yourself, reach into the farthest corner of your heart . . . Only then can you dare to announce that you are pure and crystal clear, when you have sifted everything in the deepest recesses of your being.*[1]

A medieval monk remarked that no matter how long a scholar lived and how assiduously he studied Saint Augustine's voluminous writings, he could not hope to get to the end of them. Still today, at the beginning of the twenty-first century, Augustine of Hippo remains the most influential, ambivalent, and controversial of Christian thinkers.

[1] Translated by Peter Brown.

The Civil Law

*I*f the greatest Roman advocate of them all, Marcus Tullius Cicero, could be brought back to teach at an American law school, he would do a good job because he was the ancient world's most famous and skillful lawyer. He is also the individual in antiquity we know most about: more than seven hundred of his letters, many highly personal and intended only for their recipients' (friends or relatives) eyes, and fifty-seven of his greatest orations, most delivered (before his own editing and fleshing out) in the courtroom, have survived. Furthermore, Cicero's Latin rhetoric, complicated but punchy in style, down through the centuries has been regarded as the standard of Latin prose, emulated by humanist scholars and taught to boys in elite prep schools.

Cicero was not the first prominent lawyer in Republican Rome. He himself mentions a certain veteran attorney named Hortensius, already successful in practice when Cicero started his own career, who was his losing opponent in the famous case that made Cicero's professional reputation. Cicero carefully observed Hortensius's courtroom style but, he claims, significantly improved on it, Hortensius being prone to stilted argument and to consulting his notes too much.

Cicero became the greatest advocate of his day, the man you wanted to represent you in litigation if you could afford it, the winner of a series of sensational cases, some with important political overtones. He was even more flawless, eloquent, and admirable in posthumous reputation, up into the mid-twentieth century, than he had been in life. His name, his visage, his sentences became etched in marble and set the model for the legal profession in common-law countries, even more than in the Roman-law world.

That is because, a generation or two after Cicero, Roman law accorded overwhelming control in the courtroom to the imperial magistrates, the emperor's judges who restricted the freewheeling aggressive advocacy that Cicero practiced, which centered on the heroic, silver-throated attorney drawing all attention to himself and talking endlessly about anything that was even remotely connected to the case.

Cicero lived and practiced in the later days of the Roman Republic (it was replaced by Caesarean autocracy just sixteen years after his death). In Republican courtrooms, the verdict was not rendered, as later, by a small panel of sober, cautious, prosaic, emperor-appointed magistrates who had no taste or time for attorneys' grandstanding, but in the old Republican and Greek manner, before a large jury—usually around forty senators or other prominent politicians eager for a show and with well-educated ears and eyes attuned to an elaborate or subtle turn of phrase, a handsome face, an elegant gesture of the hand and arm, and a well-cut toga.

In Cicero's day, in the late Republic, for upper-class people, both civil and criminal actions started when someone made a petition to a political official (resembling a mayor) called a praetor. The latter would then appoint someone experienced in the law to act as presiding judge in a trial. A jury, comprising usually 40 to 50 men (but it could be as many as 180), would then decide the case, after an often lengthy trial with presentations by counsel.

How criminal trials of poor people in Cicero's day were conducted in Rome is not known; presumably, they received summary justice from a magistrate. The capability of ordinary people to engage in civil suits was limited by the very high cost of such actions, involving not only the hiring of counsel but substantial court costs.

Whether civil or criminal, the trials in which Cicero participated nearly always concerned litigants or defendants from the upper class. Even when he undertook to represent a person of modest circumstances, it was likely that a wealthy interested third party gave him at least a token fee on the side.

* * *

The courtroom in which Cicero practiced in his glory days around 60 B.C. was more like the California courtroom of today than the structured, judge-dominated courtroom of imperial Rome, which had fully

developed by 150 A.D. and is still the legal practice in Germany, France, and other Western European countries, with their Roman-law heritage.

Furthermore, between about 1300 and 1950, and perhaps still occasionally today in upscale prep schools, the core curriculum in humanities for adolescents was, astonishingly, Cicero's own great courtroom orations. When they grew up to be practicing lawyers in the common-law courts in London, Boston, or Toronto, they only had to call on their educational experience in their most impressionable adolescent years to know viscerally and spontaneously what great advocacy was. Cicero had shown them the way, and they had, under duress of stern schoolmasters, absorbed these Ciceronian lessons into the very depths of their consciousness.

Cicero's talent for writing as well as speaking the difficult, cumbersome Latin language has never been equaled by anyone. His Latin prose style became the model for all subsequent masterful writers in Latin, such as the Christian theologian Saint Augustine in early-fifth-century Tunisia, and the Renaissance humanist Petrarch in mid-fourteenth-century Florence. Furthermore, Cicero's prose style, with its immensely skillful use of subordinate clauses, and rushing, cascading phrases leading to a pithy climax, has been imitated by some modern masters of English prose, notably Edward Gibbon in the eighteenth century and Winston Churchill in the twentieth.

Though it is risky to use this exuberant, richly textured style, it has tremendous impact if done well. Lawyers are not, as a rule, great prose stylists, and no advocate or attorney has come remotely near challenging Cicero's empyrean position as a writer. With this important but singular exception, he was, in every way, a typical highly successful lawyer of the Western world, up to the immediate present among English barristers or Wall Street law firms. He fitted fully the pattern of an important lawyer's background, ambitions, behavior, lifestyle, interests, and legal and political philosophy. He was the prototype of the big-time advocate.

Privately, Cicero acknowledged that judicial orations were part of his work as a barrister and often did not represent his personal opinion: "Anyone who supposes that in my necessarily forensic speeches he has got my personal views under seal is making a great mistake . . . We

orators are brought in not to say what we personally think but what is required by the situation and the case in hand."[1]

The role and attitude of an attorney in the later English common law (and in the United States today) could not be more succinctly and bluntly stated.

Cicero's role as the typical upscale lawyer is, to a limited but still significant degree, a matter of his personal impact, through his writings, on subsequent generations. How a great lawyer speaks, writes, behaves, and lives is enshrined in Cicero's voluminous writings. Those who had what we would today call a prep school (that is, humanities secondary) education, or immersion in the Latin classics in college, could get immediate inspiration for modeling themselves on the master advocate from Cicero's own communications.

However, Cicero's place as a typical lawyer of high public image and immense professional success, with attendant behavioral patterns and personal style, can best be explained sociologically rather than by the longitudinal perpetuation of a tradition that he started. Given the work commitments of a litigator in an adversarial kind of courtroom scene—one advocate against another in oral pleading in front of a jury—Cicero's talents, temperament, lifestyle, interests, and philosophy comprised a well-rounded category of public and private persona: the prominent, affluent, influential, and much admired lawyer, "Get me Cicero."

Cicero's class and family background are highly typical of successful lawyers at all times and places. He was not an aristocrat, not from a senatorial family, nor from a clan of great landholders, corporate magnates, and statesmen. He was from the provincial, aspiring middle class. His family could afford to give him a very good education; after that he was on his own. Cicero moved upward socially to become what the Romans aptly called one of the "new men," a millionaire lawyer, a member of the senatorial elite, and, for a short time, the holder of high political office and a mover and shaker in circles of supreme power.

Cicero's one problem was that he lived in a bad time, the disintegrating, tempestuous, violent later years of the Roman Republic, in which vicious political rivalry among elite political groups, seeking power and booty, spilled over into violence, assassinations, and civil

[1] Translated by John Cook.

war. This era ended only a few years after his death, when the surviving leader of one party, originally founded by the now assassinated Julius Caesar, made himself dictator by force of arms, ruled powerfully and wisely as Augustus Caesar, and established benign imperial power to replace the disordered, collapsed, and discredited Republic.

Cicero was insufficiently adept politically, or lacking in sufficient good fortune, to dance his way through the political maelstrom of late Republican Rome. After he gained the pinnacle of office, that of consul, in 63 B.C., his political fortunes went into decline. In the end, twenty years later, he was not even allowed to live peacefully in retirement on his beloved country estate. Because his powerful oratory had aroused the abiding enmity of Mark Anthony, the famous lover of Cleopatra, he was cut down by soldiers in the employ of that powerful political gangster, himself soon to be vanquished by the ascending Augustus Caesar.

In his younger days as a lawyer in Rome, Cicero did all the right things to assure professional, fiscal, and political success. He gained public attention by a politically correct judicial onslaught on a corrupt colonial governor, representing the wounded and outraged citizens of Sicily. He won temporary power and popularity by successfully prosecuting for treasonous conspiracy a shadowy aristocrat, Catiline, who had become the leader of a left-wing populist group; thereby, Cicero endeared himself to the conservative majority in the Senate. He closely associated himself with the billionaire businessman and politician Crassus, and bought a large house from this magnate, going into heavy debt to do so.

Cicero had a lavish domicile in the fashionable heart of Rome. He also bought a large country estate, for which he had genuine affection, spending a lot of time there, writing. Not only did Cicero jettison his first wife under Republican Rome's easy divorce laws to marry into a more influential clan, but, for enough money, he could also be persuaded to represent shady people or members of opposing political parties.

He likewise did what in American law is called pro bono work, representing for little or no fee a worthy indigent client, carefully choosing (as great attorneys do) such clients to get maximum favorable publicity. Thus Cicero represented an obscure Greek writer, one Archias, in a

humble immigration case, getting Archias his permanent residency in Rome. This case enabled Cicero to expound at length on the glories and uses of literature, not ignoring the mundane ("Good literature spends the night with us; accompanies us on our travel").

Since oratorical advocates like Cicero were gentlemen supposedly removed from trade, they, like later English barristers up to the present day, did not directly bill clients. This fiction is meaningless except to give a fake aristocratic aura to the Roman advocate and the English barrister. In both instances, a third party collected the fees, and the charges were heavy. Consequently, Cicero became wealthy from his courtroom work.

Cicero's speeches and letters resonate with two seminal legal ideas that are absolutely integral to English common law, which were developed by his less flamboyant successors, the masters of Roman law, beginning in the constitutive era between 50 and 200 A.D.

The first of these ideas may be called the moral "penumbra" effect of judicial finding. Without this idea, many of the progressive decisions of the U.S. Supreme Court in the Warren-Burger era and thereafter, between 1954 and 1975, would have been impossible. Ronald Dworkin, holder of chairs of jurisprudence at Oxford and at NYU Law Schools in the 1980s and 1990s, could not have constructed his thick, lengthy, liberal judicial essays—many of which initially appeared in the *New York Review of Books*—without the Ciceronian penumbra doctrine. It is a simple idea, but a very important one—namely, that law is part of a moral continuum. Or, a circle of ethical compulsion surrounds the legal planet and exercises a gravitational pull on it.

Every judicial issue and decision gives off a moral bank of light. The good attorneys and magistrates focus on the moral penumbra and extrapolate from it back to the specific legal point at issue, whereby they advocate and render decisions in accordance with the conditioning ethical ambience. Every lawsuit has moral implications that the good attorney and wise magistrate will select and define.

There is a strong sanction for progressive court findings, rising from the ideal of a moral penumbra that surrounds every judicial act. Cicero did not inaugurate this ethical approach to law. It is powerfully rendered in Plato's *Republic* and *Laws*, and more moderately and circumspectly in Aristotle's ethical and political writings. It came to

Cicero directly from the Stoic philosophers of his day, a group of applied Platonists and aristocratic political pundits.

Yet Cicero's assertion of the penumbra idea was a main channel for its actual transmission into the judicial culture of the Western world, along with (after 1200 A.D.) direct impact from the Greek philosophers themselves.

Penumbra is not a legal theory that has gone without challenge. Skeptical thinkers, hard-headed realistic ones—called sophists in ancient Greek times, and, in later times, positivists and utilitarians—have dismissed the penumbra as a fog of unknowing, at best a convenient myth, at worse mischievous "nonsense on stilts," as the English legal philosopher Jeremy Bentham said around 1780. But it has persisted and has had tremendous consequences for the recent history of the U.S. Supreme Court.

The famous U.S. Supreme Court case *Roe* v. *Wade* (1973), which, in effect, legalized abortions, was decided on the basis of the penumbra theory. The argument was that, although the American Bill of Rights (1791), the first ten amendments to the Constitution, did not specifically recognize a right of privacy, taken together, the ten amendments radiated such a powerful ethical penumbra that a right of privacy and a woman's right to an abortion in the first trimester of her pregnancy are implicit in the Bill of Rights. That Ciceronian penumbra still carries weight is indicated by the fame of its prominent and current expounder, Dworkin, who is idolized by mobs of law students on two continents.

* * *

If in recent times the penumbra idea has had a liberal, progressive ring to it, Cicero's other main judicial doctrine would be regarded as a highly conservative one today, although in medieval or eighteenth-century England it was, at times, arguably on the progressive side.

The idea is this: Everyone in a country, even aliens, has an equal right to the due process of the law. But this judicially substantive equality does not mean that the law can be used to amend hierarchical class structure and the economic inequality that exist in society. Indeed, the due process of the law signifies not only an equal chance in the law courts for the poor man, but also protection of the rich man's property and privilege.

Cicero hated anything that smacked of what the ancients called "an agrarian law," using law to redistribute property to the poor—that is, socialism. That was morally wrong and politically dysfunctional, and would destroy the stability and harmony of the Republic. Cicero's bifocal vision—legal equality, social and economic inequality, both confirmed by the law—became central to English common-law culture in the period of formation, 1200–1500. It also became the cardinal doctrine of the Whig political party in England, and of the American Federalists and their Republican successors.

Cicero's judicial equality conforming to social inequality was not a simple reductive ideological blueprint for making English common law. Common law developed this principle empirically in the first century or so of its development (1150–1250). Then, in the later Middle Ages, well-read people sensed that Cicero had propounded much the same principles back in the closing era of the Roman Republic. This literary discovery strengthened the hold of the common-law idea that emerged initially out of social exigencies and judicial experimentation. It reinforced the notion that the common law was eternal—and eternally correct. The coincidences of Cicero's jurisprudence and the forms of English common law enhanced the Roman advocate's reputation and made his writings all the more valued in the Western literary world.

An obvious question arising from the texts of Cicero's courtroom orations is, How close to the actual oral presentation is the written form that we have? A prominent English lawyer of the early nineteenth century, Henry Brougham, said of one of Cicero's forensic disquisitions that only a sixth of it actually dealt with the issue judicially and that this kind of freewheeling rhetoric would never be allowed in an English court of law.

The inclination therefore is to regard the written texts as much amplified from Cicero's courtroom advocacy and to assume that much humanistic material was inserted after oral delivery. But it should be remembered that Cicero was addressing a jury composed mostly of highly educated and leisured gentlemen. They enjoyed—and expected—a lengthy rhetorical display.

Even in the late first century A.D., orotund oratorical advocacy was still acceptable, if lawyer and state official Pliny the Younger can be

believed. Recounting one of his courtroom triumphs, he set this theatrical scene:

> *There they were, one hundred and eighty jurors . . . a huge collection of counsel for both plaintiff and defendant, rows and rows of seats in court, and a deep ring of auditors standing up . . . I piled on every canvas — indignation, rage, distress — and sailed the seas of that tremendous {judicial} action like a ship before the gale.*[1]

Except for mention of the huge jury, this account could have been written by a prominent London barrister or an American trial lawyer today. A reasonable guess is that while Cicero's forensic orations were indeed embellished by him for publication, they were remarkably not far from the actual oral delivery.

But already in Pliny's time, courtroom fireworks by an attorney must have seemed old-fashioned and, by the middle of the second century A.D., highly unusual. Roman law became professionalized and bureaucratized, and the focus of the court switched from attorneys to judges. As power was taken into the hands of an autocratic emperor, as the political theory was broadcast and generally accepted that the Roman people had irrevocably surrendered their legislative power to the emperor, Roman courts became much less glamorous and autonomous than in Cicero's or Pliny's day. Unlimited legal power was vested by the emperor in a small group of jurisprudents (experts) and magistrates who tightly supervised court proceedings. They elaborated both civil and criminal law in great detail and began the task of codifying it.

By the third century A.D., a small panel of judges completely controlled court proceedings. Advocates could still make presentations, but they were closely watched and supervised by the judges. The judges no longer had time or patience for expansive oratorical presentations in the Ciceronian mode. By 200 A.D. the attorneys were very much officers of the court and were there to help the magistrates as much or more than to represent their clients.

Cicero's orations were now studied for their stylistic content and

[1] Translated by John Crook.

humanistic value, not as models of lawyering. Cicero's kind of high-profile humanistic advocacy would be much more at home in an American court today than in a Roman court in the later years of the second century A.D. Trying to emulate Cicero's aggressive style of advocacy would therefore bring only stricture and censure in the Roman judicial court that developed in the two centuries after him, as in the legal system that still prevails in Western Europe and is known to us as Roman law.

* * *

We get our word "empire" from the Roman word "imperium," which means "power" or "authority"; hence "imperator" for Augustus Caesar and his successors, who took authority over the Roman state shortly after the death of Cicero. In the following three centuries, the Roman Empire developed the system of Roman law that prevails in continental Europe to this day. But the definitive test of the Roman law comes not from the first Rome on the banks of the Tiber in Italy but from the second, Byzantium. The legal culture that predated by half a millennium (and, to some extent, affected the shaping of) English common law was fully developed here. The Emperor Constantine in the early fourth century built a new eastern capital for the Roman Empire, one that would be thoroughly Christian—which the ancient city of Rome was not yet—and from its magnificent site on the Bosphorus would dominate the eastern, more thickly settled, and richer Greek-speaking part of the empire. Constantine named this second Rome after himself.

Since 1453 A.D., Constantinople has been part of Muslim Turkey, and, since 1930, has been called Istanbul. Its early medieval glories, when it was possibly the largest and wealthiest city in the world, are much subdued now, hidden under the dust of centuries. But its glorious buildings and unparalleled physical location still hark back to its days as Constantinople, Constantine's city; built over the old Greek port of Byzantium and then enduring as the capital of the Eastern Roman, or Byzantine, Empire.

The way Cicero behaved as an attorney and conceived of the law foreshadowed some key aspects of Anglo-American common law as we know it, and, in time, had some actual marginal influence on it. But the massive and perpetual impact of Roman law on Western Europe, and the imagining and implementation of a system of law that still

prevails on the European continent, came directly not from Cicero but from an emperor of Byzantium after the Germanic invasions of Western Europe in the fifth and sixth centuries.

The relationship between English common law and the other system of European law emanating from the Middle Ages, that of Roman law, remains today one of the most vexed issues in legal history. During the seventeenth and eighteenth centuries, conditioned by contemporary political disputes and ideological formulations, a widespread conviction developed among the lawyers in England that the two systems of law, English common law and Roman continental law, were antagonistic and mutually exclusive. In the past century there has been a significant move away from this paradigm of juristic repulsion and separation. Learned claims have been put forward as to how much English common law in its medieval era of formation owed to Roman judicial traditions and how broadly it integrated Roman law concepts into English judicial culture. Harold Berman of Emory University has been a particularly forceful advocate of this integrative view of legal history.

This is my view of this controversial matter:

In England, one of the German-dominated successor kingdoms to the Roman Empire, a legal system distinct from Roman law emerged. By the twelfth century, there was visible influence on English common law from continental Roman law, particularly on some aspects of civil law and in the development of the legal profession. This means that while continental law experienced a massive absorption of Roman law of late antiquity and the Middle Ages, English law, to a much lesser but still real degree, has to be seen in the context of Roman legal culture as somewhat derived from it.

The Byzantine emperor so important in the transmission of a formative Roman-law heritage from late antiquity to the medieval world, and from there into modern times, was Justinian I (527–565 A.D.), a ruler of tremendous energy and much accomplishment (if not always wise in policy, or fortunate in impact) in almost every aspect of life in the Mediterranean world of his day. Justinian surrounded himself with very capable officials and generals. He was much influenced by his vivacious and ambitious wife, Theodora, a former prostitute and cabaret dancer. Justinian made a strenuous effort to recover North

Africa and Italy from the German invaders, and had some short-term success. But within a century of his death, the reconquered Algeria and Tunisia fell to the Muslim Arabs, as did Sicily. His twenty years of war of reconquest in Italy left that peninsula devastated and impoverished. Most of the Italian territory Justinian regained was soon taken over by new Germanic invaders, whose name is memorialized in the regional term "Lombardy."

The two enduring monuments of Justinian's rule were the vast cathedral of Hagia Sophia (Holy Wisdom) in Constantinople, which, after the Turkish conquest of the city in 1453, became a Muslim mosque for half a millennium and is today a somewhat musty and run-down museum; and the definitive codification of Roman law, the *Corpus Juris Civilis*, forever appropriately referred to as the Justinian Code.

There is a small confusion in citing the Justinian Code by its official title, *The Corpus of the Civil Law.* In Anglo-American parlance, the term "civil law" has two quite distinct meanings. Civil law is noncriminal law. But the Roman legists came to refer to their legal system as a whole, including criminal law, as the civil law, the law of society. (In the later Middle Ages, experts on Roman law were often called "civilians.") Thus, "civil law" is a term for one of the two main branches of law, along with "criminal law." It is also a term synonymous with Roman law and the Justinian Code. The unfortunate duplication of the term exists, but the distinction in meaning can be readily extrapolated from the context.

For at least five centuries after 1100 A.D., in the law schools of continental Europe, the Justinian Code—the last literary work of the Byzantine Empire to be written in Latin rather than Greek—was the basic textbook. From these law schools, well-trained and highly literate graduates went out to staff the administrations of the emerging European monarchies of the later Middle Ages, and the papal bureaucracy in Rome.

Thereby, the general mindset enshrined in the Justinian Code—as well as specific juristic doctrines and the institutional legal system it was supposed to facilitate in operation—entered profoundly and, perhaps, forever inextricably into the judicial and political culture of the European states and the Roman Catholic Church to the present day.

"Its abstract and reiterated legal concepts made Roman law . . . a mine of precious materials that jurists, as specialists arrogating to themselves a monopoly on the theorization of social relations, could recuperate and reutilize."[1]

In modern print, the Justinian Code runs to some dozen volumes. (An obscure Philadelphia lawyer produced a good English translation of it in the 1930s.) It draws on the imperial legislation and court workings of the Roman Empire, going back five centuries to Augustus Caesar. It owes much to a series of Roman jurisprudents, particularly one Gaius, who wrote around 200 A.D., and to a first effort at codification (425 A.D.) named for the otherwise incompetent Emperor Theodosius II.

Justinian himself took a personal interest in the *Corpus Juris Civilis.* He not only commissioned and funded its preparation, but played some indeterminable role in the actual work of writing and editing. Yet most of the job was in the hands of a panel of great lawyers headed by Tribonius, about whose personal life we know nothing.

It may be asked why Roman law developed so elaborately in the half millennium between Cicero and Justinian I. Why did the Roman Empire produce this complex yet well-articulated system of law?

It was said at the beginning that law develops creatively in large political entities, and the Roman Empire was the largest contiguous political structure the world had ever seen. At its farthest point, by the second century A.D., it stretched from the Scottish border to the frontier of Iran, from the Rhine and Danube to three hundred miles into the Magreb in North Africa—what is today Algeria and Tunisia. Its population was extremely diverse ethnically and culturally, its people were bound together by Roman imperial administration and the Roman law courts, to which all citizens (which, by 212 A.D., meant at least 70 percent of the population of the Mediterranean world) had access and to which they were subject. It is no surprise that such a vast multicultural political entity should have developed a legal system to provide for security, peace, and enterprise.

A second reason why the Romans developed their distinctive system of law was the extreme tension, spilling over into civil war, that

[1] Translated by Manlio Bellomo.

developed among the elite ruling families in the later years of the Republic. A function of the law was to countervail the divisiveness of these debilitating social and political conflicts among families and other groups fighting for command over wealth and power. Roman law supported the emperor in gaining peace and stability. The law enforced imperial authority, and the emperor in return gave legitimacy and force to the law and supported the magistrates who implemented it.

A third reason for the development of Roman law was the high capacity for literacy among the Roman ruling elite. Legal articulation and law codes were a prime outlet for intellectual and literary capability in the later empire.

The existence of an elaborate written text, particularly if it is ostensibly nonfiction, more attractively if it has explicit social and political meaning, most powerfully if it has legitimizing state power behind it, will in time become the focus and fountain of an ongoing culture. Professors, who mainly conceive it their métier to comment on written texts, will explicate it—in the medieval law schools they were called the glossators and postglossators. Students will exhibit their capacities and prepare for remunerative careers by memorizing large chunks of it. Enterprising writers and publishers (in the twelfth century, initially, scribbling monks, then successful lawyers) will produce textbook summaries of it. Theorists inside and outside universities will emerge who will take up aspects of it, extend and develop one or the other side of the original text, and further activate the ongoing culture by thinking up novel positions rising out of the culture that grew up around the text and among the elite who lived off it.

This is what happened with Roman law as enshrined in the Justinian Code, from the late eleventh century to well into the seventeenth. There were persistently, in each generation, centers of Roman-law study, beginning with Bologna (still going strong today), a professional elite of magistrates and attorneys trained in Roman law and ready to implement it in every conceivable way, students who sought professional careers by mastering it, and theorists who took off from it.

In France, Germany, and Italy, this acculturation and socialization of the Justinian Code, modernizing and adjustments, accretions, and imitations having been made, can be said still to be going on. It will

never stop. The solidification and intensification of the European Union, both in its concept formation and in its fostering of a narrow ruling cosmopolitan professional elite, will make sure of that.

In the United Kingdom, the strange medley of rightist Tories and leftist Labourites, who resist Britain's absorption into the European Union, are not really sure why they are resisting. They speak with foolish nostalgia of British imperial and populist socialist traditions, which are obsolete and are as superseded as British dominance in soccer or cricket. What they are really resisting but cannot articulate is the melding of Britain, with its cognate but still very much separate common-law ethos, into the pervasive, homogeneous, immensely rich and productive, continental Roman-law culture derived from the heavy volumes of the Justinian Code.

The fundamental principles of Roman law in the Justinian Code are absolutism and rationality. Absolutism is based on the constitutional myth that developed in the early Caesarean empire of the first century A.D. As the code itself says: "Whatever is approved by the sovereign has the force of law, because by the *Lex Regia* [royal law], from whence his power is derived, the people have delegated to him all their jurisdiction and authority."

Long ago, legislative sovereignty resided in the Roman people; they have irrevocably surrendered this authority to the emperor. His will is now law. The law resides in his mouth, in his breast.

The emperor is the head of the Greek church; he holds divinely constituted authority. So, in the Code, religious sanction is added to legislative and executive authority, "for what is greater or more sacred than the Imperial Majesty? Nothing in this world."

Going along with this absolute authority by which the emperor dictates the particulars of the civil law, the law of the immediate society he governs, is natural law, the judicial principles that reason perceives as applicable to all peoples, and hence—the Code declares—constitutes the Ius Gentium, the law of nations.

This idea goes back to the Stoic philosophers and, hence, was already suggested by Cicero. It was clearly stated by Gaius around 200 A.D., as the Mediterranean world under Roman rule became more of a homogeneous political unit and Roman citizenship was gained by the majority of people under Roman rule. In the Justinian Code, natural

law is universalized to the point that it "is not peculiar to the human race, but applies to all creatures which originate in the air, on the earth and in the sea."

In the later centuries, beginning with the thirteenth, and blatantly so by the eighteenth century, the idea of natural law would be a liberalizing or even revolutionary vision: A law of the state that offended reason lost its legitimacy. In the Justinian mode, natural law is, in fact, a highly conservative principle. It gives greater legitimacy and universality to the law of the imperial state. Reason now buttresses the people's surrender of constitutional authority to the emperor.

The laws promulgated by the emperor are given additional force by according with what "natural reason has established among all peoples." There is no ground for questioning, let alone nullifying, the imperial law or resisting the judgment of the emperor and his magistrates. To do so offends nature and conflicts with reason, and such high treason is worthy of the most dire and immediate punishment.

"The union of male and female" is part of natural law, and the emperor's laws regulate sexual union in marriage. The hierarchic organization of society, including slavery, is also legitimated by natural reason.

The political theory of the Justinian Code is very well thought out and fully articulated to prevent any possible resistance to imperial judicial authority. Since the emperor is the head of the church, religious sanction cannot be used against him; indeed, faith supports imperial power. Resistance to imperial law cannot be based on reason and appeals to natural order. Natural reason conditions imperial law and gives it an additional covering of legitimacy.

* * *

What is the temperament behind this legal theory? One side of the psychology behind the Justinian Code is an unlimited lust for power and control, for wealth and dominance, for personal and social mastery. An imperial courtier named Procopius wrote, presumably in secret, a lurid account of Justinian and Theodora's insatiable appetites, including sexual practices.

Another side is a yearning for peace, security, social harmony, and judicial clarity. "We adorn peace and maintain the Constitution of the State," says the prologue. Alongside this is a desire for efficiency and order. "We have found the entire arrangement of the law which has

come down to us . . . to be so confused that it is extended to an infinite length and is not within the grasp of human capacity." The law must be clear, accessible, finite, easily researched, and readily learned. This is the most admirable side of the Justinian system.

In comparison, rationalization and codification of English common law was only attempted in the mid-thirteenth century by Henry of Bracton, a clerical lawyer trained in Roman law; his effort resulted in a mess and had no practical outcome. Codification was talked about in the English revolutionary era of the 1650s; nothing happened. It was called for by liberal reformers in the late eighteenth and early nineteenth centuries; nothing happened. It was officially begun in the 1960s but has made very little progress. In the United States, the codification of federal commercial law carried out in the early 1950s by a Columbia law professor was regarded as well-nigh miraculous.

Codification is improbable in Anglo-American law because, in comparison with Roman law or today's European continental law, the legal profession is too autonomous, and there are too many vested interests enjoying benefits from the current infinite and inefficient legal corpus. Justinian overcame such obstacles; his authority could repress the special interests, and the judges and attorneys all worked by his mandate. It is also true that sixth-century Byzantium was a more homogeneous and compact society than Victorian England and early-twenty-first-century America.

But Germany today is a complex society, and it has, in the Justinian tradition, a highly compact and well-articulated legal code put together by law professors and applied by judges thoroughly trained for that purpose. Rationalized codification in the Justinian style, and open-ended confusion and disorder in the common-law tradition, are the outcome more of a cultural than of a functional polarity.

What made the Roman-law system in its Justinian mode work was a set of magistrates who held judicial power delegated by the emperor and who thoroughly controlled the courtroom and its proceedings. This had been the trend in Roman law since the first century A.D., away from the autonomous courtroom with its huge jury before which Cicero orated. The professionalization, bureaucratization, and centralization of Roman law came to fruition in the world of the Justinian Code and in continental Western Europe, which enthusiastically adopted it and rigorously applied its operation.

A small panel of magistrates, usually three or five, now presided over the Roman-law court. In civil actions they received written briefs from the litigants or, more frequently, from their attorneys, interrogated the disputants based on these briefs, made whatever further inquiries were necessary, and rendered a decision in written form, which the majesty of the state enforced.

In criminal actions the judges also used written pleadings as much as possible. A charge having been laid against a defendant, one or more magistrates conducted—with the aid of state police officials—a thorough investigation of the case. There was no time limit on this investigation, an aspect of Roman law today that shocks and frightens people used to the speedy trial provisions of common-law countries, even if those provisions are less and less observed in actual practice, owing to impossibly crowded court calendars and delaying tactics by attorneys and judges.

Roman law required at least two witnesses against the defendant. One of these witnesses could be, and preferably was, the defendant himself. Far from prohibiting self-incrimination, Roman law sought it. The defendant was "put to the question" under torture.

In the course of the long inquiry and questioning of a defendant, the magistrates frequently worked out a plea bargain with the defendant, by which he confessed to a lesser charge or was promised a more moderate punishment than otherwise, in return for his confession. No less than in common-law criminal actions today, the Roman-law system in its criminal jurisdiction needed plea bargaining to make the wheels of justice turn.

There was no jury in the Justinian-type court, no half dozen or dozen representatives of society to consider the facts of the case and decide on guilt or innocence. In modern times some continental countries added a jury to give a more democratic mien to the court system. But the jury deliberates with the magistrates and has none of the independence of the common-law jury. Torture was abolished in Roman-law countries only as late as the eighteenth century. But defendants can still be kept in jail for several years before trial, while the magistrates conduct their investigations, a form of nonviolent torture. In films or plays about trials in Roman-law countries, what is often made to appear as the product of fascist inclination or a backward cultural effect is actually within the straight-line Justinian tradition.

Roman law was extremely sophisticated in working out the theory and applications of important aspects of civil law. The Roman law of written contract, property, inheritance, and marriage entered into the mainstream of continental law after 1100 A.D. It was in the area of contract law that Roman law exercised its greatest influence on medieval common law and all modern contract law. "One of the greatest Roman inventions . . . is the consensual contract, a contract that is legally binding simply because of the parties' agreement and requires no formalities for its formation."[1] This Roman juristic instrument lies behind the common-law principle of freedom of contract.

The Justinian system required a fairly large body of highly educated, experienced, and well-paid judges. Attorneys for the prosecution and defense appeared in court and participated, but their role was marginal. In comparison with the role of defense attorneys in common law, the defendant's advocate in a Roman-law court was of modest importance.

Yet in civil actions, under Roman law, attorneys were critically important because they prepared the elaborate briefs making the case for their clients. It was on the judge's study of these briefs that the civil action in the case moved. If a brief was not well prepared, the client lost.

<p style="text-align:center">* * *</p>

In old Byzantium there were probably barely enough qualified magistrates and attorneys to keep the system functioning well. The Justinian system could not be implemented in Western Europe in the early Middle Ages, before the growth of law schools after 1100 provided a cohort of trained professional lawyers. It was not until three generations had passed, by the early thirteenth century, that supply of law-school graduates caught up with demand, and the Roman-law system could be widely instituted—in Italy and France by 1250 and in Germany by 1450. What contributed to the proliferation of law schools, usually on university campuses in the late twelfth and thirteenth centuries, was the realization by kings and their chancellors that law school graduates made excellent bureaucrats of any kind, and that the authoritarian political theory embedded in the Justinian Code could be cited to sustain claims for extravagant royal power.

[1] Translated by Alan Watson.

The first law school, in Bologna, was founded sometime between 1080 and 1110, either to serve the legal needs of northern Italian merchants or to serve the papacy, which was engaged in codifying the canon law of the church along Roman-law lines. Possibly Bologna would be of use to both sets of clients. The merchants wanted to recover the law of a commercial society; the papacy, to rest judicial authority within the church in Rome. The great teacher and scholar at Bologna was Irnerius, who died around 1130.

Codifying work on the church's canon law was begun under papal auspices by the ambitious Gregory VII in the 1070s or, perhaps, a few years earlier, while Gregory was Cardinal Hildebrand and head of the papal administration. The codification of the canon law accorded the pope the position of absolute authority in the church that the Justinian Code gave the emperor. Alternative, more collegial traditions in early medieval canon law were shunted aside during the codification of canon law in favor of the Romanist position. The first definitive code of canon law was completed by Gratian, an Italian monk and legist, around 1140, and subsequent amplifications were issued by popes in the 1170s and 1240s. Gratian was something of a liberal. He "assigned to the jurist . . . only the task of evaluating acts, not hidden thoughts."[1] Unfortunately, his successors among the canon lawyers between 1200 and 1700 did not always make this distinction, and the courts of the Inquisition sometimes sought to probe into thoughts as well as actions.

By 1200 the papal Curia and the College of Cardinals were an international court of appeals for thousands of cases a year. More time was now spent in Rome on legal than on theological or even spiritual matters. All but one of the popes from the mid-twelfth to the early fourteenth century were canon lawyers. The great majority of the cardinals were lawyers. Annulment actions alone took up thousands of hours a year of litigation in the papal courts.

In the thirteenth century a law-school graduate with a first-class degree had two career choices: He could go to work in a royal judicial system, hoping to become a judge and maybe, ultimately, a leading royal official. He could be a secular person, get married, and establish a bourgeois family, a dynasty of lawyers from which, over the decades or centuries to follow, would come further "nobility of the robe."

[1] Translated by Manlio Bellomo.

Or the law school graduate could take a further degree in canon law (becoming a doctor of both kinds of jurisprudence, secular and ecclesiastical), take holy orders, and go to work in Rome, or as a judge or attorney for a bishop elsewhere. In the latter case, he could not legally marry and raise a family carrying his name; taking a concubine and producing bastard progeny was normally permitted, however. Who would end up as royal chancellor or as pope was the ultimate outcome of a career decision made by a law-school graduate around the age of twenty-five. It was not much different from the stark contrast of choices facing an American law-school graduate with a first-class degree today.

Roman law worked well when its courts were staffed by well-trained, experienced, and self-confident judges who were not hard pressed by kings or bishops to make specific partisan decisions. The quality of magistrates remained so important to the continental legal systems that, in Germany today, law students must choose whether they wish to be trained as attorneys or magistrates. The latter are given different courses and different postgraduate experience from the former.

The Roman-law systems in the Justinian tradition were very good at civil actions and in ordinary criminal cases. They were effective at ensuring law and order in society. Their weakness lay in being so judge-centered that inadequate training, corruption, and excessive ambition among the judges to climb even higher in state or church by making decisions that would please those in authority, eroded the quality of the system.

Put another way, the flaw in the Roman-law system was the lack of independence of the judiciary, which became very evident when the defendant in a criminal action, or one of the litigants in a civil action, was in disfavor with the government for ideological or other reasons. This situation became most infamously known when the papal-established courts of inquisition were set to work against alleged heretics in the thirteenth century. The situation was similar, however, when a king wanted to bring down an obstreperous lord or merchant capitalist. A Roman-law court could easily become an engine of royal policy.

There was one other fundamental problem in Roman law as it

developed out of the Justinian Code, and that concerned the principle of equity. The purpose of the courts in theory was to assure justice in accordance with abstract principles of natural law and universal reason. The written law was supposed to provide that. But if a case came before the judges, in which normal application of the law would fail to provide justice, they had the authority to suspend or go beyond the written law to provide equity or perfect justice.

This was a charming and morally attractive idea, but it gave the judges a degree of discretion that worked against the idea of a codified written law. Since little in the way of actual court records of medieval Roman law trials has survived, it is unknown how extensively equity was actually practiced. Papal inquisitors being rough on dissenters, or using their authority to persecute Jews (which they were not supposed to do), can be seen as a kind of reverse equity.

The concept of equity drifted into common law in the fifteenth century and is perpetuated in what are known as chancery, or "equity," proceedings in common-law countries. It was supposed to provide special court intervention on behalf of vulnerable groups, like widows and children, through the issuing of injunctive relief from the bench. In the nineteenth and twentieth centuries, the injunction was often used to protect big business from the impact of workers going on strike.

Equity was a thin, double-edged sword. On the one hand, it seemed the highest fulfillment of the Roman-law principle of the exercise of natural reason. On the other, it undermined the codifying and clarifying qualities of Roman law—its greatest advantage—and opened the way to idiosyncratic or prejudicial behavior on the part of judges. Equity is the point on which the two main principles of Roman law, authoritarianism and rationalism, came into conflict, and this conflict threatened to unravel the stability of the system.

Remembering Antiquity

*T*wo books on how and why the classical legacy from antiquity was preserved, rediscovered, and cultivated were published in the early 1960s, one in the United States and the other in Britain.

One book is formalist, that is, it stresses the intrinsic value of the literature and thought of ancient Greece and Rome—particularly the Homeric epics; the tragedies, especially *Oedipus Rex*; Thucydides' history of war among the Greek city-states; the philosophy of Plato and Aristotle; and Latin poets. No intellectual and literary achievements in Western civilization ever surpassed these classical works, so it was natural that the Greek and Roman writings should be preserved and cultivated. This was the view of Columbia University's Gilbert Highet.

The Cambridge University scholar R. R. Bolgar took a more pragmatic view of the durability of the classical heritage. The Greek and Roman writings served social and political needs of elites in later times, he said; they were also intrinsically majestic.

From 500 to 1000 A.D. the classical heritage, or much of it, was preserved because it served the needs of Church and state. The language of Christian ritual was Latin or Greek; ancient writings had to be maintained as texts in education. The thought world of the early medieval Church was heavily Platonic. Early medieval kings, if they conquered and prospered, saw themselves as continuators of what Constantine I and Theodosius I had started in the Christian Roman Empire of the fourth century A.D.

In the twelfth century, Europe's novel inspirations emerged for cultivating the classical heritage. Antiquities offered explanations of nature—the nature of the universe and the nature of the state. In line with this intellectual quest, the value of Aristotle was recognized for

the first time as a guide to natural science. When fully absorbed, Roman law improved the operations of government at all levels, in both state and Church. The writings of Cicero provided ethical justification and guidelines for the state.

At the end of the thirteenth century, a third wave of exploiting the classical heritage appeared in Western Europe. The Italians, and then other peoples, saw themselves, in middle-class circles especially, as Romans, the upholders of cities and monarchy and republics. This led to close examination of the physical remains of Athens and Rome lying about, and some excavation of the structures in the Roman Forum was undertaken.

Political philosophers, statesmen, and merchants saw themselves as direct perpetuators of Roman traditions, and great efforts were made to collect and then, after 1490, to print Latin texts. In the sixteenth century the intellectual structures of the Church of late antiquity were stressed, first by Protestants and then by Catholics as well. The thinkers of the eighteenth-century Enlightenment emphasized the rational currents in ancient thought.

* * *

In the nineteenth century, the classical heritage became part of the education and ethos of the British elite that went out, like the Romans, to rule a world empire. The not-very-hidden homosexuality in the classical writings also fitted the psychology of adolescents and young men educated in single-sex private schools before becoming imperial proconsuls.

At the end of the nineteenth century, a much deeper and more confident exploration of antiquity was cultivated in universities, but by the 1920s, the fashion for studying the legacy of ancient Greece and Rome among the educated middle class in Europe and America was eroded, being replaced by the natural and social sciences in school and college curricula. Since the 1950s, however, there has been something of a revival in studying the ancient writings as a foundation of Western civilization. Sensing the shape of the market, publishers have strained to bring out new and more accurate translations of the classical texts. Greek tragedy and Roman historical literature received a renewed and deeper appreciation.

Meanwhile, after some French scholars accompanied Napoleon

Bonaparte on his conquest of Egypt in the 1790s and first examined the pyramids close up, a push toward archaeological inquiry was mounted by British and German diplomats in the Near East. An Oriental Institute was founded in Chicago to buttress the truth of the Bible from material remains, and this quest was taken up in the 1950s by Israeli archaeologists. That this quest undermined, rather than confirmed, the historicity of the Hebrew Bible did not hinder the resulting much deeper understanding of the Ancient Near East.

* * *

The monuments of antiquity in the last two decades of the twentieth century entered into the canon of prescribed art and architecture for educated people in the West. Today, to appreciate the beauty of the ancient heritage, it is necessary to visit museums in London, New York, and St. Petersburg, as well as in Athens, Rome, and Cairo.

The preservation and cultivation of the classical heritage signifies the ascription of political, ethical, literary, philosophical, and artistic values to antiquity. But along with being a wellspring of the right, the good, the established, and the aesthetic in Western civilization, exported and exportable from Europe to the rest of the world since the sixteenth century, there is a fundamental problem with the perpetuation of the ideas and values of antiquity.

The ancient world has handed on to later centuries more than just the silver cup of civilization around which modern society and culture are integrated. Antiquity has also passed on the poisoned chalice of thought and behavior patterns that represent so much trouble, deprivation, and, for us, death, in the third Common millennium.

First, antiquity assumed the right of the strong over the weak, the going to war against one's neighbors simply because of a conviction that they can be defeated and humiliated and conquered, or made to pay tribute of one kind or another from the defeated and the weak to the victorious and strong. This assumption of righteousness of war lies at the center of the wars among the Greek city-states and the wars that facilitated the creation of the Roman Empire. The two world wars of the twentieth century are the modern legacy of this lamentable aspect of the culture of antiquity.

Second, antiquity handed on the assumption that, domestically, the strong shall dominate the weak, the rich exploit the poor, adults

rule children and adolescents, and men should oppress women. The ultimate refinement of the cruelty of hierarchy, class, gender, and age—this, too, is part of the contents of the poisoned chalice handed down from antiquity.

Will we ever cut off this side of classicism and achieve a free, peaceful, and equitable society? That remains a great question of history. We both love and perpetuate antiquity, and fear and loathe its adverse heritage.

Perhaps, however, we ascribe both too much praise and excessive blame to antiquity. Both the creative and the mean side of human nature were possibly set in human genetic makeup from the beginning of anthropological man in East Africa 2.5 million years ago. The upside and downside of the human genome shaped the course of antiquity and still fosters human development in our own time.

The violence and oppressiveness of the human species was built into the genetic structure from earliest times by Darwinian struggle for existence and survival of the fittest. So were the progressive traits. Antiquity showed what happened when the good genes clashed with the bad ones. So does the history of our time, with a heavier penalty in this postmodern age, that of the threat of extinction of humanity. There is a jauntiness, a naïve exuberance about the people of antiquity, as described by their historians, that we can no longer share in our own social relations.

* * *

The one area of social interaction in which we have transcended the ancients is that of slavery. Roughly one quarter of any major society in antiquity were human chattels—someone's property. Slavery in the ancient world derived from the rules of war. A defeated people, including women and children, could be, and frequently were, passed under the iron code of slavery.

Unlike American slavery in the eighteenth and nineteenth centuries, ancient slavery did not imply a particular skin color. No more than 5 percent of the slaves in the Roman Empire could have been black Africans. The majority of Roman slaves were derived from defeated peoples in the Near East.

Some slaves were highly educated, and a favorite role for them in domestic households of the upper classes was service as schoolteachers

and tutors. They could be poets and musicians. Slaves were active in philosophical speculation and historical writing. There were slaves who lived lives of comfort and relative affluence. But at least half of the slaves in antiquity were subject to continued hard labor on estates, in mines and quarries, in shops and boats.

Since slaves do not reproduce their own numbers, and after 100 A.D. the Romans no longer engaged in wars of conquest (too expensive, and, in any case, the barbarian Huns and Germans made poor, undisciplinable slaves), slavery declined in the later Roman Empire. By 400 A.D., it was being challenged by a sharecropping system that the Middle Ages knew as serfdom. The *coloni,* as the Romans called these serfs, were not chattels. They were bound to the land and the factory, but they had rights.

Around 1910, the great sociologist Max Weber called the rise of the colonate a trend toward social melioration. But the violence, exploitation, and general meanness in Roman society continued unabated. The Christian Church chose not to challenge slavery. It spoke of an inner, spiritual freedom, not social liberation and legal equality. Only around 1800 did a variant of Christianity become an opponent of slavery.

* * *

From time to time there have been loud disputes in the West over the value and content of the classical heritage. In the second century B.C., some of the old senatorial aristocracy in Rome railed against the importation of Greek literature, language, and art as enervating and weakening the Roman military spirit.

Between 250 and 450 A.D., some Church leaders claimed Athens had nothing to do with Jerusalem. In the mid-eighteenth century, there were disputes in England and France between the partisans of ancient and modern literature. In the 1990s, the "culture wars" raged on American campuses and among the more intellectual media outlets, between adherents of the canon of Western civilization grounded in the classics and "the relativists," who sought freedom to create new curricula devoid of the alleged imperfections of the classical legacy.

The fact remains, however, that there was a narrow spectrum of choice with regard to the classical heritage. The genres of art and literature handed down from antiquity, and the sterling models that clas-

sical culture provided, showed that antiquity's legacy was too inextricably woven into the warp and woof of our culture to be removable without a revolutionary anti-antique consciousness. The eagerness of publishers to publish translations from classical literature, the popularity of exhibits of ancient art, and the reversion since 1980 to core curricula on the Victorian model of "the best that has been thought and said" indicates the continuing vitality of the literature, philosophy, and art of antiquity for our own times.

In reconstructing the sites of antiquity in our imagination, we are greatly helped by the astonishing heritage of art and architecture, either remaining on-site or exhibited in museums—monuments like the statue of Zeus lifted out of the bottom of a harbor near Athens; the Elgin Marbles from the Acropolis; Egyptian jewelry, of which good imitations can be cheaply bought at the Metropolitan Museum of Art; the giant head of Constantine from the fourth century A.D.

I want to point out three memorials of a less dramatic and aesthetic nature. First, there is a Greek island with a simple temple perched on a hill overlooking the harbor, welcoming tired sailors home from their far-flung journeys.

Second, there is the racetrack of what was once the Hippodrome in Rome, where chariot races were held before huge excited crowds. The ground is now covered with thick grass, but underneath the grass the shape of a racetrack can still be glimpsed.

Third, at Caesarea, on the Israeli coast, forty miles north of Tel Aviv, there is a partly restored Roman open-air theater, seating some five hundred people, the seats facing out toward the Mediterranean. Here, tragedies were performed; here, in summer, rock concerts are now held, terrorists permitting. I can see the people involved in these humble places, the ancient masses who do not speak. The poets and dramatists and philosophers speak to us for antiquity, but these little sites of prayer and entertainment memorialize the millions who came and went and, always silent, are now forgotten.

A GUIDE TO FURTHER READING

The modern and recent historical literature on antiquity is vast in size. There are at least three thousand volumes in English worth reading on the ancient world. The weakness of this literature is that it is often too academic and technical to be accessible to the lay reader and beginning student.

Time and again authors fail to take pains to write in readable style. Since 1960 there has been a marked tendency to avoid highly interpretive works, and to write with focus on detailed information. Few people have the time and educational background to plow through these densely learned volumes.

Part of the problem is that surveys of ancient history are no longer offered in many respectable American colleges, so the market for introductory works and textbooks is very small.

Another problem arises from Britain where many writers on antiquity have been studying Greek and Latin since they were five years old, and presuppose fluency in the classical languages. A famous case is that of a British historian of the Roman Empire, now holding a chair at Yale, who published a thick study of a fourth-century-A.D. Roman historian but did not translate the Latin quotations.

The following books offer many hours of pleasure and high education. These recommendations focus on recent publications. Readability is noted.

PREHISTORY

There is a gap of 2.5 million years between the emergence of recognizable humans in East Africa and the appearance of literate civilizations in the Nile and Tigris-Euphrates valleys around 3500 B.C. What is known from archaeological data about this period of so-called prehistory is summarized in Colin Tudge, *The Time Before History* (New York: Scribner, 1996), Donald Johnson and Blake Edgar, *From Lucy to Language* (New York: Simon and Schuster, 1996), and Virginia Morrell, *Ancestral Passions* (New York: Simon and Schuster, 1995), a fascinating biography of the famous Leakey family of paleontologists.

HYDRAULIC DESPOTISMS

An authoritative, if difficult, summary of the history of the Ancient Near East before 300 B.C. is Amelie Kuhrt, *The Ancient Near East,* 2 vols. (New York: Routledge, 1995). More concise summaries are H. W. F. Saggs, *Civilization Before Greece and Rome* (New Haven, Connecticut: Yale University Press, 1989), and Charles K. Maisels, *The Near East* (New York: Routledge, 1993). Kuhrt will be the standard reference work for many years to come; Maisels is easy reading and is also well-informed. A dry but authoritative account of the material foundations of ancient Iraq is D. T. Potts, *Mesopotamian Civilization* (Ithaca, New York: Cornell University Press, 1997); J. N. Postgate, *Early Mesopotamia* (New York: Routledge, 1996) is more lively. Of the vast literature on ancient Egypt, three recent books stand out: Barry J. Kemp, *Ancient Egypt* (New York: Routledge, 1989), Nicholas Grimal, *A History of Ancient Egypt* (Cambridge, Massachusetts: Blackwell, 1988), and Ian Shaw, ed., *Oxford History of Ancient Egypt* (New York: Oxford University Press, 2000). Kemp's work is easy reading. Jean Vercoutter, *The Search for Ancient Egypt* (New York: Abrams, 1993) is a well-illustrated and concise history of Egyptian archaeology.

THE JEWS AND THEIR BIBLE

From 1967 to 1980, the Israelis ruled the Sinai Peninsula. During this period their archaeologists sought proof of the liberation myth in the Book of Exodus. The result of the Sinai search and many excavations in Israel is summed up in Israel Finkelstein and Neil Silberman, *The Bible Unearthed* (New York: Free Press, 2001)—"There was no Exodus." Also important and readable are Richard E. Friedman, *Who Wrote the Bible?* (New York: Summit, 1987), and Robin Lane Fox, *The Unauthorized Version* (New York: Viking, 1991). For ancient post-biblical Judaism, there is the brilliant book by Shaye J. D. Cohen, *From the Maccabees to the Mishna* (Philadelphia: Westminster, 1987).

THE GREEKS

The authoritative and well-organized textbook by Claude Orrieux and Pauline Schmitt Panel, *A History of Ancient Greece* (Cambridge, Massachusetts: Blackwell, 1999) is the starting point for all further reading on ancient Greece. For the Hellenistic era, Peter Green, *From Alexander to Actium* (Berkeley, California: University of California Press, 1993) is the authoritative survey, well-written. H. D. Kitto, *The Greeks* (New York: Penguin, 1985) remains the best book on Greek culture, but see also Anthony Andrews, *The Greeks* (New York: W. W. Norton, 1967), and Robert Garland,

The Greek Way of Life (Ithaca, New York: Cornell University Press, 1990) for insightful surveys. The archaeological quest for ancient Greece is well told in Roland and Françoise Etienne, *The Search for Ancient Greece* (New York: Abrams, 1990), beautifully illustrated. Richard Jenkyns, *The Victorian and Ancient Greece* (Cambridge, Massachusetts: Harvard University Press, 1980) is a fascinating account of nineteenth-century English devotion to Athens. The biography of Alexander the Great by Robin Lane Fox, *Alexander the Great* (New York: Penguin, 1986), is both deeply learned and well-written, a masterpiece. The underside of Greek life is sharply depicted in Eva C. Keuls, *The Reign of the Phallus* (Berkeley, California: University of California Press, 1993).

THE ROMANS

The authoritative textbook, but not always easy reading, is Marcel Le Glay, Jean-Louis Voison, and Yann Le Bohec, *A History of Rome* (Cambridge, Massachusetts: Blackwell, 1996). It is particularly good about incorporating recent archaeological discoveries. Very different is Michael Grant, *A History of Rome* (New York: History Book Club, 1997), a well-written, highly personal account based on close reading of the literary sources. Colin Wells, *The Roman Empire*, 2nd ed. (London: Fontana, 1992), and Averil Cameron, *The Late Roman Empire* (London: Fontana, 1986) are sober and reliable surveys. Michael Rostovtzeff, *Social and Economic History of the Roman Empire*, 2nd ed. (Oxford, England: Clarendon Press, 1957) has not been superseded and remains the single best book ever written about antiquity. Nor has Tenney Frank, *An Economic Survey of Ancient Rome*, 6 vols. (New York: Octagon, 1975) been superseded. Fergus Miller, *The Roman Empire and Its Neighbors*, 2nd ed. (London: Duckworth, 1981) is an entry to advanced study but difficult reading. Fergus Miller, *The Emperor in the Roman World* (London: Duckworth, 1977) is important but prolix. C. N. Cochrane, *Christianity and Classical Culture* (New York: Oxford University Press, 1957) is an interesting indictment of Roman civilization from a Christian point of view. J. A. Crook, *Law and Life of Rome* (London: Thames and Hudson, 1967) remains the best introduction to the civil law. Claude Moratti, *In Search of Ancient Rome* (New York: Abrams, 1992) is a splendidly illustrated and insightful history of Roman archaeology.

THE CHRISTIANS

The literature is vast but seven books stand out as informed, incisive, and very well written: Paula Frederikson, *From Jesus to Christ* (New Haven, Connecticut: Yale University, 1988), Henry Chadwick, *The Early Church*

(New York: Penguin, 1993), Robin Lane Fox, *Pagans and Christians* (New York: Knopf, 1987), Peter Brown, *Augustine of Hippo,* 2nd ed. (Berkeley, California: University of California Press, 2000), A. H. M. Jones, *Constantine and the Conversion of Europe* (Toronto: University of Toronto Press, 1978), Elaine Pagels, *The Gnostic Gospels* (New York: Random House, 1979), and Judith Herron, *The Formation of Christendom* (Princeton, New Jersey: Princeton University Press, 1987). Chadwick has an infectious sense of humor and Pagels is a proponent of feminism. Lane Fox's book is another enjoyable masterpiece.

GENERAL READING

R. R. Bolgar, *The Classical Heritage and Its Beneficiaries* (Cambridge, U.K.: Cambridge University Press, 1963) is still very much worth reading as a pragmatic and relativist view of the classical legacy. In Charles Freeman's *Egypt, Greece, and Rome* (New York: Oxford University Press, 1996), the part on Greece is well done. Barry Cunliffe, ed., *The Oxford Illustrated History of Europe* (New York: Oxford University Press, 1996), presents the archaeological point of view, lavishly illustrated and diagrammed. It replaces the 1948 classic by V. Gordon Childe, *What Happened in History?* (New York: Penguin, 1952). Brian M. Fagan, *The Seventy Great Mysteries of the Ancient World* (New York: Thames and Hudson, 2001) is not always factually reliable but provides good bedtime reading. The feminist perspective is discussed in Riane Eisler, *The Chalice and the Blade* (New York: HarperCollins, 1988), and Marija Gimbutas, *The Language of the Goddess* (New York: HarperCollins, 1991).

Index